THE ART OF DRAWING
IN FRANCE
1400-1900

THE ART OF DRAWING
IN FRANCE
1400-1900

DRAWINGS FROM THE NATIONALMUSEUM, STOCKHOLM

PER BJURSTRÖM

Published in association with The Drawing Center, New York

SOTHEBY'S PUBLICATIONS

This book has been made possible with public funds from the National Endowment for the Arts and the New York State Council on the Arts.

British Airways is the official airline of The Drawing Center.

The Drawing Center acknowledges the assistance of the Vincent Astor Foundation. The Center is proud to be a recipient of a Challenge Grant from the National Endowment for the Arts.

First published 1987 for Sotheby's Publications
by Philip Wilson Publishers Ltd
26 Litchfield Street, London WC2H 9NJ
in association with The Drawing Center

Published on the occasion of the exhibition
'The Art of Drawing in France' at The
Drawing Center, 35 Wooster Street,
New York, NY 10013

Distributed in the USA by
Harper & Row, Publishers, Inc
10 East 53rd Street
New York, NY 10022

ISBN 0 85667 328 5
LC 86–50737

Designed by Polly Dawes
Typeset by Tradespools Ltd, Frome,
Somerset
Printed and bound in Belgium by Snoeck,
Ducaju and Zoon, NV, Ghent

The Drawing Center would like to dedicate this book to Edward H. Tuck, who as the first Chairman of the Board had the courage to guide the Drawing Center in its early days. Over the last ten years he has continuously lent his enthusiasm and graciousness to this organization. Because of his love of France, I thought this a fitting place to put his name.

Mrs Felix G. Rohatyn
CHAIRMAN

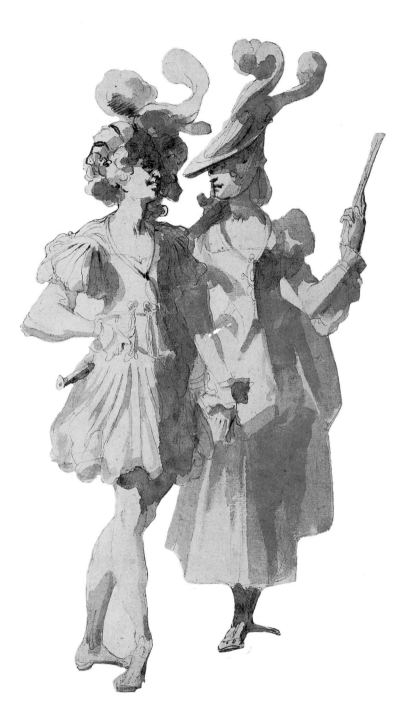

CONTENTS

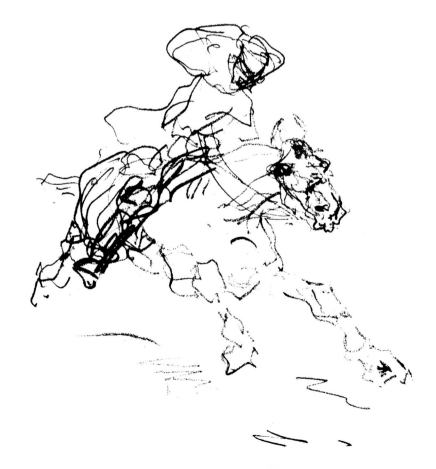

FOREWORD

This exhibition celebrates the tenth anniversary of The Drawing Center. Since its opening in 1977, the Center, a nonprofit institution, has sought through exhibitions and educational events to express the diversity, quality and importance of drawing – the creation of unique works on paper – as a major art form. Each year the Center presents five exhibitions. Those of an historical nature complement the Center's *Selections* series – group exhibitions of drawings by promising, contemporary artists whose work is shown by the Center for the first time in New York. These are chosen from the Center's ongoing Viewing Programme. Through this programme, over 2,000 artists each year are able to make appointments to show their drawings to curators or leave a portfolio for viewing by the curatorial staff. In each of the four annual exhibitions, the work of eight to fifteen artists is shown. Over the past ten years, 400 artists have been shown in thirty-seven *Selections* exhibitions. The work of over 75 of these artists is now in the collections of museums around the world. These exhibitions are very special to the Center, since every well-known artist – even Watteau and Chardin – was at one time a promising unknown.

It is with special pleasure that The Drawing Center presents these drawings from the Nationalmuseum in Stockholm. This exhibition is a particularly important one for The Drawing Center as the collection of French drawings at the Nationalmuseum is celebrated the world over. Also, the Director, Per Bjurström, has been a good friend and adviser to the Center – it is certainly with his help that the Center is able at this time to celebrate its tenth anniversary.

The organization of the exhibition was greatly facilitated by the constant support of the Directors of The Drawing Center: Mrs Felix G. Rohatyn, Chairman, Mrs Walter N. Thayer, Vice Chairman; James M. Clark, Jr.; George R. Collins; Mrs Colin Draper; Colin Eisler; Michael Iovenko; Werner H. Kramarsky; William S. Lieberman; John McGarrahan; Mrs Gregor W. Medinger; and Edward H. Tuck. I also appreciate the contribution of the Advisory Committee: Egbert Haverkamp-Begemann, Per Bjurström, Dennis Farr, John Harris, C. Michael Kauffmann, A.W.F.M. Meij and Pierre Rosenberg. Special thanks go to my colleagues, Elinore Antell, Director of Development; Peter Gilmore, Exhibition Assistant and Janet Riker, Assistant Curator. All of us thank the many work/study students and interns who have made our task easier and more pleasurable.

Finally, I would like to thank the following people who helped in innumerable ways: Mrs Vincent Astor, David Bancroft, Michael Beirut,

Huntington T. Block, Monica Bretherton, Duncan Bull, Timothy Clifford, Tamar Cohen, Keith Davis, Margaret Holben Ellis, Mildred Fitzgerald, Linda Gillies, Mr and Mrs Sydney Gruson, Laura Hillyer, Paul Hopper, Heather Jones, Marie T. Keller, John Lampl, Irene Mann, Colin Marshall, Ward Mintz, Richard Oldenburg, Andrew Oliver, Felix G. Rohatyn, Sarah Rubenstein, Walter N. Thayer, Brenda Trimarco, Joline Tyhach, David Tunick, Lawrence Turcic, Lella and Massimo Vignelli, Paula Volent, John W. Wallden, Alice Martin Whelihan and Philip Wilson.

Martha Beck
DIRECTOR
THE DRAWING CENTER

INTRODUCTION

It was when Martha Beck at the Drawing Center in New York approached Sweden's Nationalmuseum for an exhibition of master drawings that the idea arose of reviewing the development of drawing in France in the light of a single collection. A travelling exhibition of old master drawings from the museum had just been arranged for the United States in 1985–6 and a new exhibition with too similar a choice was out of the question.

The suggestion happened to coincide with the completion of work on the third and final volume of the museum's catalogue of French drawings. With all the material freshly considered it was therefore tempting to display both the quality and the breadth of this collection in an exhibition. From there it was a short step to the idea of backing up the exhibition with an account of the contexts and developments it was designed to illustrate. Although hazardous, the attempt seemed worth while as a means of enabling the exhibition to be properly appreciated outside a limited circle of connoisseurs.

The collection of old master drawings at the Nationalmuseum can be said to have started with Nicodemus Tessin the younger. Besides being responsible for court ceremonies and festivities, Tessin was the architect in charge of the new royal palace that was built in Stockholm in the early eighteenth century. For this work he amassed reference materials consisting of treatises, engravings, architectural drawings, ornamental designs, theatrical sketches and so on. As one would expect, this collection included drawings from France. These were mostly decorative (for example, work by Thomas Blanchet and Nicolas Dorigny), but there were a number of freehand drawings – for instance, by members of the Corneille family and Sébastien Bourdon.

When Tessin's son, Carl Gustaf, went to Paris in the mid-1710s, he took with him a printed catalogue of his father's collection of engravings and drawings, with orders to make suitable additions if the opportunity arose. The only drawings the younger Tessin acquired on that occasion were a few sheets and about ten counterproofs by Watteau, which were more to his own taste than to that of his father. He seems to have made no effort to fill gaps in the existing collection either on that occasion or when he returned to Paris in 1728. He procured pictures but no drawings, except possibly for two sheets by Lancret.

One may ask whether Carl Gustaf Tessin would ever have assembled his collection of drawings had he not been in Paris on a diplomatic mission at the time when the fabulous collection of Pierre Crozat, numbering nineteen thousand drawings, was sold by auction in the course of four weeks, from 10 April to 13 May 1741. The bulk of the Crozat collection was made up of Italian drawings, but about one-tenth was French work.

It was probably Pierre-Jean Mariette (1694–1774), the leading art historian and dealer of the day, who encouraged Tessin to take this opportunity of founding a collection. Tessin saw a good deal of Mariette, whose judgement he respected, and was no doubt well informed about the auction because Mariette was in charge of the arrangements and also compiled the outstanding catalogue, a milestone in the annals of art history.

It is noteworthy that Tessin's approach to the auction was that of an art historian. This selection from the vast quantity of material which was to be sold formed a conspectus of the history of drawing – an aspect of his purchasing policy which is mentioned time and again in his manuscript catalogue. Mariette was his informant, both in person and via the auction catalogue.

The French drawings were auctioned in 102 lots, of which Tessin acquired thirteen and parts of three more. He did not buy any of the sixteenth-century French work, which made up three lots, since the Fontainebleau school was already represented among his previous purchases in the form of studies by Primaticcio. His most important acquisitions were numerous drawings by Poussin, Callot, La Fage and Mellan (though a number of the Poussin sheets have not found favour with modern critics), as well as work by artists such as Le Sueur, Charles de La Fosse, Jean Jouvenet and Antoine Coypel. Another valuable purchase consisted of some sheets by Antoine Watteau that the artist had once presented to Crozat. Tessin also made some supplementary purchases from art dealers in connection with the auction, but these were of secondary importance.

Tessin stopped buying old master drawings almost as abruptly as he had started, but he made great efforts to acquire sheets by contemporary French artists. The outstanding items here are his incomparable set of sheets by François Boucher and numerous works by Natoire, Desportes, Oudry and other artists. He also managed to obtain three drawings by Chardin – until recently the only ones that could be attributed for certain to this artist.

Tessin was delighted with his collection, which he catalogues with great care. In 1755, however, financial straits obliged him to sell it to the King of Sweden. In due course it became public property when the Royal Museum was set up in 1794 (the name was changed to Nationalmuseum when the collections were transferred from the palace to the present building in 1866). The collection of Carl Gustaf Tessin makes up more than one-third (650 items) of the present-day collection of French drawings at the National-museum, not counting all the sheets that he had inherited from his father, Nicodemus Tessin the younger.

For the period up to the 1740s the collection of drawings at the Nationalmuseum is in fact dominated by the contribution from the Tessin family. One must also mention, however, the collection that the sculptor Johan Tobias Sergel assembled, mainly while he was a student in Rome 1767–78; though smaller than the Tessin collection, it is nonetheless important for the light it throws on a period of French art in Rome that is surprisingly poorly documented in France.

Substantial though the Tessin and Sergel accumulation of works by the artists of their choice were, the collection as a whole provided a very uneven coverage of the history of French drawing. For example, the presentation of Boucher and his contemporaries ceased abruptly at the point when Tessin returned to Sweden, and the drawings that Sergel left cover just a few years in the life of each artist concerned. Some of the more glaring gaps were, however, filled early on by generous donations or by fortunate acquisitions – for instance, works by Gabriel de Saint Aubin and Eugène Delacroix. Other acquisitions were more a matter of chance.

A new period of active collecting started, however, in 1958, primarily as a consequence of the exhibition, *'Five Centuries of French Art'*, which Professor Carl Nordenfalk mounted in that year at the Nationalmuseum. An appraisal of the collection of drawings disclosed evident shortcomings. The most deplorable omission – the complete absence of Claude Lorrain in an otherwise

Gustaf Lundberg, *Carl Gustaf Tessin*
(Nationalmuseum, Stockholm)

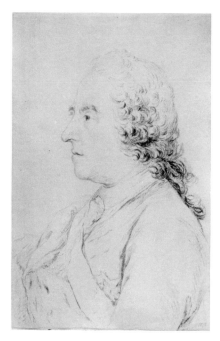

admirable seventeenth-century section – was happily rectified for the exhibition by the provision of a large landscape, two smaller animal studies and a drawing of a plant. Further works by this artist have subsequently been added. The museum has also tried to make the sixteenth-century section more representative, to fill in the period 1740–70 and give the collection continuity from the French Revolution up to the present day.

In the last twenty-five years more than four hundred drawings have been added to the French collection. Not all of them are masterpieces but each one performs a function in a collection based on the scholarly principles laid down by Carl Gustaf Tessin.

The Nationalmuseum cannot hope to cover the entire field. The really costly pieces – an Ingres portrait, for instance – are beyond its means. Nevertheless, the museum is able to display many aspects of such artists as Fragonard and Hubert Robert, Greuze and David, Géricault and Victor Hugo, ranging from spontaneous sketches to finished drawings. Occasionally an important acquisition is made to enrich a section that is already well represented. A case in point is a notable Watteau drawing which has a direct counterpart in the museum's painting *La Leçon d'Amour*. Efforts are also made to augment the collection with drawings which throw light on paintings in the museum.

By European, not to mention American, standards the financial resources of the Nationalmuseum are extremely modest. In a way, this has favoured the collection of French drawings in recent years, since, with really important paintings and sculptures beyond its reach, the museum does, however, have sufficient funds to purchase outstanding, and sometimes costly, drawings. Bengt Dahlbäck, Director of the Museum in the 1970s, championed the view that there was more point in acquiring a notable drawing than in spending the same money on a painting of inferior quality.

It is hazardous – perhaps even foolhardy – to try to offer an account of the art of drawing in France with reference to a single collection only. Even the collections in the Louvre are not complete in every respect; for example, the emergence of the great portrait tradition in the sixteenth century is documented not there, but at the Musée Condé, Chantilly or in the Bibliothèque Nationale. Obviously the same proviso applies to the Nationalmuseum. Even in the nineteenth century there are still some embarrassing gaps, with no drawings at all by Courbet or Seurat and no notable drawing by Manet. Nonetheless, even though we risk attracting attention to such shortcomings, we take the opportunity of making the collection known to a wider international circle.

BEGINNINGS AND PRECURSORS

As in Italy, so in France the art of drawing started in earnest during the Renaissance. Chance seems to have played such a large part in the preservation of earlier work that the picture this gives of development is bound to be incomplete.

One of the outstanding documents is the sketchbook of an architect, Villard de Honnecourt (Bibliothèque Nationale, Paris), apparently from the period 1230–50. It contains numerous figure and animal studies that can be traced back to prototypes in Byzantine art and Roman sculpture. Other sheets are nature studies. The ink drawings concentrate on essentials, using geometric shapes as well as a certain amount of stylization. The forms serve to rewrite the figures, establish proportions and balance the elements in the composition.

Little is known about the art of drawing in the fourteenth century. In the period c. 1400, however, a number of important artists moved from court to court and made their influence felt in many parts of Europe. An Eastern, refined and mannered tradition, centred on Lombardy and Austria, can be distinguished from a simpler, more realistic approach in France and the Netherlands. The development of this realism owed a great deal to Pol, Hermann and Jannequin de Limbourg, the famous miniaturists who worked for the Duc de Berry. Though there is some stylistic variety in pictures of this period, they express common ideals, those of the International Gothic, depicting a courtly world where elegance and sophistication prevail. The scenes, usually done in a decorative, miniaturist silverpoint technique, have a still, poetic mood.

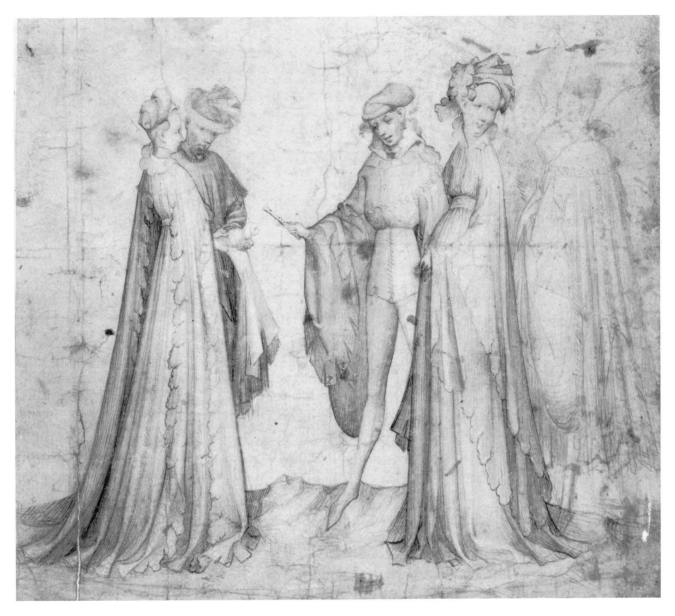

1 Unknown artist

WORKING *c.* 1415
COURTLY COMPANY
Silver-point, partly retouched in ink, on
white prepared paper
17.5 × 22.2*
University Library, Uppsala

The gallant figures and the refined style
indicate that the drawing was produced at a
court, a typical work of the years *c.* 1400.
The costumes are similar to those worn at the
court of Charles IV of France (1380–1422).

Scholars differ about the exact origin of
this drawing, even if most agree on a location
in the lower Rhine area. Although the
drawing most probably represents a
provincial school, it reflects an international
style which had its centre at the French
court.

BIBLIOGRAPHY
G. Ekholm, Om Uppsala universitetsbiblioteks
handteckningssamling, *Uppsala Universitets
Minnesskrift 1821–1921*, Uppsala 1921,
pp. 575 ff.
C. Dodgson, *Vasari Society*, Series 2, 16 (1935),
pl. 8
O. Benesch, 'Eine Zeichnung vom Meister des
Utrechter Marienlebens', *Die graphischen Künste*,
N.F.2 (1937), p. 14, ill. p. 15
A. Stange, *Deutsche Malerei der Gotik III*, Berlin
1938, p. 116, ill. p. 151
G. Ring, *A Century of French Painting*, London
1949, p. 201, no. 70B
E. Schilling, 'Altdeutsche Zeichnungen in
Skandinavien', *Kunstmuseets Årsskrift* 38 (1951),
p. 47, ill.
E. Panofsky, *Early Netherlandish Painting*,
Cambridge, Mass. 1953, p. 397
O. Kurz, 'A Fishing Party at the Court of William
VI, Count of Holland, Zeeland and Hainault', *Oud
Holland*, 1956, p. 128
R. v. Luttervelt, 'Ein Beiers-Hollandse
familiegroep', *Oud Holland*, 1957, p. 139

EXHIBITIONS
Stockholm, Nationalmuseum, *Dutch and Flemish
drawings*, 1953, no. 1
Amsterdam, Rijksmuseum, *Middeleeuwse Kunst der
Noorderlijke Nederlanden*, 1958, no. 171
Stockholm 1958, no. 174
Vienna, Kunsthistorisches Museum, *Europäische
Kunst um 1400*, 1962, no. 265

*All dimensions are expressed in centimetres,
height before width.

EARLY
PORTRAITURE

Late mediaeval Europe was ruled to a large extent by feudal lords and princes. Kings and emperors had difficulty in holding their own. Artists moved freely from patron to patron, helping to spread ideas and styles.

The situation in France was no exception. England ruled parts of the country for many years and the towns were financially independent of the monarchy. A lasting unification started, however, with Jeanne d'Arc and the capture of Orléans in 1429. The Hundred Years' War with England finally ended in 1453. Then Louis XI (1461–83) managed to break the resistance of the feudal barons and laid the foundation of absolute monarchy.

It is also in about the middle of the fifteenth century that one can begin to discern a specifically French art of drawing. Two artists in particular were responsible for this development. One was Le Maître des Grandes Heures de Rohan, whose *Pool of Bethesda* (Herzog Anton Ulrich Museum, Brunswick) has a clearly mediaeval religious mood but also an expressiveness in the refined, elongated figures, heralding a new epoch.

A similar analytical approach is displayed by Jean Fouquet in the portrait he drew of Guillaume Juvénal des Ursins (Kupferstich-Kabinett, Staatliche Museen Preussischer Kulturbesitz, Berlin), identified with the aid of the painting in the Louvre. The portrait gives evidence of the artist's psychological insight and his ability to convey the complexity of the subject's character. Juvénal had been made a royal councillor at the age of twenty-three, which was particularly remarkable for a member of the bourgeoisie. His father was alderman of the Parisian goldsmiths and a significant political figure. His heavy figure and confident appearance make Juvénal physically impressive. Though this is apparent in the painting, it is still more so in the drawing,

Le Maître des Grandes Heures de Rohan,
The Pool of Bethesda
(Herzog Anton Ulrich Museum, Brunswick)

where the face, rendered as surfaces with a few precise accents, fills the sheet. Juvénal was born in 1400 and the drawing seems to have been done in about the middle of the century. It represents the start of a portrait tradition that is remarkable for its vitality over a hundred years.

The drawn portrait became something of a French speciality, cultivated not only at the royal court but also among the nobility and bourgeoisie. With the accession of Francis I in 1515, the artistic initiative in this genre passed to Jean Clouet (c. 1475/80–1541). A native of Brussels, Clouet concentrated on portraiture. There are some faint links with Fouquet, but Clouet seems to have been a great innovator, excelling in the drawn portrait. The Musée Condé, Chantilly, has all but a few of the 127 sheets by him that are still in existence.

Clouet, like most artists at that time, was influenced by developments in Italy. In Aix-en-Provence c. 1476 King René had commissioned a number of portraits of himself to present to members of the court. They were done in black chalk, most probably by an Italian trained in Florence, and may have given Clouet his inspiration without the need for him to visit Florence.

Jean Fouquet,
Guillaume Juvénal des Ursins, c. 1460
(Staatliche Museen Preussischer Kulturbesitz, Kupferstich-Kabinett, West Berlin)

Jean Clouet, *Odet de Foix,*
Seigneur de Lautrec, c. 1515
(Musée Condé, Chantilly)

Clouet started a portrait by establishing the main features in silverpoint. His line serves as an exact demarcation, defining the volumes – precision and detached observation dominate at this stage. Chalk is then used to render the features plastic. The arsenal of values in black chalk creates a subtle interaction between planes. The chalk is applied in parallel strokes, short and delicate in the face, freer in the hair and clothes. Red chalk serves to supplement the black, giving warmth to the face or highlighting lips and eyes. It is the solid form that interests Clouet rather than the contour, which tends to be indistinct as a result of repeated redrawing. Parallel diagonal strokes of varying value and density had already been used to achieve plasticity by quattrocento Florentine artists, and this method was perfected by Leonardo da Vinci. Clouet may have had a chance of studying sheets that Leonardo brought to France in 1517. At all events, he seems to have adopted the technique in earnest after 1520.

Jean Clouet accordingly developed a system and a deceptively simple technique more or less independently. The real strength of his portraiture lies, however, in his vigorous use of the chalk and penetrating observation. He concentrates entirely on the face and clothes of his subject; there is usually no more than a suggestion of the hands.

Clouet's drawings were of great importance for his successors. It is his earliest portraits, from 1515–20, that are rated most highly. The technique may still be imperfect but there is a striking intensity in the perception of the model. When the younger Holbein, who worked in a similar way, visited France in 1524, he abandoned silverpoint for chalks. This is not to say that he modified his style – which, unlike Clouet's, is highly dependent on contours.

The Clouet tradition was carried on in France for generations, starting with Jean's son, François Clouet (c. 1516–72). He transformed the perceptive, simple and uncompromising portraiture of his father into a delightful courtly art, elegant and mannered. He produced likenesses without depth, was unwilling or unable to probe a personality, and delighted in the portrayal of a hairstyle and costumes. There is a uniformity about his portraits that comes between us and the subject, denying individuality even though all the personal features are exactly rendered.

Despite or because of these qualities, portraits by François Clouet were collected and imitated. It was during the reign of Henry II (1547–59) that Clouet's services were most in demand. Later he obtained numerous commissions from the dowager queen, Catherine de' Medici. Portraits were an important instrument in the arrangement of royal marriages – Catherine de' Medici had a collection of more than five hundred drawn portraits that she kept in a chest.

Clouet had many industrious pupils. It has proved difficult to distinguish between them and researchers tend to disagree about the attribution of portraits. In the next generation an artist with some personality was François Quesnel (1543–1617). Unlike his predecessors, however, he was primarily a painter. He used red chalk to heighten the colouristic effect. Mixed with black chalk, it suggests the colour of hair; mixed with less black chalk, it indicates the complexion; applied alone, it underscores the lips. Without being entirely realistic, the red colour has a significance here that has to do with reality. Quesnel differs in this respect from Jean and François Clouet, for whom red chalk was primarily a means of emphasizing important components of the picture – for instance, the sitter's eyes. Quesnel can be said to have introduced a method that was to flourish, above all, in the eighteenth century: that of drawing *aux trois crayons* – with three chalks (black, red and white) – on tinted paper.

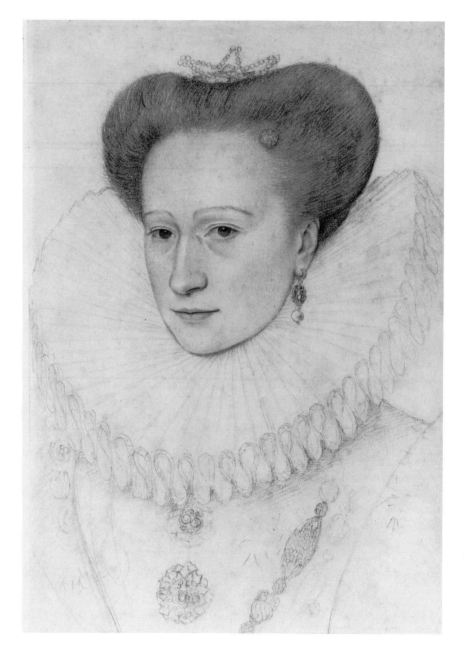

2 François Quesnel

PARIS 1543–PARIS 1617
PORTRAIT SAID TO BE CHRISTINE
OF LORRAINE, GRAND DUCHESS
OF TUSCANY
Black and red chalk
30 × 21
No watermark
NM 117/1974

According to Dimier inscribed on a separate
piece of paper (now lost): *Duchesse de Florence
fille de Carle V.*

The sheet is attributed to François Quesnel
by Dimier, who proposes 1582 as an
approximate date. Christine of Lorraine
(1565–1637), daughter of Charles II of
Lorraine, was the wife of Ferdinand I of
Tuscany, who died in 1609. If she is in fact
the model and Dimier's date is correct, the
portrait was made when she was seventeen.

PROVENANCE
Henri du Bouchet de Bournonville, dit Villeflix
(?). Jean-Jacques du Bouchet de Villeflix (?).
Charles Wickert. Edward M. Hodgkin. Duveen
Brothers Inc. London, Sotheby's sale, 27 June
1974, no. 8

BIBLIOGRAPHY
L. Delteil, *Catalogue de crayons français du XVI
siècle, composant la collection de M. Ch. W****, sale,
Paris, Galeries Georges Petit, 3 May 1909, no. 29
E. Moreau-Nélaton, *Les Clouets et leurs émules*, Paris
1924, 2, pp. 99 f., 3, p. 153
L. Dimier, *Histoire de la peinture de portrait en France
au XVIe siècle*, 2, Paris 1925, no. 911, p. 227
Bjurström, 1976, no. 78

EXHIBITIONS
Cincinnati, Art Museum, 1921
Toledo, Museum of Art, *Exhibition of French
drawings and watercolours*, 1941, no. 4
Jacksonville, Cummer Gallery of Art, *French art of
the sixteenth century*, 1964, no. 19
Washington, Fort Worth, San Francisco 1985–6,
no. 36

THE FIRST SCHOOL OF FONTAINEBLEAU

Louis XII (1498–1515) had skilfully managed to neutralize the new aristocracy in the wealthy provincial cities, and when he was succeeded by Francis I (1515–47), power was concentrated in the person of the king. A concordat with the Pope gave François almost unlimited possessions with which to reward loyal servants – bishoprics and abbeys, which had the additional advantage of being uninheritable. Looking ahead, one can see that this led to the power of cardinals in seventeenth-century France. The new order also provided financial resources for a fitting manifestation of the royal power in architecture and the other visual arts.

Foreign affairs were no less important for artistic development in France. Italy had been invaded earlier by Charles VIII (1493–98), who wished to assert a dynastic right to the throne of Naples. This attempt failed but was repeated by Louis XII, who extended the claim to include Milan. Although he was no more successful, the expeditions had aroused among the French an interest in Italy and its art, as well as in the refined society of the courts of the Italian city states. The culture and philosophy of antiquity attracted less attention at that time.

To enhance his own prestige, Francis I invited some outstanding Italians to visit France. He had no success with Michelangelo but scored a great triumph, when, in the year after his accession, he induced Leonardo da Vinci to move to France and settle there in 1517 at the Château de Cloux, near Amboise.

Too old to paint, Leonardo still drew a great deal. There may be some loss of visual precision in his late drawings, but there is no mistaking the forcefulness of his conception or the energy of its execution. His senses were still as open and his interests as multifarious as ever. Projects from this period include palace plans, a proposed system of canals, and costume sketches for two court festivals. He preferred charcoal to silverpoint or ink, crowding his sheets with a spontaneous flow of ideas and proposals. His sojourn in France was very brief – he died in 1519 – and during these years he suffered from ill health.

The pupils who accompanied Leonardo to France all left the country on his death. Only a decade later, however, Giovanni Battista di Jacopo di Gasparro, usually called Rosso Fiorentino (1495–1540), came to France after one of his drawings had caught the eye of Francis I. Rosso had worked in Florence before moving to Rome, where he was influenced by Michelangelo. When the city was sacked by imperial troops in 1527, Rosso fled to northern Italy and there met Pietro Aretino, a famous satirist who prudently obtained the support of many contemporary rulers, not least the Pope and Francis I. Aretino gave Rosso the idea for a drawing, showing Mars being freed of his armour and helmet by cupids while Venus is disrobed by the Graces – an allegory of Francis I terminating the war with the emperor Charles V and marrying the latter's sister. The drawing (now in the Louvre) was sent by Aretino to Francis, who immediately summoned the artist to his court. Rosso arrived in October 1530 and two years later he started to decorate the palace of Fontainebleau.

Leonardo da Vinci, *Octagonal Building in the Romorantin Project*, (1515–17)
(Courtesy of the Trustees of the British Museum)

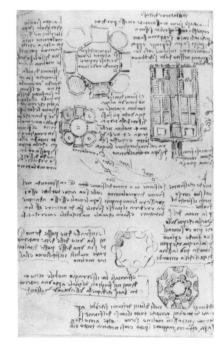

His principal work there consists of twelve large frescoes for the Galérie François I. Together with Francesco Primaticcio (of whom more shortly), he was also responsible for masquerade costumes, triumphal arches and other preparations for the reception of Charles V.

Rosso was a versatile draughtsman, using ink, chalk and wash as well as various combinations of these. His drawings are extreme examples of lessons learnt from Michelangelo. Bodies are pressed into exaggerated postures, twisting in different directions. Faces are contorted; limbs are elongated but are also rendered in an angular fashion to keep them within the picture. Long, sensuous contours alternate with dramatic hatching. The overall impression is nervous and disintegrated. The stylistic ideals of mannerism are also evident in Rosso's compositions. The picture merges with its ornamental frame, just as in the large wall decorations the painted subjects, instead of occupying well-defined surfaces, are enclosed in decorative painting and stucco to conceal the wall itself.

Rosso died in 1540 – by his own hand, according to an unconfirmed rumour – having been eclipsed by a more talented rival, Francesco Primaticcio (1504–70). In the work of Primaticcio and the artists who followed him, the

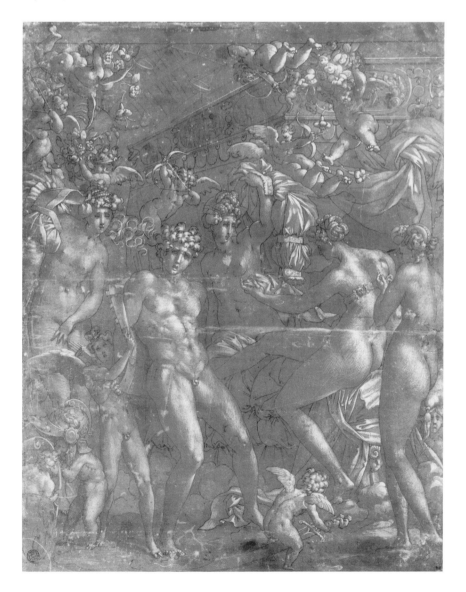

Rosso Fiorentino, *Mars and Venus*
(Cabinet des Dessins, Musée du Louvre, Paris)

ideals apparent in Rosso's work are still more evident. Here French art undergoes a direct transition from the late quattrocento style to fully fledged mannerism. Influenced by the art of Parma, Primaticcio gives his figures the same elongated proportions as Rosso, but their attitudes are more harmonious and graceful. Instead of Rosso's tense dynamism, drawings by Primaticcio contain balanced, gracious and poetic forms; the figures are relaxed and their limbs are clothed in generous folds.

Primaticcio had assisted Giulio Romano in Mantua before he was summoned to Fontainebleau in 1532. After the death of Rosso, he was put in charge of work on the palace and also assisted the king with art purchases, the restoration of antiques and so on.

The greatest single task undertaken by Primaticcio at Fontainebleau was the decoration of the Galérie d'Ulysse, which ran the entire length (150 metres) of the Cour du Cheval Blanc. This work engaged him from 1540 until 1559, when he was succeeded by Nicolò dell'Abate. The gallery was demolished in 1738–9 and we have no exact record of the decorative arrangement. From the numerous drawings that have survived it seems that Primaticcio used the whole of his register. Violent scenes in the manner of Michelangelo alternate with more elegiac pictures that hark back to Parmigianino.

The drawings are done in chalk, black or red, on paper tinted to match the chalk, which is balanced by much use of white heightening. This gives a painterly effect.

The compositions are highly personal variations on the tradition of monumental fresco that stems from Raphael, with plentiful architectural elements that serve to place the various groups in the picture. The perspective is extreme – athletic foreground figures are almost too tall to fit into the picture, while those in the middle distance and background rapidly dwindle. The architecture, often highly complicated, is foreshortened in a similar manner. The painterly quality of the technique contributes to the dramatic effect.

The drawn œuvre of Primaticcio is very large, but there are few paintings by his hand. The decorative work was based on his draft drawings, which is probably why he uses the full range of values. Vasari tells us that Primaticcio then drew the composition on the wall, while the colour was filled in by his assistants.

Besides creating lasting monuments and works of art, Primaticcio – like Rosso before him – was involved in the production of court festivals. Costume sketches by him for such events have been preserved, though the occasions have not been identified. In such sketches it is important that details of the costumes are shown as clearly as possible. Still the artist manages to convey the feeling of a dignified procession, with the participants lining up to enter a banqueting hall. Here the ink drawing is supplemented with watercolour to aid the tailors.

Nicolò dell'Abate (1509/12–71?) came to Fontainebleau in 1552 and largely adhered to the intentions of Primaticcio. He had been trained in his native Modena and developed a style that is more yielding and painterly than Primaticcio's. Coming from Italy, he was able to contribute the latest skills in illusionistic painting. His talents were also used for festivals; the costume sketches by his hand are evidence of a softer approach than that of Primaticcio.

The Italian artists who directed the decorations at Fontainebleau recruited French assistants. These were artists with a tradition of their own, and although Rosso and Primaticcio were very dominant initially, new tendencies arose from the encounter between Italianism and French fifteenth-century art. One of those whom Rosso trained was Geoffroy Dumoustier (known 1535–

Jean Cousin the Younger, *Pan and Syrinx*
(Cabinet des Dessins, Musée du Louvre,
Paris)

73). He assisted Rosso at Fontainebleau 1537-40 and adheres closely to his style.

Similarly, Etienne Delaune (1518-83) can be said to have continued the tradition from Primaticcio. As an ornamentalist, engraver and goldsmith he also drew on a strong heritage of craftsmanship. Apart from purely decorative commissions, his principal work is a series of allegories of the seven liberal arts. Meticulously executed in ink and grey wash on vellum, these pictures were done *c.* 1570 and dedicated to the twenty-year-old monarch Charles IX (1560-74). The series had been commissioned by one of the leading bourgeois patrons, Nicolas Houel, a Parisian apothecary and the author of the programme. The anatomy of the figures and the use of perspective show a strong Italian influence, while the minute attention to detail harks back to the French miniaturists.

Besides supporting Delaune, whose Protestant faith obliged him to leave the court, Houel was the patron of Antoine Caron (*c.* 1527-99), who was working under Primaticcio as well as Nicolo dell'Abate *c.* 1560. For his patron, Caron produced a similar series of drafts in 1562 for tapestries on the history of king Mausolus' faithful widow Artemisia (an obvious allusion to Catherine de' Medici). Caron continued to work for Houel and obtained other commissions, too. He produced many complex allegories, some of them perhaps for the court festivities in 1564-73 that he also depicted and helped to arrange – such as the marriage of Marguerite de Valois and the King of Navarre (1572) or Henri III's entry into Paris (1573). The allegorical theme was accompanied by or developed into subjects of a fantastic and mysterious nature. These also contain elements of violence and cruelty that it seems natural to relate to the political situation at this time.

For the death of Henry II in 1559 was followed by a period of civil war and religious struggle. Royal authority waned during the reigns (1559-89) of his three sons: Francis II, Charles IX and Henry III. To outward appearances the struggle was between Calvinists and Roman Catholics, but the interests at stake were the lost power of the aristocracy and the freedom of the towns. The bourgeoisie was the backbone of the Protestant cause, but both factions were led by noblemen and the religious divide was by no means clear-cut.

Apart from Jean Cousin the younger (*c.* 1522-*c.* 1594), Caron was the only notable artist at this time. He had Catholic leanings, but external events seem to have had little effect on court life.

Drawings by Caron tend to lack assurance. The subject-matter is scholarly, the drawing pedantic. His formal language is related to mannerism, but movement turns into attitude, gesture into pose. His strength lies in the use of wash to charge his rather dry line drawings with strong atmospheric accents. In composition he has the habit of repeating the position of a figure sometimes with slight variations – two, three, or four times in the same picture. Perhaps this is what gives them an unreal air.

3 Leonardo da Vinci (?)

VINCI 1452–AMBOISE 1519

GODDESS STANDING IN A
CHARIOT DRAWN BY TWO
HORSES, ONE OF WHICH IS
FALLING

Pen and brown ink on grey paper

11.5 × 11

No watermark

NM 1462/1863

Numbered at lower right in pen and black
ink: *1278*. (Sparre)

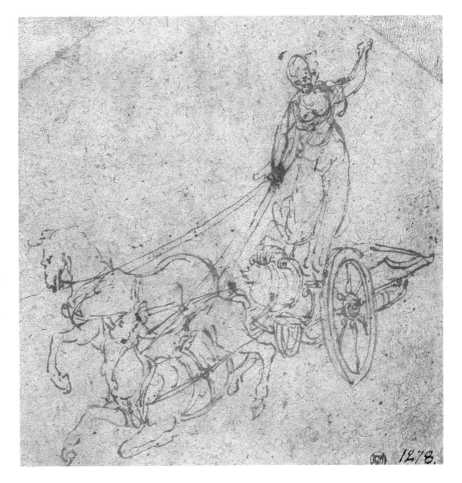

This drawing was listed under Veronese by
Crozat and Tessin but Sirén was doubtful and
regarded it as belonging to Veronese's circle,
certainly Venetian but probably later than
Paolo Veronese.

Zelotti was suggested tentatively by
Fiocco; Terence Mullaly supported this in the
catalogue for an exhibition at the Fondazione
Cini, Venice, in 1971, comparing the
present sheet with two other pen drawings by
Zelotti at the same exhibition[1] and arguing
that the three together provide a basis for
assessing Zelotti's manner of drawing with
the pen.

The whole question of the attribution of
this drawing has to be considered in a new
light as Bengt Dahlbäck in 1979 suggested
that it might be a work by Leonardo da
Vinci; he described the sheet as an
emblematic drawing of a carriage and two
horses, one of which has fallen to the ground,
with a standing female figure pulling the
reins.

In 1983 Dahlbäck obtained support from
Carlo Pedretti, who considers that the
drawing could quite possibly be by
Leonardo, done very late, perhaps in France
after 1517. The drawing is executed on
coarse brown paper, as in Leonardo's latest
drawings and manuscripts. Pedretti further
notes that the untidy touch of the pen and
careless perspective are precisely as in
Leonardo's latest drawings. The subject
might have something to do with his studies
for a Rape of Proserpina or the 'cavalli per il
re Valesio', known to have been done in France.

It might be that the fragment was at one
time part of some sheet in the Codex
Atlanticus.[2]

[1] Terence Mullaly, Catalogue of exhibition, *Disegni
Veronesi del cinquecento*, Venice 1971, nos 59 (coll.
McCrindle, New York), 56 (Christ Church,
Oxford).

[2] Letter from Carlo Pedretti, 5 September 1983.

PROVENANCE

Crozat (Mariette, no. 690 or 691). C. G. Tessin
(List 1739–42, p. 48 v.; Cat. 1749, livré 10, no.
16). Kongl. Biblioteket (Cat. 1790, no. 1278).
Kongl. Museum (Lugt 1638)

BIBLIOGRAPHY

Sirén 1917, no. 476
Bjurström 1979, no. 126 (as Zelotti)

EXHIBITIONS

Stockholm 1962, no. 236
Venice 1971, no. 62
Washington, Fort Worth, San Francisco 1985–6,
no. 5

4 Rosso Fiorentino

FIRENZE 1495–FONTAINEBLEAU 1540
VENUS AND CUPID IN A CHARIOT
Pen and brown ink, brown wash
21.3 × 20.8
Laid down
NM 156/1863
Numbered at lower right in pen and brown
ink: *115* (Sparre) and *47* (struck out)

PROVENANCE
Crozat (Mariette, no. 44). C. G. Tessin (List
1739–42, p. 54 r.; Cat. 1749, livré 4, no. 19).
Kongl. Biblioteket (Cat. 1790, no. 115). Kongl.

Museum (Lugt 1638)

BIBLIOGRAPHY
Sirén 1917, no. 295, as copy after Primaticcio or
Rosso
Bjurström 1976, no. 80

5 Francesco Primaticcio
BOLOGNA 1504–PARIS 1570
ULYSSES HAS PENELOPE'S
SERVANTS KILLED
Red chalk, heightened with white (partly
oxidized), on paper tinted light red
23.9 × 32
Laid down
NM 832/1863
Numbered at lower right in pen and brown
ink: 690. (Sparre) and 15 (struck out)

Recommended by Giulio Romano, who was
his master for the work on the Palazzo del Té
and the Palazzo Ducale in Mantua,
Primaticcio arrived in Fontainebleau in
1532. He was responsible chiefly for the
decoration of the palace after the death of
Rosso Fiorentino in 1540. The work was
collaborative, and Primaticcio's own style is
chiefly discernible in his drawings.

This compositional drawing for one of the
paintings in La Galérie d'Ulysse at
Fontainebleau belongs to a set of nineteen
similar drawings in Stockholm. The

composition has been engraved by van
Thulden as no. 42.

La Galérie d'Ulysse at Fontainebleau,
which depicted the changing fortunes of
Ulysses after leaving Troy, was executed
between 1541 and 1570. The wall paintings
to which this subject belongs were executed
at the beginning of this period, 1541–7.

There are other Primaticcio drawings in
the Albertina, Vienna, in the Museum
Boymans van Beuningen, Rotterdam, and at
Chantilly, which are related to this work.

PROVENANCE
Crozat (Mariette, nos. 399, 400). C. G. Tessin
(List 1739–42, p. 55 r.; Cat. 1749, livré 5, no.
31). Kongl. Biblioteket (Cat. 1790, no. 690).
Kongl. Museum (Lugt 1638)

BIBLIOGRAPHY
L. Dimier, Le Primatice, Paris 1900, no. 179
Sirén 1917, no. 245
W. McAllister Johnson, 'Primaticcio revisited:
Aspects of Draftsmanship in the school of
Fontainebleau', Art Quarterly, 39, 1966, p. 261,
fig. 24
Bjurström 1976, no. 40

EXHIBITIONS
Leningrad 1963
New York, Boston, Chicago 1969, no. 17

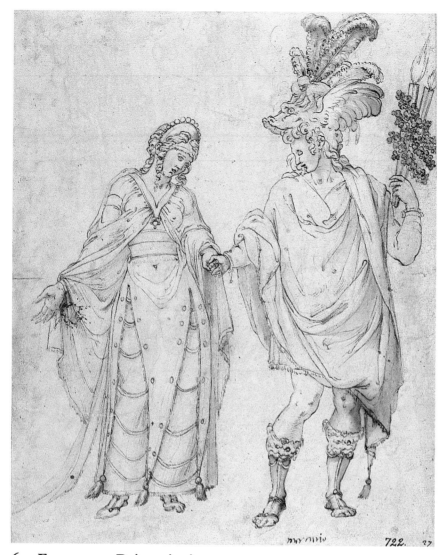

6 Francesco Primaticcio
MERCURY LEADING A WOMAN BY THE HAND

Pen and brown ink, watercolours, over traces of black chalk
30.3 × 24.9
No watermark
NM 865/1863
Inscribed under the male figure in pen and brown ink: *Mercurio* (Primaticcio's hand). Numbered at lower right in pen and brown ink: *722.* (Sparre) and *27*. Inscribed verso in pen and brown ink: *p il duca di lorena*

The winged helmet identifies Mercury but the woman has no distinct symbol; she has been identified as the doleful Eurydice.

The inscription on the verso clearly indicates that the series has to do with a French courtly celebration. It has been suggested by W. McAllister Johnson and Massenet that a closer study of the colours in the sheets might help to pin down the exact occasion, since each noble family wore its colours and these featured in the symbolism at feasts and tournaments.[1] Unfortunately this is hardly feasible because practically all the sheets in the series are in the same colouring, with light-green, light orange-red and violet hues.

PROVENANCE
Crozat (Mariette, no. 412, as Nicolò dell'Abate). C. G. Tessin (List 1739–42, p. 41 v.; Cat. 1749, livré 26, no. 66). Kongl. Biblioteket (Cat. 1790, no. 722). Kongl. Museum (Lugt 1638)

BIBLIOGRAPHY
L. Dimier, 'Några, minnen från den gamla Fontainebleauskolan', *Ord och bild*, Stockholm 1899, pp. 594 ff.
L. Dimier, *Le Primatice*, Paris 1900, no. 203
L. Dimier, *Le Primatice*, Paris 1928, pp. 66 ff.
Sirén 1917, no. 268
Bjurström 1976, no. 51

[1] Paris, Grand Palais, *L'École de Fontainebleau*, 1972, no. 188.

7 Francesco Primaticcio

TWO HERALDS

Pen and brown ink, watercolours, over traces
of black chalk

36.3 × 26.4

Watermark: Grapes with letters S G

NM 875/1863

Inscribed under the figures in pen and light
brown ink: *Crederei che questi dui Genij
comenciassero la pompa del gioco d'Agona*
(Primaticcio's hand). Numbered at lower
right in pen and brown ink: *732.* (Sparre)
and *45*

This sheet is one of the 'dessins des
Mascarades pour des Ballets et pour un
Tournoy' (Mariette) that Tessin purchased at
the Crozat auction. Tessin assumed,
mistakenly, that 'ils son faits pour des Fêtes
données a Charles V par François Ir,'[1] but the
drawings are later than this. Dimier
compares them with the description of
Francis II's entry in 1560 into Chenonceaux,
which his mother had just acquired.

Twelve of these drawings – one of which is
reproduced here – can be regarded as a
relatively homogeneous group on external
grounds, such as inscriptions and paper.
According to McAllister Johnson and
Massenet, the inscriptions indicate that the
drawings were made between 1555 and
1562.[2]

The question of the occasion or occasions
for which these costumes were intended is
still unsettled. However, the presence of
torches and other symbols suggests that
several figures had to do with a wedding.

PROVENANCE
Crozat (Mariette, no. 412, as Nicolò dell'Abate).
C. G. Tessin (List 1739–42, p. 41 v.; Cat. 1749,
livré 26, no. 76). Kongl. Biblioteket (Cat. 1790,
no. 732). Kongl. Museum (Lugt 1638)

BIBLIOGRAPHY
L. Dimier, 'Några minnen från den gamla
Fontainebleauskolan', *Ord och bild*, Stockholm
1899, pp. 594 ff.
L. Dimier, *Le Primatice*, Paris 1900, no. 211
L. Dimier, *Le Primatice*, Paris 1928, pp. 67 f.
Sirén 1917, no. 277
Bjurström 1976, no. 50

EXHIBITION
Stockholm 1958, no. 184

[1] 'They are made for the festivities held for Charles
V by Francis I.'

[2] Paris, Grand Palais, *L'École de Fontainebleau*,
1972, no. 178.

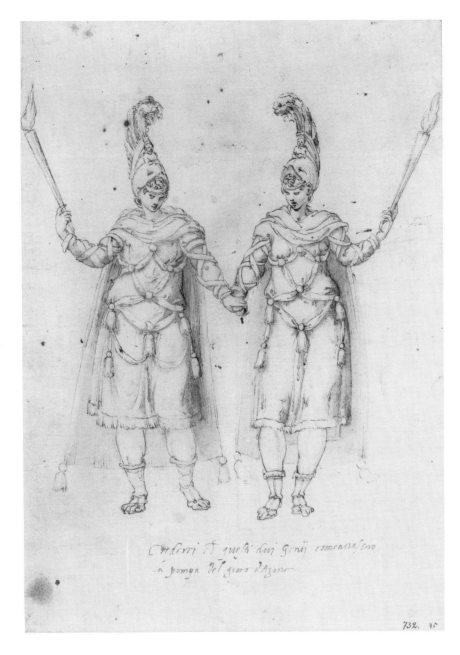

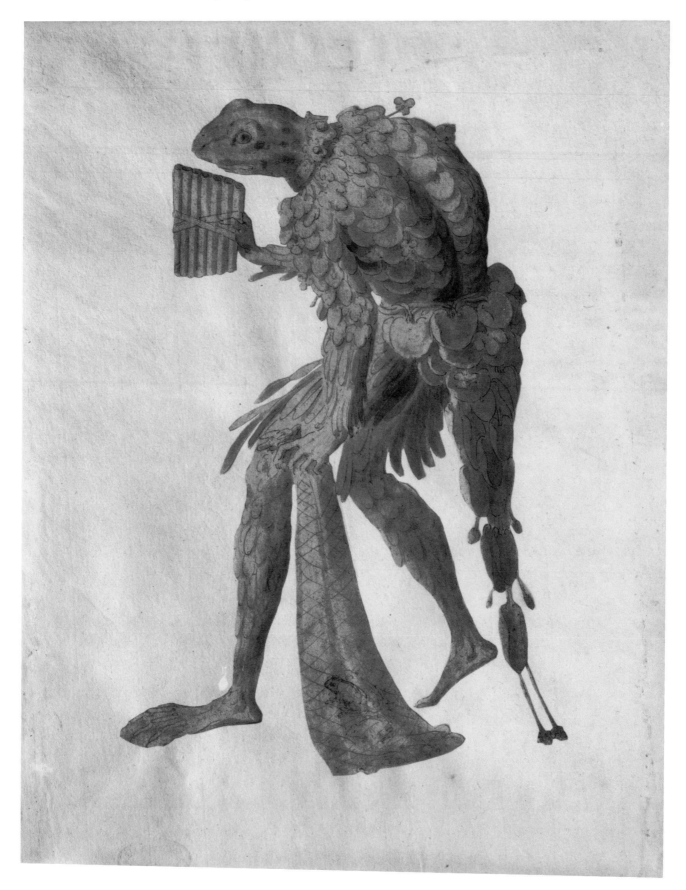

8 Nicolò dell'Abate

MODENA 1509 OR 1512–
FONTAINEBLEAU(?) 1571(?)
THE FROG MAN
Pen and brown ink, brown wash
35.5 × 24.8
Cut to the outline of the subject
Laid down
NM 81/1874:91

This drawing is closely related to another of
the same type, *The Bird Man*, which bears
the old inscription, *Niccolò dell'Abbate*, and is
now in the Theatre Museum, Clara Ziegler
collection, in Munich. The two drawings are
alike in style and treatment and the subjects
are analogous: the Frog Man catches frogs in
his net, the Bird Man birds in his cage.
Nothing is known about the part played by
these characters, but Papageno in Mozart's
The Magic Flute can be taken as a later variant
of the Bird Man.

PROVENANCE
Prince Victor-Amédée de Carignan (1680–1741).
C. G. Tessin. Gustaf III. Swedish Royal Family.
Karl XV (Rosersberg). Kongl. Biblioteket.
Transferred to the museum in 1874

BIBLIOGRAPHY
P. Bjurström and B. Dahlbäck, 'Témoignages sur
l'éphémère', *L'Œil*, 24, 1956, pp. 38 f.
Bjurström 1976, no. 8

EXHIBITIONS
Paris 1956, no. 40.
London 1956, no. 4

9 Geoffroy Dumoustier

KNOWN FROM 1535–PARIS 1573
FEMALE MUSICIAN, A
WOODWIND INSTRUMENT ON
HER SHOULDER
Pen and brown ink, light watercolours, over
black chalk
25.7 × 14.8
Watermark: Grapes
NM 879/1863
Numbered at lower right in pen and brown
ink: 736. (Sparre) and *54*

The figure probably belongs to a procession
with female musicians. There is another
sheet from the series, with a woman playing
a lute, in the Collection Rothschild in the
Louvre.[1] The attribution is based on the
correspondence with the drawing of the
Madonna and Child in the Ecole des Beaux-
Arts, Paris,[2] which in turn has been
attributed by Dimier to G. Dumoustier on
account of its clear connection with this
artist's engraving of the same motif.[3]

PROVENANCE
Crozat (Mariette, no. 412, as Nicolò dell'Abate).
C. G. Tessin (List 1739–42, p. 41 v.; Cat. 1749,
livré 26, no. 80). Kongl. Biblioteket (Cat. 1790,
no. 736). Kongl. Museum (Lugt 1638)

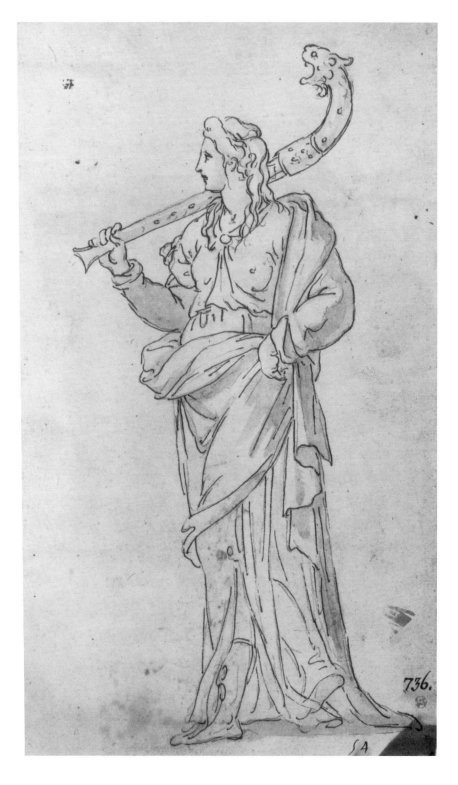

BIBLIOGRAPHY
Sirén 1917, no. 290 (as school of Primaticcio)
Bjurström 1976, no. 26

[1] Inv. no. 1621 D R.

[2] Inv. no. Masson 918. Cf. exhibition catalogue,
Paris, Grand Palais, *L'Ecole de Fontainebleau*, 1972,
no. 117.

[3] H. Zerner, *Ecole de Fontainebleau*, Paris 1969, G.
Dumoustier, no. 13.

10 Etienne Delaune

ORLÉANS *c.* 1518–STRASBOURG 1583
DIALECTIC
Pen and grey ink, grey wash, on vellum
29 × 20.5
NM 155/1979

This drawing belongs to a series of seven
sheets representing the liberal arts. They are
all done on vellum and six of the seven are to
be found in public collections in France and
Germany: *Grammar* (Berlin, Kunst-
bibliothek), *Rhetoric* (Paris, Louvre,
Collection Rothschild), *Geometry* (Chantilly,
Musée Condé), *Arithmetic* (Berlin-Dahlem,
Kupferstichkabinett), *Astronomy* (Paris,
Louvre, Collection Rothschild) and *Music*
(Paris, Louvre, Cabinet des dessins). This
sheet completes the set.

As an allegory of Dialectic the entire
composition consists of pairs of opposites:
Wisdom and Folly dispute on the stage, the
attributes of War and Peace appear in the
central cartouche above, and so on. In the
drawing of Geometry a pillar on the right
carries a list of the seven liberal arts. A
frontispiece for the series, now in the Venice
Accademia,[1] shows the arts, personified by

seven scholars with the respective attributes,
receiving laurels from a young Charles IX,
whose device – PIETATE ET IVSTITIA –
runs along a banderole above the
composition. The king is accompanied by his
mother, Catherine de' Medici, and his
brothers, Henri d'Anjou (later Henry III) and
Hercule, known as François, Duc d'Alençon.

Apart from the frontispiece, the drawing
of Dialectic is the only one that alludes
directly to Charles IX – a crowned C above a
cornucopia occurs on either side of the stage.
This seems to clinch the argument that the
series was dedicated to the young monarch.
The drawing of Music bears the initial of
Nicolas Houel, who probably instigated the
series. The drawings can be dated to *c.* 1570.

The hypothesis that the series was done for
tapestries has now been abandoned in favour
of the view, put forward by Bacou and
Béguin, that the drawings are drafts for
engravings.[2] An alternative suggestion by
Berckenhagen is that they are sketches for
work in enamel.[3]

PROVENANCE
Private collection, Orléans (sale, 2 December
1972). Prouté

BIBLIOGRAPHY
*Dessins originaux anciens et modernes exposés chez Paul
Prouté S. A.*, Paris 1978, p. 7, no. 6
Bjurström, 'Annual report for 1979',
Nationalmuseum Bulletin 4 1980: 1, pp. 4 f.
Bjurström 1982, no. 788

EXHIBITION
Washington, Fort Worth, San Francisco 1985–6,
no. 35

[1] I. Toesca, 'Quelques dessins attribués à Etienne
Delaune', *La Revue des arts, Musées de France*, 1960,
6, pp. 254–9.

[2] Paris, Grand Palais, *L'Ecole de Fontainebleau*,
1972, p. 73 f. no. 72.

[3] E. Berckenhagen, *Die französischen Zeichnungen der
Kunstbibliothek, Berlin*, Berlin 1970, p. 22, Hdz
3419.

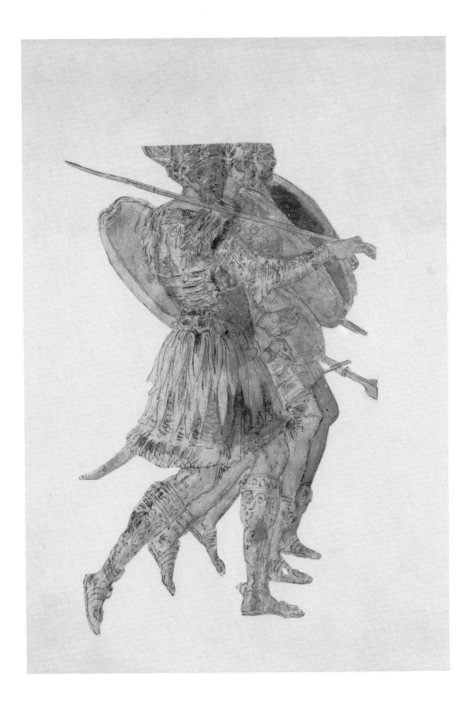

11 Antoine Caron

BEAUVAIS *c.* 1527–PARIS 1599
THREE SOLDIERS
Pen and brown ink, watercolours
26.8 × 17.8
Cut to the outline of the subject
No watermark
NM 84/1874:155
Inscribed verso in pen and brown ink:
Masquerade des poullonois

Caron was already active at the time of
Charles IX's entry in 1561 and he and
Jacques Patin were organizers of the
celebrations that were arranged for the Polish
ambassadors who came to Paris in 1573 to
offer Henry III their country's crown.

This drawing no doubt had to do with
these celebrations. As they have all been cut
out, it is unfortunately impossible to deduce
anything about the arrangement except that
it appears to have been composed
symmetrically. This was characteristic of
Caron's method, as was the repetition of
figures in groups of two or three.

Caron's name was suggested as the most
likely attribution at the time of the
exhibitions in Paris and London in 1956 and
this opinion has been gaining ground ever
since.

PROVENANCE
Prince Victor-Amédée de Carignan (1680–1741).
C. G. Tessin. Gustaf III. Swedish Royal Family.
Karl XV (Rosersberg). Kongl. Biblioteket.
Transferred to the museum in 1874

BIBLIOGRAPHY
Bjurström 1976, no. 15

EXHIBITIONS
Paris 1956, no. 42
London 1956, no. 5
Stockholm 1958, no. 180
Paris, Grand Palais, *L'Ecole de Fontainebleau*, 1972,
no. 46

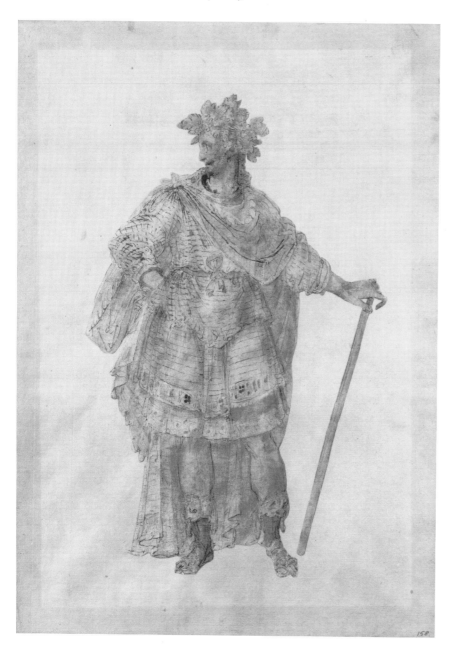

13 Germain Pilon

PARIS 1528–PARIS 1590
PROJECT FOR A TOMB, POSSIBLY
FOR JEAN D'ESTRÉES
Pen and brown ink, watercolours and gilding
31.3 × 24.3
Laid down
NM CC 467
Paraph to the right of the figure. In the space
under the coat of arms: POVR ESCRIRE
GRAVER ET DORER CE QVIL PLAISRA
AV DICT SEIGNEVR

Germain Pilon was the leading sculptor in
France during the second half of the sixteenth
century. A pupil of Primaticcio, he
developed his master's style in a realistic
direction, showing great skill in the
rendering of details of dress and jewellery.

This drawing is a compositional study for
a tomb which is constructed in almost
exactly the same way as in the drawing[1] for
the tomb of Philippe de Volvire, Count of
Ruffec, which is dated 18 May 1588. The
Louvre drawing is on parchment but the
technique and colouring are the same. This is
not the case, however, with the
representation of the deceased – done with a
brush and emphasising the plastic qualities
in the Louvre sheet, indicated rapidly here
with the pen of a master.[2]

The coat of arms on the present tomb
indicates that it was intended for a member
of the d'Estrées family, presumably the
Marquis Jean d'Estrées (1486–1571), who
became a general and served four monarchs:
Francis I, Henry II, Francis II and Charles
IX. The aged appearance of the figure
supports this identification as Jean d'Estrées
reached the remarkable age of 85. On the
other hand, there is no documentary evidence
that Pilon executed a tomb for a member of
the d'Estrées family.[3]

PROVENANCE
C. J. Cronstedt and descendants. E. Langenskiöld.
Gift to the museum in 1941

BIBLIOGRAPHY
Bjurström 1976, no. 27

EXHIBITION
Stockholm 1942, no. 96 (as anonymous)

[1] E.-J. Ciprut, 'Nouveaux documents sur Germain
Pilon', *Gazette des Beaux-Arts*, 6:73, 1969,
pp. 265 ff. Louvre, Inv. no. RF 5285.

[2] Another drawing by Pilon in the Louvre is in the
same manner as this (Inv. no. 32 441).

[3] Cf. E.-J. Ciprut, 'Chronologie nouvelle de la vie
et des œuvres de Germain Pilon', *Gazette des
Beaux-Arts*, 6:74, 1969, pp. 333–44.

12 Antoine Caron
WARRIOR IN ANTIQUE
COSTUME, CROWNED WITH
VINE LEAVES
Pen, brown and grey ink, watercolours,
gilded
35.1 × 22.3
Cut to the outline of the subject
No watermark
NM 84/1874: 158

This is a costume for a masquerade or solemn
procession – perhaps a prince impersonating
Bacchus, or, if an actor, a character
representing one of the French princes,
possibly the King himself. It is similar in
style and execution to the preceding number,
but the paper is different. Even so, this figure
may also have to do with the celebrations in
1573.

PROVENANCE
Prince Victor-Amédée de Carignan (1680–
1741).C. G. Tessin. Gustaf III. Swedish Royal
Family. Karl XV (Rosersberg). Kongl.
Biblioteket. Transferred to the museum in 1874

BIBLIOGRAPHY
A. Beijer, *Slottsteatrarna på Drottningholm och
Gripsholm*, Stockholm 1937, p. 24 (repr.).
Bjurström 1976, no. 19

EXHIBITIONS
Paris 1956, no. 43
London 1956, no. 6
Stockholm 1958, no. 180

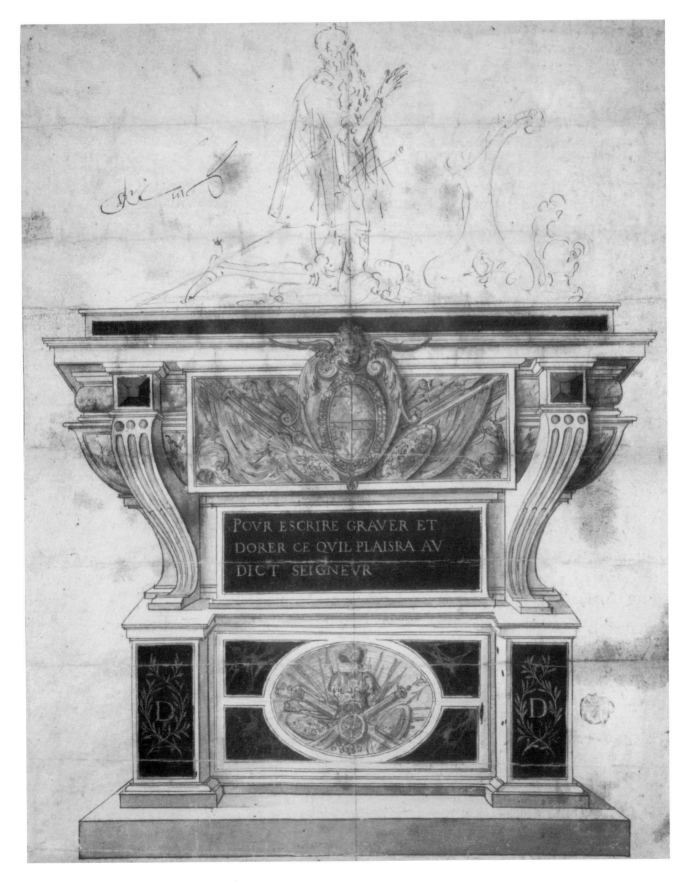

THE SECOND SCHOOL OF FONTAINEBLEAU

When Henry IV had abjured Calvinism and finally entered Paris in 1594, there was a chance of reuniting the kingdom. Together with Sully, his minister, the king set about reconstructing the national administration and economy. He also embarked on the decoration of royal palaces, entrusting this work to Ambroise Dubois (1542/3–1614), Toussaint Dubreuil (1561–1602) and Martin Fréminet (1567–1619). As their functions roughly corresponded to those of Rosso and Primaticcio earlier at Fontainebleau, these artists have come to be called, somewhat inappropriately, the second school of Fontainebleau.

Dubreuil died young and nearly all his work for the Louvre, Fontainebleau and St Germain has been lost. The drawings that have survived are strongly influenced by his predecessors, Rosso and Primaticcio, but the mannerism of the forms is not as extreme and has been combined with a certain classical balance. Dubreuil represents a link with Poussin and his contemporaries.

Dubois is a French translation of Bosschaert, which was this artist's name in his native Antwerp. The influence of Parma and Primaticcio is blended in his work with a northern mannerism acquired in Flanders. Instead of the compositional complexity of mannerism, however, Dubois seems to be reviving simpler principles. His pictures are peopled by a limited number of sizable figures.

Many pictures by Dubois have a poetic subject. At the palace of Fontainebleau, in *c.* 1605 he was engaged on a series for Le Cabinet de la Reine (the story of Clorinda, from Tasso's *La Gerusalemme liberata*) and later on a similar series for Le Grand Cabinet du Roi (Theagenes and Chariclea, from the *Aethiopica* of Heliodorus).

Extant drawings by Dubois are largely connected with his paintings. Mannerism is evident in the composition, with foreground figures cut by the picture frame and the main action in the middle distance, involving just a few figures in distinct scenes. The pattern of movement has become less dramatic and landscape is sometimes used as a component. The individual figures are also represented with large, defined volumes, but clothing and drapery are still rendered with sharp folds and billowy forms.

Dubois has a versatile technique, employing ink and wash as well as chalk. His brush is free, with northern antecedents, while his chalk drawings, with their skilful hatching, may owe something to earlier masters at Fontainebleau.

Dubois can be seen as another notable bearer of the sixteenth-century tradition and a forerunner of seventeenth-century classicism.

Martin Fréminet went early to Rome and worked in Venice and at the court of Turin; then he was summoned back to France to succeed Dubreuil as court painter of Henry IV in 1603. Drawings attributed with certainty to Fréminet are rare and adhere stylistically to a mannerism developed by northern artists active in Rome. His personal contribution seems to be a complex articulation of the composition by the distribution of light. In this he anticipates the manner of drawing of Simon Vouet and Nicolas Poussin.

Toussaint Dubreuil, *Diana imploring Jupiter* (Cabinet des Dessins, Musée du Louvre, Paris)

Martin Fréminet, *God commanding Noah to enter the Ark with the Animals* (Nasjonalgalleriet, Oslo)

14 Ambroise Dubois

ANTWERP 1543–FONTAINEBLEAU 1614
SHOULDER-LENGTH STUDY OF A
FEMALE HEAD
Black chalk on brownish grey paper, pricked
for transfer
41.5 × 35
Watermark: Reflected G in a laurel wreath
NM 1150/1973

This sheet differs in scale from most other
works by Dubois, but in this respect it has a
parallel in the Louvre in the form of a
drawing of a falling figure.[1] Both sheets have
been blackened on the verso for transfer to
canvas or a wall. They present a characteristic
line, with long, parallel outlines and clear
shading.

Dubois drew a highly characteristic female
type. The present face is almost identical,
though reversed, to that of *Psyche at her Toilet*
in The Pierpoint Morgan Library, New
York.[2]

PROVENANCE
London, Sotheby's, sale, 8 June 1972, no. 203

BIBLIOGRAPHY
Catalogue of exhibition, *L'École de Fontainebleau*,
Paris, Grand Palais, 1972, pp. 85, 87
Bjurström 1976, no. 25

EXHIBITION
Washington, Fort Worth, San Francisco, 1985–6,
no. 32

[1] Inv. no. 26.244.
[2] S. Béguin, *Il cinquecento francese,* Milano, 1970,
p. 86, pl. 32.

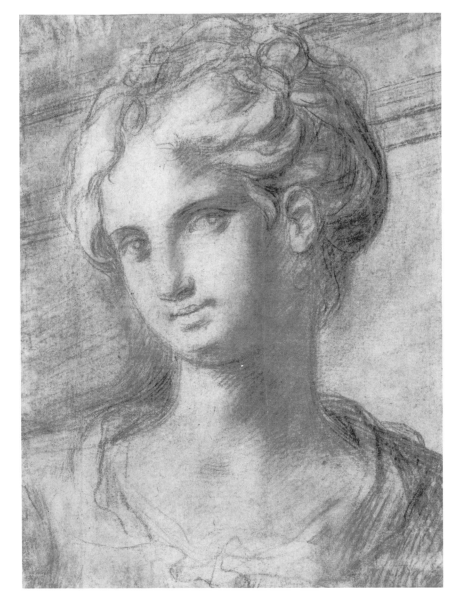

THE SCHOOL OF LORRAINE

At the time when problems associated with a succeeding generation can be discerned in Paris – the epoch that faded out with the second school of Fontainebleau had had a more illustrious beginning – there was a new vitality in Lorraine, at the ducal court in Nancy. The style is still firmly rooted in the mannerist language of form, while the content is bursting with expressiveness. In those days Lorraine was a duchy of the Holy Roman Empire and its rulers had sovereign power. Cultural and political links were stronger with Italian states than they were with France. Marriage ties made the connection with Florence particularly close.

Four artists were chiefly responsible for the new departure: Jacques Bellange (c. 1575–after 1616), Georges Lallemand (c. 1570–1635), Claude Deruet (c. 1588–1660) and Jacques Callot (1592–1635). All four used drawing as a highly important means of expression.

Bellange was primarily a graphic artist, though Charles III of Lorraine did commission him to decorate the Salle des Cerfs in the palace at Nancy. His drawings are, indeed, strongly calligraphic, combining playfulness and precision in an elegant language of form. Elegance is also the hallmark of his costume drawings for the duke's masquerades, triumphs and ceremonial entrances.

There is another, sombre side to Bellange's art, not least in his etchings. The figures are mannerist to an extreme degree, with elongated limbs, tiny heads, complicated poses and artificial attitudes. Clothing that either clings to the body or forms billowing folds also distorts the proportions. Many of the compositions present a familiar subject in a new light – almost as if they were riddles which we are asked to solve. This is particularly true of Bellange's religious pictures. The mystical, somewhat terrifying atmosphere is perhaps an echo of the Counter-Reformation, which evidently dominated Nancy and instigated many *autos-da-fé*. The active period in Bellange's life seems to have been short (1600–16), and he vanished as abruptly as he appeared; he is rumoured to have been burnt at the stake for practising black magic.

Georges Lallemand made his name in Paris rather than in Lorraine. He moved to the French capital in 1601 and had some outstanding painters as his pupils: Poussin in 1612, Philippe de Champaigne in 1621 and Laurent de la Hyre. Lallemand obtained French citizenship in 1616, but, beyond this, not much is known about him. His style seems to have been close to that of Bellange, which suggests either a period of mutual dependence or a common source of inspiration, Claude Henriet, who was active in Nancy from c. 1586 but whose work has all disappeared.

Claude Deruet represents a modified version of the expressive Nancy style. He studied under Henriet and then spent some time with Tempesta in Italy before his work brought him to the court in Lorraine, where Henry II ennobled him for services rendered. His place in the history of art arises from his collaboration with Callot, together with the fact that Claude Lorrain was his assistant for a time.

While there are traces of Bellange and other artists in work by Deruet, as the years went by he became more and more cautious and pedantic, particularly after he had transferred his services to the French court in the 1630s. The earlier calligraphic freedom gives way to meticulous detail, just as the flowing wash and dramatic accents are tamed into sober recording with the pen.

Jacques Callot also had his roots as an artist in Lorraine, though he was only sixteen when he moved to Rome in 1608. It is not clear whether Bellange was his teacher, but his early drawings do have a strong affinity with the art of Bellange – and indeed of Lorraine. This is not true of his etchings, since he learnt that art in Rome from the engraver and publisher Philippe Thomassin. Late in 1611 Callot moved to Florence for an appointment at the court of Cosimo II, Grand Duke of Tuscany; and a commission to produce engravings of the funeral ceremony for Margaret of Spain. Soon after this he did scenes from the life of Ferdinand I of Tuscany, based on drafts by Florentine painters. His work in Florence also included arrangements for the festivals which Giulio Parigi staged so successfully. The collaboration of these two artists resulted, for instance, in *Guerra d'Amore* or *Intermezzi*, a set of engravings in which Callot gives us some impression of Parigi's fantastic floats and allegorical figures.

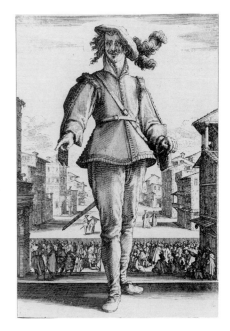

Jacques Callot, *Le Capitan*: Etching executed after the drawing cat. no. 20

Besides his work for princes and other patrons, Callot produced drawings and etchings on his own account. These display a great interest in ordinary people and daily life, its hardships as well as its celebrations. In this he was unique in his day and even in his century. Bellange did display a similar tendency, but scarcely exploited it. Callot can be seen as an artistic practitioner of the popular images which were circulated as broadsheets – a form of narrative propaganda for the illiterate, a vehicle for moral and political messages as well as for traditional themes, such as the Dance of Death. The sheets were often divided into squares or arranged as strips and Callot also used this approach. As one might expect, he drew inspiration from the popular Italian Commedia dell' Arte, as witness his series on hunchbacks (*Gobbi*), beggars and gypsies (*Capricci*) and Commedia types (*Balli di Sfessania*).

Rather than confine himself to single figures, Callot assembled his characters in large pictures which display his immense zest for detail. On one occasion in 1618, when convalescing with the Buondelmonti family at Impruneta, outside Florence, he was fascinated by the great fair of St Luke and set out to record its colourful vitality. Thousands of drawings went into the preparations for his final sheet, which contains innumerable figures.

When the Grand Duke of Tuscany died in 1621, his frugal widow dismissed Callot, who decided to return to his native Nancy. In this he was no doubt influenced by the visit to Florence of his father's patron, Jean de Porcelles, Bishop of Toul. After his return to Lorraine, Callot's first work was a large sheet representing the miracle of St Mansuetus, the foremost patron saint of Lorraine. The features of the saint are said to be a likeness of the bishop.

Callot now produced new editions of the most famous of the series which he created in Florence, repeating them afresh on new plates. He also received commissions from the Duke of Lorraine to document notable events, like the Combat à la Barrière, the spectacle which was arranged in 1627 for the Duchess of Chevreuse, when she had to flee from the French court after intriguing unsuccessfully against Richelieu.

Callot's personal work, not done to commission, now takes a more serious turn. In the *Great Passion*, likewise a series, Florentine mannerism is abandoned. Interest is focused on the figure of Christ – although small, this is

isolated by the flow of light and dominates these scenes. There is no mistaking the influence of Caravaggio. The strong chiaroscuro is a decisive element, particularly in the preparatory drawings, in which Callot uses a flowing wash. As perceived by Callot, the Passion is therefore a drama, a tragedy.

After a brief stay in the Netherlands in 1627 to prepare his highly accomplished account of *The Conquest of Breda*, followed by a short visit to Paris in 1629, Callot returned to Lorraine for good. Here he experienced the French invasion in 1633, with all its brutality. This was clearly an inspiration for his last great series, *Grandes Misères de la Guerre*, a terrifying catalogue of the savage treatment that was meted out to the civilian population.

These and similar impressions also seem to have contributed to the new version of *The Temptation of St Anthony*. The large etching on this theme done in his youth (1616) has much in common with Bosch and Brueghel. The late work is rather a representation of hell, a frenzied account of its torments. It does include the saint, but he is tucked away in a cave beneath the unquenchable flames of a city besieged by artillery manned by monkeys. The contemporary parallel could not be missed.

The *St Anthony* etching was published in the year of Callot's death. There are also four preparatory drawings which are much more expressive than the final work. One constantly finds this distinct contrast, almost a contradiction, between the painterly expressiveness of Callot's drawings and the primarily analytical quality of the etchings. There is a miraculous precision in the etchings, an ability to organize myriad details into a gigantic composition. In the drawings Callot concentrates instead on the essentials, be they figures in ink or red chalk or an extensive landscape rendered with a flowing brush. Some of these landscapes are used as backgrounds for scenes with figures, but it is just as common for Callot to work up an idea into a pure landscape etching. Here he follows the tradition of Northern Europe and the Netherlands. In particular, he seems to have been acquainted with the landscape drawings of Brueghel.

Callot was only forty-three when he died, but he left an immense heritage of etchings as well as more than two thousand drawings, ranging from small, meticulous studies of details to large compositional drafts. His drawings are on the same scale as the etchings and there is often an intimate relationship between them. There are few artists whose work provides such good opportunities for following its conception up to the birth of the final version. The preparatory sketches vary the approach; ultimately one version is adopted, tried out by Callot in one or several compositional sheets that lead up to the finished work.

Graphic artists of this calibre are few and far between – one thinks of Dürer and Rembrandt; in each case one finds this creative, exciting cross-fertilization of the expressive potentials of the two media.

15 Jacques Bellange

WORKING *c.* 1600–1616
HORTULANA
Pen and brown ink, blue wash
32.7 × 10.4
Cut to the outline of the subject. Marks from
tracing in the outlines
No watermark
NM 81/1874:88

This is a draft for one of the etchings in the
Hortulana series,[1] though Walch considers
that it has been worked over by another
hand. The Louvre also has a drawing
connected with this series.[2] A drawing in
reverse in the British Museum is probably a
copy by Claude Deruet from the etching.[3]

According to Walch, the Hortulana series
belongs to the early etchings in Bellange's
mature manner. Shortly after its completion,
the series was copied by Mattäus Merian the
elder with the addition of a landscape
background.[4] Another series of copies was
made by Abraham Bosse in 1622.[5]

Hortulana has been associated in the
literature with various festivities at the ducal
court in Nancy, but it has not been possible
to establish a link with any particular
occasion.[6]

PROVENANCE
Prince Victor-Amédée de Carignan. C. G. Tessin.
Gustaf III. Swedish Royal Family. Karl XV
(Rosersberg). Kongl. Museum. Transferred to the
Nationalmuseum in 1874.

BIBLIOGRAPHY
B. Dahlbäck, 'De Bellange à Deruet', *Bulletin de la
société de l'histoire de l'art français*, 1953, pp. 79 f.
F.-G. Pariset, 'Bellange et Lagneau; *Latin
American art and the baroque period in Europe, Studies
in western art* ('Acts of the XX international
congress of the history of art'), New Jersey 1963,
3, p. 123, pl. XLII:3
Vienna, Albertina, *Die Kunst der Graphik 4,
Zwischen Renaissance und Barock*, 1967–8, no. 387
(not exhibited)
Ibid., *Die Kunst der Graphik 5, Jacques Callot und
sein Kreis*, 1968–9, no. 87 (not exhibited)
N. Walch, *Die Radierungen des Jacques Bellange*,
Munich 1971, p. 143, n. 174
P. Rosenberg, 'Dessins de Nationalmuseum de
Stockholm', *Revue de l'art*, 11, 1971, p. 100
Bjurström 1976, no. 117

EXHIBITIONS
Paris, Musée Carnavalet, *Théâtre et fêtes à Paris,
XVIe et XVIIe siècles*, 1956, no. 45
London, Arts Council, *Sixteenth and seventeenth
century theatre design in Paris*, 1957, no. 25
Stockholm 1958, no. 190
Paris, Brussels, Amsterdam 1970–1, no. 32

[1] A. P. F. Robert-Dumesnil, *Le peintre-graveur
français*, Paris 1835–71, 5, no. 44; N. Walch, *Die
Radierungen des Jacques Bellange*, Munich 1971, no.
11.

[2] Coll. Rothschild, vol. III, p. 34; B. Dahlbäck
and F.-G. Pariset, 'Dessins de costumes de Théâtre
de J. de Bellange et l'Ecole Lorraine', *Revue de la*

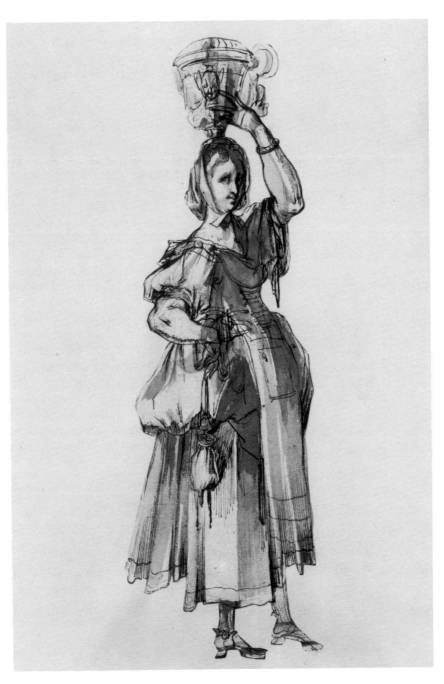

Société d'Histoire du Théâtre, 1954, 2, p. 68, pl. XI.
[3] Inv. no. 5227.
[4] L. H. Wüthrich, *Das Druckgraphische Werk von
Mattäus Merian d. Ae.*, Basel 1966, 1, nos 90–93.
[5] A. Blum, *L'Œuvre gravé d'Abraham Bosse*, Paris
1924, nos 1–4.
[6] F.-G. Pariset, 'Figures féminines de J. de
Bellange', *Bulletin de la société de l'histoire de l'art
français*, 1950, pp. 27–35; B. Dahlbäck and F.-G.
Pariset, op. cit., pp. 68–71; H. R. Rossiter, 'The
etchings of Jacques Bellange', *Bulletin of the
Museum of Fine Arts, Boston*, 40, 1942, p. 7; C. E.
Eisler, 'A new drawing by Jacques Bellange at
Yale', *Master Drawings*, 1, 1963, p. 38, n. 18; N.
Walch, op.cit., p. 143, n. 175.

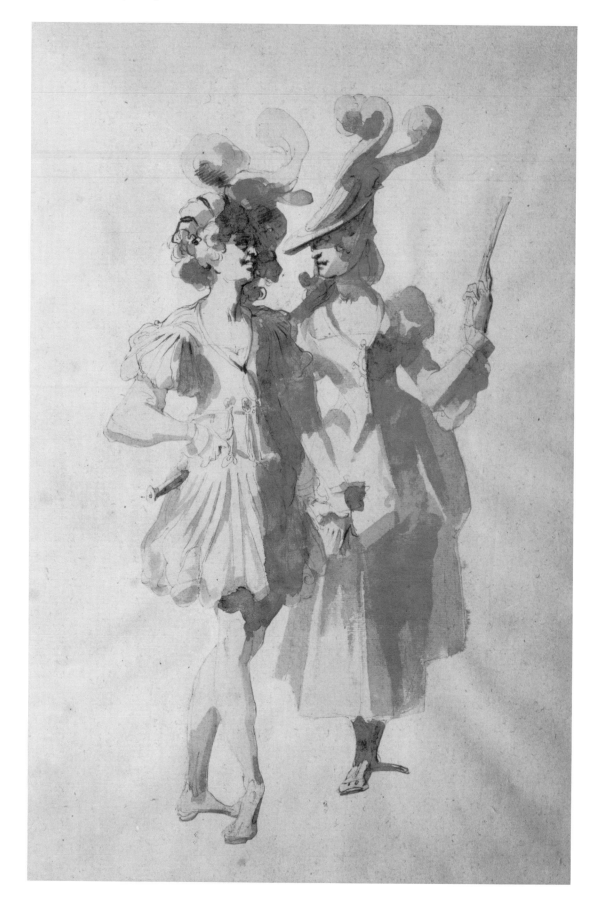

16 Jacques Bellange
COUPLE PROMENADING
Pen and brown ink, brown wash
33.8 × 18.5
Cut to the outline of the subject
No watermark
NM 84/1874: 136

The fantastic character of the headdresses,
and of the apparel of the left-hand figure,
indicate that these costumes are for the
theatre. Both figures were cut out and
included in a volume of costume drawings in
the late seventeenth or early eighteenth
century. It is not clear whether they come
from a large composition or were originally
sketches for theatrical costumes.

PROVENANCE
Prince Victor-Amédée de Carignan. C. G. Tessin.
Gustaf III. Swedish Royal Family. Karl XV
(Rosersberg). Kongl. Biblioteket. Transferred to
the Nationalmuseum in 1874

BIBLIOGRAPHY
B. Dahlbäck, 'De Bellange à Deruet', *Bulletin de la
société de l'histoire de l'art français*, 1953, pp. 78–81.
P. Bjurström and B. Dahlbäck, 'Témoignages de
l'éphémère', *L'Œil*, 24, 1956, pp. 36–41
Bjurström 1976, no. 120

EXHIBITIONS
Paris, Musée Carnavalet, *Théâtre et fêtes à Paris,
XVIe et XVIIe siècles*, 1956, no. 47
London, Arts Council, *Sixteenth and seventeenth
century theatre design in Paris*, 1956, no. 27
Stockholm 1958, no. 188
New York, Boston, Chicago 1969, no. 81

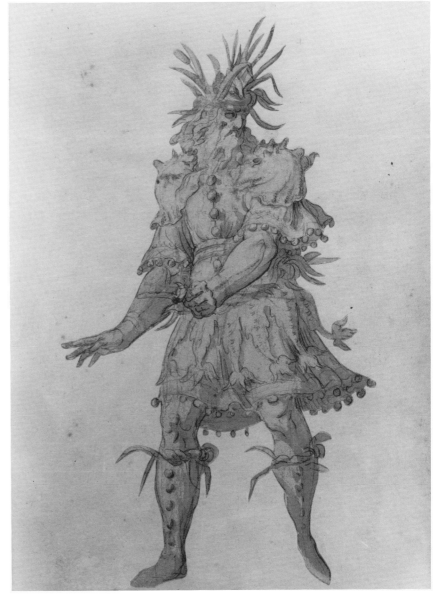

17 Georges Lallemand
NANCY *c.* 1570–PARIS *c.* 1635
RIVER GOD
Black chalk, grey wash
29.8 × 17
Cut to the outline of the subject
No watermark
NM 81/1874:93

Born in Nancy, Lallemand brought the
artistic tradition of Lorraine to Paris at about
the turn of the century, opening a studio
there not later than 1601 and attracting
Poussin and Philippe de Champaigne as his
pupils.

The graphic *œuvre* compiled by Pariset is
made up of disparate material but this sheet
seems to fit in quite naturally.[1] The mixture
of realism and mannerist emotionalism that
characterizes Lallemand's art is present here,
along with characteristic detail such as the
muscular arms, the violent movement and
the penetrating gaze.

PROVENANCE
Prince Victor Amédée de Carignan. C. G. Tessin.
Gustaf III. Swedish Royal Family. Karl XV
(Rosersberg). Kongl. Biblioteket. Transferred to
the Nationalmuseum in 1874

BIBLIOGRAPHY
Bjurström 1976, no. 462

[1] F.-G. Pariset, 'Georges Lallemand émule de
Jacques de Bellange', *Gazette des Beaux-Arts*, 6:43,
1954, pp. 299–308.

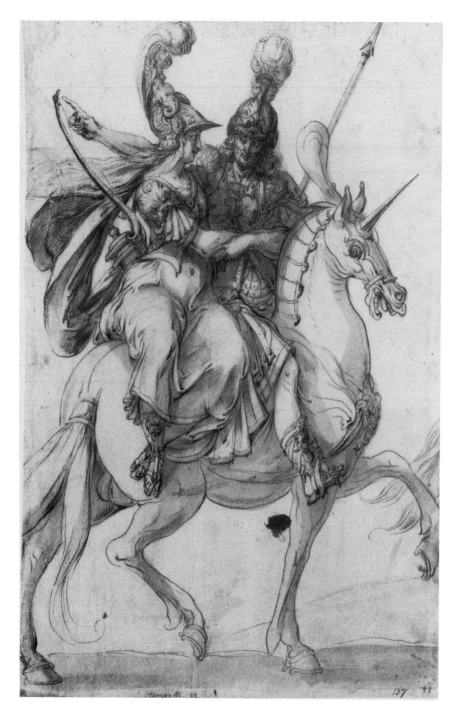

18 Claude Deruet

NANCY 1588–NANCY 1660
COUPLE ON A HORSE
Black chalk, pen and brown ink, brown wash
40.2 × 26.5
Several repairs. Dark brown stain below the
belly of the horse
No watermark
NM 178/1863
Inscribed at the bottom centre in pen and
brown ink: *tempeste*. Numbered in the lower
right corner *137* (Sparre) and *84* (struck out)

The couple form part of a cavalcade,
supposedly of Amazons. In front of their
horse, the tail of the horse ahead is visible.
There is a related drawing of a single Amazon
in the Pierpont Morgan Library in New
York,[1] and the Albertina in Vienna has a
Deruet etching of a mounted Amazon which
also seems to be related to some kind of
celebration.[2]

 In his development as an artist, Deruet
was strongly influenced by Bellange, whom
he succeeded in 1620 as organizer of
festivities at the court in Nancy. This
drawing no doubt dates from his activities
there – that is, before he left in 1633, when
Louis XIII occupied the town.

PROVENANCE
Crozat (Mariette, nos. 65–68?). C. G. Tessin (List
1739–42, p. 66 v.; Cat. 1749, livré 26, no. 4, as
Tempesta). Kongl. Biblioteket (Cat. 1790, no.
137 as Tempesta). Kongl. Museum (Lugt 1638).

BIBLIOGRAPHY
Sirén 1917, no. 115 (as Tempesta)
B. Dahlbäck, 'De Bellange à Deruet', *Bulletin de la
société de l'histoire de l'art français*, 1953, p. 79
F.-G. Pariset, 'Les "Déesses" du Musée de
Strasbourg et un tableau de Claude Deruet au
Musée Lorrain à Nancy', *Revue des arts*, 9, 1959,
p. 276, n. 2
G. Viatte, 'Quatre tableaux de Claude Deruet', *La
Revue du Louvre*, 14, 1964, p. 224
Bjurström 1976, no. 354

EXHIBITIONS
Paris 1956, no. 49
London 1956, no. 29
New York, Boston, Chicago 1969, no. 80

[1] Inv. no. 1959. 4. See F.G. Pariset, 'Claude
Deruet', *L'Œil*, 155, 1967, pp. 12 f.

[2] Inv. no. 1933/1731, unicum. A. P. F. Rubert
Dumesnil, *Le peintre-graveur français*, Paris 1835–
71, 11, p. 63.

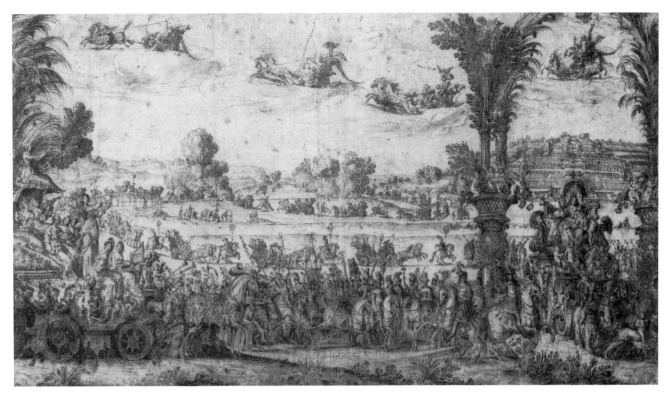

19 Claude Deruet
THE TRIUMPH OF ANNE OF
AUSTRIA
Pen and brown ink
33 × 61
Laid down
Drottningholm Theatre Museum, Stockholm

The drawing comprises the central and left
parts of a large composition; the right part is
now in the Louvre.[1] The two drawings
combined present La Terre (The Earth). The
composition forms with three other paintings
a set depicting the four elements that was
commissioned from Deruet in 1640–2 by
Cardinal Richelieu to decorate 'Anne of
Austria's room' in his palace Richelieu in
Poitou.[2]

This sheet was done after Deruet had
moved to Paris in 1633 to work there for the
king and Richelieu. The technique is full of
detail and all the elements of the composition
are presented with great exactness. It is
uncertain whether the sheet is a preliminary
study for the painting or a draft for an
engraved version, planned but never
executed. The central part shows the queen
in her chariot in front of the palace at Saint-
Germain-en-Laye; to the left of this there is a
grand procession and in the far distance a
chariot with the nine muses. The part of the
composition which is now in the Louvre
shows Richelieu on horseback at the head of a
procession and, on the far right, a chariot
with Renown, Rumour and the goddesses
Juno, Pallas, Diana and Venus in the

company of Amor. It seems that these parts
of the composition may have been based on
an actual procession.

PROVENANCE
Acquired in 1951 from a private owner at an
auction in Stockholm

BIBLIOGRAPHY
B. Dahlbäck, 'De Bellange à Deruet', *Bulletin de la
société de l'histoire de l'art français*, 1953, pp. 80 f.
Cf. J. Vallery-Radot, *Le dessin français au XVIIe
siècle*, Lausanne, 1953, no. 15
F. G. Pariset, 'Claude Deruet', *L'Œil*, 155, 1967,
p. 14
M. Sérullaz, *Dessins du Louvre, École française*, Paris
1968, no. 15
Bjurström 1976, no. 355

EXHIBITIONS
Paris 1956, no. 48 a
London 1957, no. 28
Stockholm 1958, no. 182

[1] Inv. no. R.F. 24.231.
[2] The paintings, heavily restored in the nineteenth
century, are in the Orléans Museum. Cf. F. G.
Pariset, 'Claude Deruet', *Gazette des Beaux-Arts*,
6:39, 1952, pp. 163 ff.

p. 111, p. 168
G. Paulsson, *Jacques Callot, Catalogue complet de son œuvre dessiné*, Paris 1962, no. 455
Th. Schröder (Intr.), *Jacques Callot, Das gesamte Werk, Handzeichnungen*, Munich/Berlin 1971, no. 338
Bjurström 1976, no. 183

EXHIBITION
Stockholm 1958, no. 212

[1] E. Meaume, *Recherches sur la vie et les ouvrages de Jacques Callot*, Nancy 1853, no. 628; J. Lieure, *Jacques Callot, Catalogue de l'œuvre gravé*, Paris 1927, no. 289.
[2] D. Ternois, *Jacques Callot, Catalogue complet de son œuvre dessiné*, Paris 1962, no. 458.
[3] Ibid., nos 459, 460.
[4] Ibid., p. 84, nos 456–534.

21 Jacques Callot
MIRACLE OF ST MANSUETUS

Red chalk, pen and brown ink, brown wash
21.2 × 27.5
Marks from tracing in the outlines of the figures. The figure of the king on a separate piece of paper fitted into a hole in the sheet
Laid down
NM 2472/1863
Numbered at lower right in pen and brown ink: *17* struck out. Inscribed on the old mount: *Callot, Du Cabinet du Comte de Tessin* and numbered *2368* (Sparre)

The drawing depicts St Mansuetus, patron saint of Toul in Callot's native Lorraine, who lived in the fourth century. He is reviving the governor's son, who had fallen into the Moselle river and had been recovered in a lifeless state; this miracle leads to the conversion of the governor, his family and subjects.

St Mansuetus is considered to be a likeness of Jean de Porcelles, Bishop of Toul, and the man with a medallion on his chest is held to resemble Callot.

The drawing is very close to the etching of the subject;[1] the latter is reversed in relation to the drawing, which bears marks of tracing. Certain details in the etching – the racket and ball in the foreground, Porcelle's coat of arms on the bishop's cloak, and the background landscape showing the cathedral and monastery of Toul – do not occur in the drawing. There was no racket and ball in a first state of the etching, mentioned by Mariette[2] but now unknown.

The date of the etching is debatable. Meaume and several writers after him hold that it was made after Callot's return to Nancy in 1621 and not later than 1624, when Jean de Porcelles died.[3] Ternois considers that the mannerist elongation of the figures and the frequent use of the burin point to an earlier date. There are also stylistic and technical reasons for dating the drawing to the Florence period – Callot uses

20 Jacques Callot

NANCY 1592–NANCY 1635
STUDY FOR THE ETCHING 'LE CAPITAN'

Black and red chalk, pen and brown ink
19 × 15.5
Laid down
NM 2561/1863
Numbered on the old mount *2457* (Sparre)

This is a drawing for the background in 'Le Capitan' an etching in the series *Les trois Pantalons*.[1] The etching is in reverse of the drawing. The architecture and the background figures are meticulously penned and show faint signs of the tracing needle. The main figure and the one in the middle ground are hinted at in black chalk.

There are certain minor differences between the drawing and the etching. Most of the foreground, for instance, is lacking in the drawing, while the arcade on the right is cut short by the margin of the etching; the circular temple in the right-hand background is replaced in the etching by a secular building. The etching can be dated to 1618–20. Studies for some of the minor figures in the etching are extant: one in the Album Julienne in the Hermitage[2] and two in the Album Mariette in the Louvre.[3] These drawings belong to a very homogeneous group of studies for individual figures in the series *Les trois Pantalons, Paysages italiens, Quattre paysages* and *Varie figure*, dating from the years 1618–20, in the Hermitage and the Louvre.[4]

PROVENANCE
Crozat (Mariette, no. 998). C. G. Tessin (List 1739–42, p. 43 r.; Cat. 1749, livré 13, no. 147). Kongl. Biblioteket (Cat. 1790, no. 2457). Kongl. Museum (Lugt 1638)

BIBLIOGRAPHY
G. Paulsson, 'Handteckningar av Jacques Callot i Nationalmuseum', *Nationalmusei Årsbok*, 2, 1920, pp. 80 f., no. 5
D. Ternois, *L'Art de Jacques Callot*, Paris 1962,

outlines with pen and wash here, whereas black chalk and wash predominate in the Nancy period. The motif provides no definite evidence in favour of a particular date. A scene such as this could have been produced before just as well as after a planned return to Lorraine.

There are three other drawings for St Mansuetus, which Blake Freedberg and, after her, Ternois arrange in the following sequence: Musée Lorrain, Nancy, Seligman Collection, New York, and Museum of Fine Arts, Boston.[4] They belong together in technique, style and composition but differ from the final version. In these drawings the saint occupies a central position, with Toul in the background and the onlookers grouped on either side.

The boy's mother has an important role in the composition. In the present drawing the saint and the boy are the central figures and the mother is little more than one of the witnesses to the miracle, all on the right behind St Mansuetus. In the Boston and Stockholm drawings, moreover, the bishop's

face is less plump than in the earlier versions and he has a short beard.

The three drawings mentioned above may refer, as pointed out by Ternois, to an earlier, vertical version, which Callot started to engrave. The Boston drawing bears marks of tracing.

PROVENANCE
Crozat (Mariette, no. 998). C. G. Tessin (List 1739–42, p. 43 r.; Cat. 1749, livré 13, no. 151). Kongl. Biblioteket (Cat. 1790, no. 2358). Kongl. Museum (Lugt 1638)

BIBLIOGRAPHY
G. Paulsson, 'Handteckningar av Jacques Callot i Nationalmuseum', *Nationalmusei Årsbok*, 2, 1920, p. 68, p. 80, no. 2, fig. 17.
A. Blake Freedberg, 'A 4th century miracle drawn by a 17th century artist', *Bulletin*, Museum of Fine Arts, Boston, 55, 1957, pp. 38 ff.
D. Ternois, *L'Art de Jacques Callot*, Paris 1962, p. 39, p. 111, p. 162
D. Ternois, *Jacques Callot, Catalogue complet de son œuvre dessiné*, Paris 1962, no. 573
Th. Schröder (Intr.), *Jacques Callot, Das gesamte Werk, Handzeichnungen*, Munich/Berlin 1971, no. 431

Bjurström 1976, no. 184

EXHIBITIONS
Stockholm 1958, no. 84
Leningrad, Hermitage, *Risunki XV–nacala XIV vv. iz nacional'nogo muzeja Stokgolma*, 1963
New York, Boston, Chicago, 1969, no. 84

[1] E. Meaume, *Recherches sur la vie et les ouvrages de Jacques Callot*, Nancy 1853, no. 141. J. Lieure, *Jacques Callot, Catalogue de l'œuvre gravé*, Paris 1927, no. 378

[2] Ph. de Chennevière and A. de Montaiglon, *Abécédario de J.-P. Mariette*, Paris 1853–68, I, p. 271.

[3] Meaume, loc. cit. Lieure, loc. cit. J. Vallery-Radot, *Le Dessin français au XVIIe siècle*, Lausanne 1953, p. 185, no. 25. A. Blake Freedberg, loc. cit.

[4] D. Tenois, *Jacques Callot, Catalogue complet de son œuvre dessiné*, Paris 1962, nos 570–572.

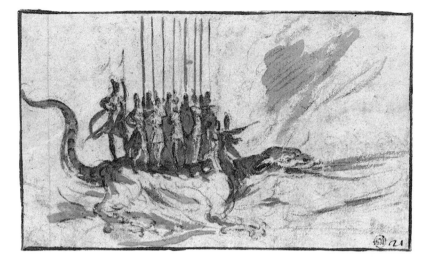

22 Jacques Callot
SALAMANDER, SURROUNDED BY
FLAMES, CARRYING A GROUP OF
SOLDIERS ON ITS BACK
Black chalk, brown wash
7.8 × 13.4
Traces of red chalk all over the surface
Laid down
NM 2562/1863
Numbered at lower right in pen and brown
ink: *21* and on the old mount *2458* (Sparre)

This and the next drawing, *Amor riding a
swan*, are studies for the etching *L'Entrée de
Mgr. Henry de Lorraine*,[1] which is one of a
series depicting the festivities arranged in
Nancy in 1627 for the Duchess of Chevreuse,
who had fled to the court there after
intriguing unsuccessfully against Richelieu.
The etchings occur in a book describing the
occasion by Henry Humbert, *Combat à la
Barrière faict en cour de Lorraine le 14 febvrier,
en l'année présente 1627*, Nancy 1627.

The drawings are of two motifs in the
etching devoted to the entry of Henry of
Lorraine. The Duke is riding the salamander,
accompanied by his train. His equipage is
drawn by Amor on the swan and is preceded
by La Fidélité, La Constance and La
Persévérance, each in a separate chariot, and
a choir making music on the back of a
phoenix.

An earlier variant of the etching[2] is very
similar to this one, which Callot was obliged
to undertake because the first sheet was too
large for the volume it was to illustrate. The
drawings are reversed in relation to the
etching.

The drawing of the salamander resembles
the etched versions. The tail points
backwards, as in the first etching; in the
second it was made more vertical, so that it
could be fitted in, and, as here, the
salamander is closer to the edge of the plate.

PROVENANCE
Crozat (Mariette, no. 998). C. G. Tessin (List
1739–42, p. 43 r.; Cat. 1749, livré 13, no. 140).
Kongl. Biblioteket (Cat. 1790, no. 2458). Kongl.
Museum (Lugt 1638)

BIBLIOGRAPHY
G. Paulsson, 'Handteckningar av Jacques Callot i
Nationalmuseum', *Nationalmusei Årsbok*, 2, 1920,
p. 80, no. 4, fig. 18
D. Ternois, *Jacques Callot, Catalogue complet de son
œuvre dessiné*, Paris 1962, no. 869
Th. Schröder (Intr.), *Jacques Callot, Das gesamte
Werk, Handzeichnungen*, Munich/Berlin 1971,
p. 555
Bjurström 1976, no. 185

EXHIBITIONS
Stockholm 1958, no. 210
Washington, National Gallery, *Jacques Callot*,
1975, no. 113

[1] E. Meaume, *Recherches sur la vie et les ouvrages de
Jacques Callot*, Nancy 1853, no. 498. J. Lieure,
Jacques Callot, Catalogue de l'œuvre complet, Paris
1927, no. 581.

[2] Meaume, op. cit. no. 490. Lieure, op.cit., no.
586.

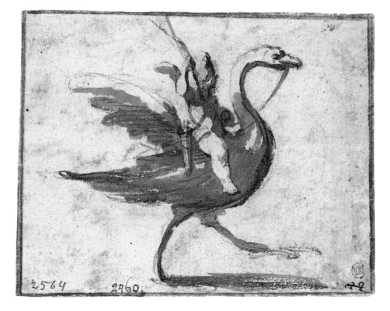

23 Jacques Callot
AMOR RIDING A SWAN
Black chalk, brown wash
7.7 × 10.1
Traces of red chalk all over the surface. Verso
prepared with red chalk for tracing
Laid down
NM 2564/1863
Numbered at lower right *22* struck out and
at lower left *2460* (Sparre), both pen and
brown ink

See the preceding number. This drawing
differs in certain respects from both the
etched versions: the neck of the swan is less
curved, its wings are outstretched and Amor
is proportionally larger.

PROVENANCE
Crozat (Mariette, no. 998). C. G. Tessin (List
1739–42, p. 43 r.; Cat. 1749, livré 13, no. 142).
Kongl. Biblioteket (Cat. 1790, no. 2460). Kongl.
Museum (Lugt 1638)

BIBLIOGRAPHY
G. Paulsson, 'Handteckningar av Jacques Callot i
Nationalmuseum', *Nationalmusei Årsbok*, 2, 1920,
p. 80, no. 3, fig. 20
D. Ternois, *Jacques Callot, Catalogue complet de son
œuvre dessiné*, Paris 1962, no. 870
Th. Schröder (Intr.) *Jacques Callot, Das gesamte
Werk, Handzeichnungen*, Munich/Berlin 1971,
p. 556
Bjurström 1976, no. 186

EXHIBITIONS
Stockholm 1958, no. 209
Washington, National Gallery, *Jacques Callot*,
1975, no. 114

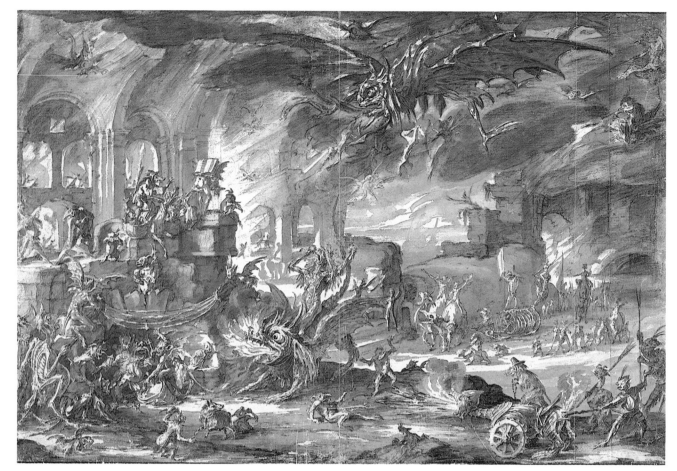

24 Jacques Callot
THE TEMPTATION OF ST ANTHONY

Black chalk, point of brush and brown ink, brown wash, heightened with white
44.8 × 67.1
No watermark
NM 2471/1863

The subject of this drawing preoccupied Callot on several occasions. He made an etching in Florence in 1617[1] and returned to it in an etching, executed in Nancy and dated 1635,[2] in the year of his death. In the catalogue of the Crozat collection, Mariette mentions this sheet as one of four preparatory drawings for the etching of 1635. According to Mariette, Crozat acquired his drawing from Antoine Triest, Bishop of Ghent, through the Dutch dealer Cornelius Vermeulen. In another connection[3] Mariette lists two drawings in the collection of Boulle. These were sold at an auction in 1732 and reappeared: one in the Lorangère collection in 1744 (this is probably the drawing now in the British Museum),[4] the other in the collection of Jullienne in 1767 (now in the Hermitage).[5] Two drawings depicting St Anthony are mentioned in the catalogue of the Paignon-Dijonvals collection in 1810.

One has since disappeared; the other is in the Ashmolean Museum, Oxford,[6] and is a sketch for the landscape without any demons and so on (its left part corresponds to the right of the etching). In addition to these preliminary studies there are several drawings which were made from the etching.[7]

PROVENANCE
Antoine Triest. Crozat (Mariette, no. 1000). C. G. Tessin (List 1739–42, p. 60 r.; Cat. 1749, livré 16, no. 88). Kongl. Biblioteket (Cat. 1790, no. 2367). Kongl. Museum (Lugt 1638)

BIBLIOGRAPHY
A. M. Hind, 'Jacques Callot', *Burlington Magazine*, 21, 1912, p. 79
L. Ugloff, Drawings of Jacques Callot for the Temptation of St Anthony', *Burlington Magazine*, 67, 1935, pp. 220 ff.
R. A. Weigert, *Jacques Callot*, Paris 1935, p. 4
A. Weigert, *Jacques Callot, Le Dessin*, 1935, p. 477
J. Vallery-Radot, *Le Dessin français au XVIIe siècle*, Lausanne 1953, p. 186, pl. 31
D. Ternois, 'La "Passion" de Jacques Callot', *Revue des Arts*, 3, 1953, p. 114
D. Ternois, *L'Art de Jacques Callot*, Paris 1962, pp. 110, 119, 125, 152, 153, 160, 162, 189, pl. 57 C
D. Ternois, *Jacques Callot, Catalogue complet de son œuvre dessiné*, Paris 1962, no. 953
Bjurström 1976, no. 192

EXHIBITIONS
London, Royal Academy, *French Art 1200–1900*, 1932, no. 669
Stockholm 1933, no. 59
Paris, Gazette des Beaux-Arts, *Le Dessin français dans les collections du XVIIIe siècle*, 1935, no. 53
Paris, Palais National des Arts, *Chefs d'œuvre de l'art français*, 1937, no. 468
Brussels, Rotterdam, Paris, *Le Dessin français de Fouquet à Cézanne*, 1949–50, no. 26
Vienna, Albertina, *Meisterwerke aus Frankreichs Museen*, 1950, no. 27
Washington, Cleveland, St Louis, Cambridge, New York, *French Drawings*, 1952–3, no. 25
Stockholm 1958, no. 214
Leningrad, Hermitage, *Risunki XV-nacala XIX vv. iz nacional'nogo muzeja Stokgolma*, 1963
New York, Boston, Chicago, *Drawings from Stockholm*, 1969, no. 85

[1] E. Meaume, *Recherches sur la vie et les ouvrages de Jacques Callot*, Nancy 1853, no. 138. J. Lieure, *Jacques Callot, Catalogue de l'œuvre gravé*, Paris 1927, no. 188.

[2] E. Meaume, op.cit, no. 129. J. Lieure, op.cit., no. 1416.

[3] de Chennevière and de Montaiglon, op.cit., I, p. 286.

[4] D. Ternois, *Jacques Callot, Catalogue complet de son œuvre dessiné*, Paris 1962, no. 955.

[5] Ibid., no. 954.

[6] Ibid., no. 956.

[7] Ibid., p. 134.

THE INFLUENCE
OF CALLOT

Although Callot was active mainly in Lorraine and Italy, as an outstanding etcher he exerted a widespread influence through prints of his work. Among his contemporaries in France this is particularly evident in the art of Stefano della Bella, a Florentine who worked in Paris, and Claude Deruet (discussed in the preceding section). So successful, in fact, was della Bella in imitating Callot that it can be difficult to distinguish their drawings.

Jean de Saint Igny (1698/1600–47) was a painter and engraver from Rouen who specialized in drawing fashions. The mannerist tradition can be discerned in his plates, but in his fashion sheets he adopted Callot's way of drawing and arranging figures. The drawings, mostly preserved in his native city, are done, however, in a highly personal hand and in a rapid, spontaneous manner.

Abraham Bosse (1602–76) was perhaps the artist in France who followed Callot most closely as a versatile engraver. He, too, portrayed everyday life – in this case the Parisian bougeoisie – but his style is heavy and laboured. His approach to contemporary scenes betrays a Calvinist simplicity and quality of outlook. In the illustrations for *Polexandre*, a precious tale by Gomberville, he seems to have a freer attitude and here the lively wash also alludes to Callot's style.

François Chauveau (1613–76) was also principally an engraver and illustrator. We know of three thousand sheets by his hand. They are thoroughly done and of sterling quality, very much in the style of French baroque. It is therefore interesting that the few preparatory drawings are in a free hand, displaying an ability to summarize and construct a complex composition swiftly and concisely.

Topographical draughtsmen also absorbed influences from Callot, notably his way of using figures to enliven an urban or rural scene. In this field, however, the technique developed by the Swiss-German engraver Mattäus Merian (1593–1650) for *Theatrum Europaeum* (first published in 1633) was also important for Dominique Barrière (1610/12–1678) and Israel Silvestre (1621–91).

Pierre Brébiette (1598–1650) stands alone among French draughtsmen of the early seventeenth century. It is thought that he was taught by Lallemand, but his style was formed in Italy. When he arrived in Rome in 1617, the subjective mannerist approach to art was being criticized and the classicism of Domenichino was the new fashion. The antique doctrine enjoyed a brief revival and artists strove to redeem nature's imperfections by selecting what was best for their compositions. Brébiette learned to apply these principles and adhered to them. Even after his return to France in 1626, his few extant drawings are devoted to subjects from classical literature or myths. Most of them are finished sheets, ready for transfer to the plate. The cool classicism contrasts strangely with the choice of subjects, which was rather libertine for French taste of the period.

25 Jean de Saint-Igny

ROUEN(?) *c.* 1595/1600–ROUEN AFTER 1647
GENTLEMAN WITH A SWORD
Black and red chalk
14.2 × 9.1
No watermark
NM 1656/1863
Numbered at lower right in pen and brown
ink: *1461* (Sparre)

The starting-point for a study of Saint-Igny's
graphic art is provided by about forty
extremely small sheets in the Musée de
Rouen, all with a long-standing attribution
to the artist and characterized by a highly
calligraphic style. They are directly related to
the artist's graphic work, in which he was
technically and stylistically closely linked
with Abraham Bosse. In addition to the
drawings in Rouen, there is one sheet in the
Metropolitan Museum, New York,[1] another
in the Teyler Stichting, Haarlem,[2] and
further isolated items in other collections
mentioned by Rosenberg.

The technique of the present sheet differs
from that of the Rouen series, but it has the
same calligraphic recklessness, the same
intense effects in the parallel shading and the
same theatrical posing of the figures.

PROVENANCE
C. G. Tessin (?). Kongl. Biblioteket (Cat. 1790,
no. 1461). Kongl. Museum (Lugt 1638)

BIBLIOGRAPHY
Bjurström 1976, no. 658

[1] Rosenberg 1971, fig. 4, p. 87.
[2] Paris, Louvre, *Cent dessins du Musée Teyler
Haarlem*, 1972, no. 32.

26 Abraham Bosse

TOURS 1602–PARIS 1676
POLEXANDRE
Black chalk, grey wash, traces of red chalk
15.7 × 10.9
Marks from tracing in the contours.
Horizontal fold in the centre
Laid down
NM 2469/1863
Signed at lower left in pen and brown ink:
Bosse f. Numbered: *2365.* (Sparre)

The drawing was engraved in reverse to
illustrate the last part of Martin Leroy de
Gomberville's novel *Polexandre*, 1637.[1]

PROVENANCE
C. G. Tessin (Cat. 1749, livré 24, no. 77). Kongl.
Biblioteket (Cat. 1790, no. 2365). Kongl.
Museum (Lugt 1638)

BIBLIOGRAPHY
Bjurström 1976, no. 164

[1] A. Blum, *L'Œuvre gravé d'Abraham Bosse*, Paris
1924, no. 166.

Chauvau.

2496.

27 François Chauveau

PARIS 1613–PARIS 1676
VENUS, THE THREE GRACES AND
THE GODS PRESENT CLOTHILDA
TO CLOVIS
Pen and brown ink, brown wash
11.8 × 18
Laid down
NM 2601/1863
Inscribed on the mount at lower left in pen
and brown ink: *Chauvau*, numbered at right:
2496 (Sparre)

This is a draft for an illustration for J.
Desmarets de Saint-Sorlin, *Clovis ou la France
chrétienne*, Paris 1657, which contains
twenty-five sheets, all compositions by
Chauveau. This drawing, no. 15, facing
p. 247, was engraved by Abraham Bosse.
 Drawings by Chauveau are uncommon and
this one seems to be almost unique as a draft
for a known engraving. In the Louvre
collection the closest stylistic affinity is to be
found in *Jeux nautiques*.[1]

PROVENANCE
N. Tessin jun. (Cat. 1730, p. 2). C. G. Tessin
(Cat. 1747, livré, no. 78). Kongl. Biblioteket
(Cat. 1790, no. 2496). Kongl. Museum (Lugt 1638)

BIBLIOGRAPHY
R. A. Weigert, *Bibliothèque Nationale. Département
des Estampes. Inventaire du Fonds français. Graveurs
du XVIIe siècle*, Paris 1939, 1, p. 507, no. 1162
Cf. also ibid., 2, 1952, p. 459, nos 584–606
Bjurström 1976, no. 302

[1] J. Guiffrey and P. Marcel, *Inventaire général des
dessins du Louvre et du musée de Versailles, Ecole
française*, Paris 1907–38, 3, no. 2259.

28 Dominique Barrière

MARSEILLES 1610/20–ROME 1678
VIEW OF ROME, 1649
Lead
25.6 × 43.5 (right-hand portion)
25.8 × 43.3 (left-hand portion)
Central vertical fold. Coloured red verso for
transfer
Watermark: Unicorn in ring
NM 2329–2330/1863
Numbered at lower right in pen and brown
ink – right-hand portion: *2120* (Sparre) and
71 (struck out); left-hand portion: *2121*
(Sparre) and *72* (struck out)

This drawing is a draft for Barrière's *View of
Rome*, published by I. de Rossi with the
inscription: RECEVS VRBIS ROMAE
AUSTRALI PLAGA PROSPECTUS ANNO
DOMINI 1648. The drawing was made so
that the view would be correct in the finished
work – that is, in reverse of this drawing –
whereas the foreground figures are
reproduced as in the draft.
 The sheet is an excellent example of the
manner developed by the French
topographical artists. Its technique is so like
that of the work of Barrière's contemporary
Israël Silvestre that a definite attribution
would have been difficult or impossible to
make on grounds of style alone.

PROVENANCE
N. Tessin jun. (Cat. 1730, p. 20, as Falda). C. G.

Tessin. Kongl. Biblioteket (Cat. 1790, nos 2120,
2121, as unknown artist). Kongl. Museum (Lugt
1638)

BIBLIOGRAPHY
Bjurström 1976, nos 115, 116

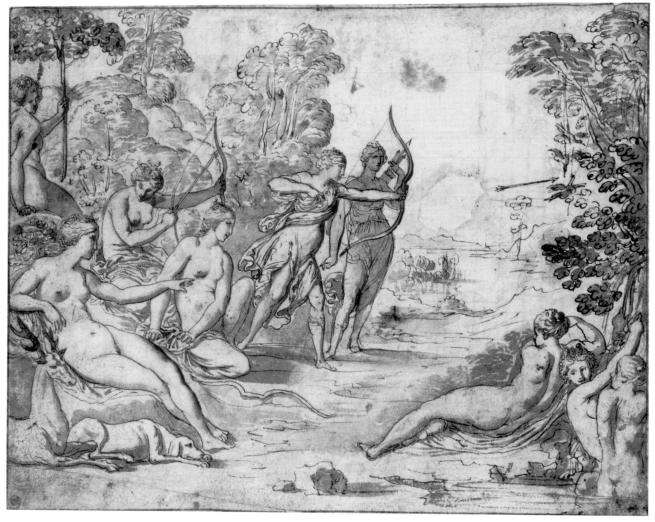

29 Pierre Brébiette

MANTES 1598–PARIS 1650
DIANA'S NYMPHS CONTESTING
WITH BOW AND ARROW
Black chalk, pen and brown ink, grey wash
16.1 × 21.7
Brown stains. A hole in the sky repaired long
ago
Laid down
NM 2696/1863
Numbered on the old mount: 2590 (Sparre)

The subject (which occurs in *Diana's Hunt*,
by Domenichino, 1617) has been traced by
Badt to the *Aeneid*, V, 485–518, which
describes a competition arranged by Aeneas
after he had been driven by a storm to Sicily,
a theme which Domenichino, probably aided
by Agucchi, has transferred to *Diana*.[1]

Brébiette is known to have been in Rome
for ten years from 1617,[2] so that
Domenichino's painting would have been
highly topical at the time of his arrival there.
The drawing is a direct draft for the reversed
engraving by Brébiette.[3]

PROVENANCE
C. G. Tessin (List 1739–42, p. 72 r.; Cat. 1749,
livré 14, no. 1). Kongl. Biblioteket (Cat. 1790,
no. 2590). Kongl. Museum (Lugt 1638)

BIBLIOGRAPHY
Bjurström 1976, no. 177

[1] K. Badt, 'Domenichino's "Caccia di Diana"
in der Galleria Borghese', *Münchner Jahrbuch der
bildenden Kunst*, III: 13, 1962, pp. 216 ff.

[2] J. Thuillier, 'Brébiette', *L'Œil*, 77, 1961,
pp. 48–56.

[3] R.A. Weigert, *Bibliothèque Nationale. Département
des Estampes. Inventaire du Fonds français. Graveurs
du XVIIe siècle*, 2, 1951, p. 117, no. 76.

CLASSICISM

At the time when the hegemony of France in Europe was being established under the firm hand of Richelieu, science and art also flourished in the hands of Descartes in philosophy, Pascal in religious literature, Corneille in drama, François Mansart in architecture and Poussin and Claude Lorrain in painting.

These two artists spent the greater part of their lives outside France and were not dependent on commissions from the Cardinal or the court in their native land. They settled in Rome in an international circle of artists who enjoyed the support of numerous patrons. Besides the papal court and religious orders, there were many private collectors – ranging from Queen Christina of Sweden, princes and cardinals to learned persons of bourgeois origin. The works of art they assembled were shown to eager visitors from all over Europe.

Claude painted for the Roman aristocracy, often composing pairs of pictures. He found favour with church dignitaries – Cardinal Guido Bentivoglio was one of his earliest admirers and Cardinal Giulio Rospigliosi (the future Pope Clement IX) acquired works from him as well as from Poussin. Both artists were represented in famous collections, such as those of the Marchese Giustiniani and Cardinal Camillo Massimi. Poussin in turn had a mentor in the antiquarian Cassiano del Pozzo, who owned no less than fifty of his paintings.

These circumstances, coupled with great artistic freedom and inspiring surroundings, are no doubt a sufficient explanation for the fact that these two great French artists refrained from dependence on the monolithic social order in their native country.

Claude Lorrain, whose real name was Claude Gellée (1600–82), was born in the village of Champagne, near Nancy. In his early teens he moved to Rome, where he worked for the Italian painter Agostino Tassi, probably just as a *garzone* (apprentice) at first. The following years were extremely important for Claude's development as an artist, for Tassi continued a North European landscape tradition he had learnt from the Flemish painter Paul Bril. In 1625 Claude returned for about a year to Nancy, where he worked as assistant to Claude Deruet. By the end of 1627 he was back in Rome and settled there for good, possibly paying a visit in the 1630s to Naples, which was a major source of inspiration for his seaport paintings.

Claude was about thirty when he started to make his reputation as a painter, attracting imitators and even forgers. To safeguard his name he started the practice, *c.* 1634, of documenting his paintings by drawing the compositions and assembling the sheets of these in a volume entitled *Liber Veritatis*. This book became the central record of Claude's *œuvre*, containing two hundred drawings which reproduce almost all the paintings he produced from that time onwards.

Nothing is known for certain about paintings by Claude before *c.* 1630 and it is also difficult to reconstruct the chronology of his early drawings. It is generally agreed, however, that what is known as the 'Early sketchbook' does

Agostino Tassi, *Ariadne abbandoned,* 1630–2 (The Uffizi Palace, Florence)

contain some of his first studies. They have the spontaneity associated with direct observation. The sketchbook includes tree studies done in pen and ink, apparently in great haste. It is remarkable that although we get the impression of individual trees as the artist saw them, there is nothing to tell what species they represent. This is often the case with tree studies by Claude. One also finds equally impressionistic representations of figures – artist friends – in a landscape. For Claude, what mattered in a composition was a general impression of heroic greatness.

A youthful acquaintance, Joachim von Sandrart, who returned to Germany in 1635, describes how Claude 'in order to penetrate all the mysteries of nature from dawn until nightfall, stayed in the Campagna in order to learn to reproduce exactly how the sky turns red when the sun rises or sets. And having observed this or that in the countryside, he soon tempered his colours accordingly, hurried home and applied what he had experienced to the work in hand.'[1]

Nature studies by Claude therefore comprise not only hasty impressions but also careful renderings of an atmosphere, attempts to catch the mood of a landscape. Even when drawing from nature, Claude adheres to certain principles of composition that turn the sheet into an autonomous work of art. Details done in chalk are backed up by surfaces of translucent wash. An accent in the foreground is balanced by heavy elments further away in the distance. Light is projected inwards, opening up the landscape and transforming what started as a working study into a finished drawing. This painterly manner of drawing is at its height in sheets that belonged to the numbered volumes from the period *c.* 1640.

In his conception and execution of landscape paintings, Claude continued to be dependent on Tassi, but his drawings indicate a much more open attitude, with experiments in almost every technique and means of expression. His early style of drawing, in which the pen practically bounces on the paper to make

Bartholomeus Breenbergh, *Tivoli*, 1625
(The Trustees of the Pierpont Morgan Library, New York)

groups of strokes, points, spirals and rapid, expressive lines, seems to have grown out of the manner cultivated by Bril and his followers.

The bold, flowing wash, in every gradation from faint surfaces to sombre shadow, suggests links both with Callot, whom Claude could well have met during his brief stay in France *c.* 1626, and with the Dutch and Flemish artists who were in Rome, primarily Bartholomeus Breenbergh, there in 1619–29. Breenbergh's vigorous washes have many of the qualities that are characteristic of the art of drawing as practised by Claude.

Most of the studies from nature belong to the earlier part of Claude's output. They dominate up to the middle of the 1640s, after which they give way to compositional studies, and hardly any date from the final decades. This is easily explained. Claude kept almost all his drawings in his studio as a vast fund of working material. Moreover, as he grew older, gout made excursions difficult. It seems relevant here to mention the small sketchbook from the period *c.* 1650 that the Nationalmuseum acquired a few years ago. The artist evidently took it with him to jot down his observations. The studies in this book are of a type that was previously unknown in Claude's *oeuvre*.

In his studio work Claude gradually changed his use of wash. Chalk and ink are combined uninhibitedly, supplemented with a tonal wash, occasionally on a tinted ground, with white heightening to round off the whole.

The compositional studies can be divided into various categories. One consists of initial, tentative ideas that are tried out and either accepted or rejected; the subject may be a complete composition or just a detail. In the next stage the conception is subjected to certain principles of composition and the overall effect of the scene is considered. Drawings of this type are often called *pensées*. Then there are the highly finished sheets that serve as drafts for the paintings and may also have been used as presentation drawings, enabling a patron to see that his intentions were understood. Sheets of a very different category are those on which Claude recorded a finished painting, as in the *Liber Veritatis*, or repeated an earlier compositional drawing. Even this work is full of artistry. In reproducing the main elements of the composition Claude frequently alters the proportions and relationships to suit the scale of the drawing, smaller than that of the painting.

In the 1650s Claude gradually changed his style of painting as well as of drawing, producing fewer pictures but making them larger and more heroic. The scenes are classical or biblical and the artist's interest in landscape has to make allowances for the subject. Details of the landscape continue to reflect his observations of the countryside around Rome, but the elements have to be combined with greater freedom. The traditional tranquil horizontals are disrupted to an increasing extent by dramatic mountain ranges or a profusion of architecture. In another respect the tranquillity is, however, heightened by the principles of composition that Claude followed more and more consistently.

Sandrart wrote, 'But while I was only looking for good rocks, trunks, trees, cascades, buildings and ruins which were grand and suited me as fillers for history paintings, Claude on the other hand only painted, on a small scale, the view from the middle to the greatest distance, fading away towards the horizon and the sky, a type in which he was a master.'[2] In other words, Claude observed nature as though through a telescope. There is no proper foreground. By starting the picture further away, so that perspective lines are less convergent, he made everything appear equally remote, assigned to an heroic past.

The gout that afflicted the ageing Claude made drawing increasingly difficult. He adopted a rather cautious manner, using short strokes of the pen because of his shaky hand. The wash is also less bold and the pictures tend to

1 J. von Sandrart, *Der Teutschen Academie, zweiter Theil*, Nuremberg 1675, pp. 331 ff.
2 Loc. cit.

have an elegiac mood that matches their content. The subjects are taken to an increasing extent from Roman history, with Virgil as the chief source of inspiration. The *Eclogues* and the *Georgics* provided descriptions of peasant life and divine apparitions in the Roman countryside; the *Aeneid* an account of the Golden Age. The pastoral and heroic aspects of Claude's art are united in the depictions of Aeneas. Shepherds and heroes meet in a landscape in which classical ruins and insignificant leaves are presented with the same devoted interest.

Claude is one of the great draughtsmen. More than a thousand sheets by his hand have been preserved. He lived essentially for his art, taking no part in public life. He never married but had a daughter, Agnèse, who was born in 1653 and grew up in his house. After his death it was she who cared for his estate.

Nicolas Poussin (1593/4–1665) was likewise in Rome for most of his life as an artist. Born in Les Andelys, Normandy, he trained under Noël Jouvenet in Rouen before continuing to Paris in *c.* 1612. Little is known about his life before 1624, when, at the age of thirty, he went to Rome. There he worked at first in late mannerist tradition and gradually began to obtain commissions for altarpieces. He tried various styles and one can discern that on his journey to Rome he had studied Veronese and encountered the art of Caravaggio and Domenichino.

In 1630 Poussin's work underwent a radical change. Turning his back on large commissions for the Church, he cultivated a small group of *cognoscenti*, learned men who commissioned him to paint subjects of their choice, mainly from classical mythology. This led Poussin to the study of antiquity. He measured and copied sculptures and reliefs, assessing the proportions of the figures and noting how they had been composed. He absorbed the whole world of ideas on which so much of his art was to be based. His copies are in no way mechanical. On the contrary, each sculpture that he reproduces he seems to treat individually, interpreting its subject's expression and studying the play of light on the work's surfaces.

Nature was his other major source of inspiration. For most of his active life Poussin went on excursions to the wooded gardens in Rome and Tivoli as well as out to the Campagna. He was a receptive observer, recording the play of light on the landscape with a flowing brush and finding ways of expressing an analytic approach to the structure of vegetation. Like Claude, he learned from the ideas and technique of the northern landscape painters Breenbergh and Poelenburgh. They had developed a painterly use of wash, with the full range of tones, from light to the darkest brown, and with brush-strokes alternating between broad sweeps and spontaneous scribbling.

The art of Poussin is utterly dissimilar from that of Claude in many respects. As far as the composition of paintings is concerned, in landscape backgrounds Poussin adheres to the Venetian tradition, Claude to a northern tradition derived from Bril and Elsheimer. On the other hand, there is a confusing similarity between the studies that both of them drew and sketched in the open, sometimes perhaps in each other's company. Claude is, however, more flexible in his approach to nature, although he does observe certain principles of composition. In Poussin's work the structure of the picture, the way in which it is built up with distinct planes and clearly defined elements, is more evident.

In landscape drawing Poussin gives the Northern European tradition a dramatic turn. The light in his pictures is intense; the illuminated surfaces are dazzlingly white. The shadows cast across these surfaces are correspondingly dark, just as the gloom in shaded areas, set against a background bathed in

Cornelis van Poelenburgh, *Landscape with Ruins*
(Kupferstich-Kabinett, Staatliche Museen Preussischer Kulturbesitz, West Berlin)

light, can be impenetrable. An accent applied with the brush suggests an outline that helps to locate the various elements in the picture space. Poussin conceives of space in abstract terms. This is particularly noticeable in his representation of landscape. His preference for a limited number of clearly contrasted tonal values gives an alternative perception of the pictures as carefully balanced two-dimensional patterns. A similar approach to the problem is to be found in, for instance, the work of Cézanne.

The majority of Poussin's drawings are, however, compositional studies. In the early 1630s these works have a spontaneous air. Paintings from this period suggest a new interest in Venetian art. Titian was his outstanding predecessor both for the representation of a scene, for its lighting and atmosphere, and for the poetic mood of the Arcadian world from which Poussin now derived his subjects. In the drawings there is a free, spontaneous use of pen and brush, coupled with an abundance of elements rendered in generous, vigorous forms. The themes, at this time usually bacchanalia and similar subjects, are varied in series of studies, expressing a vitality and imaginative fertility that are characteristic of this 'baroque' phase of Poussin's art.

Later in the 1630s his style shifts as Poussin turns to the harmony and classical principles of Roman models. A study of Raphael and Annibale Carracci is accompanied by lessons learned from antiquity, and Poussin now gives his pictures a more three-dimensional structure. The composition is worked out in numerous preparatory sketches.

In c. 1641 Poussin spent about a year-and-a-half in Paris, where he worked for Louis XIII on the decoration of La Grande Galérie du Louvre. His situation was, however, uncongenial to him and he took the first opportunity of returning to the intellectual circle in Rome which he preferred, and in which he remained for the rest of his life.

The art of Poussin matured after his return from Paris. He adopted a more serious, more moral attitude and turned to a different set of themes. One of his commissions for a French intellectual, Paul Fréart de Chantelou, was a series of paintings on the *Seven Sacraments*. Compared with his first series, from the late 1630s, this set is more austere. Similarly, in the classical field, themes from Ovid were abandoned in favour of Stoic heroes, such as Scipio, Diogenes and Phocion. The stoic ideal was prevalent in intellectual circles outside the court and is paralleled in the plays of Corneille.

In his concern for veracity, Poussin followed literary sources as closely as possible in the representation of a subject. He frequently studied and compared different accounts of an event. His practical preparations were also extremely thorough. Having first done a very rough sketch for a picture, he modelled and draped wax figures. These he arranged on a miniature stage on which he could vary the lighting, paint a background landscape and so on. Different ideas for the composition were tried and the modifications were recorded in further sketches. When the necessary formal balance and clarity of content had been achieved, the composition was established in a drawing and a larger, definitive model was constructed as the starting-point for the painting. This procedure helps to account for the frigid classical severity of so much of Poussin's output, particularly in his later years.

The dazzling daylight in his washes is transformed into a nocturnal twilight or the dramatic illumination of an interior. The compositions are built up on strictly geometrical principles. The effect of this is much more apparent in the drawings than in the paintings. The idea behind a composition is clearer and more prominent.

The tendencies seen in work from the early 1640s onwards grew stronger by degrees, not least because a physical ailment made Poussin's hand increasingly

shaky. This accentuated the need for a deliberate approach to make the most of his resources and to cut out inessential elements in a picture. The terse simplicity is matched by high seriousness in the composition. Horizontals in the landscape and vertical figures serve as accents in a geometrical structure that hints at a universe based on mathematical laws in the spirit of Descartes. Foreground figures, landscape and architecture are used as equivalent elements in a grand design. Strong emotions are expressed with great economy and the picture exudes serenity.

Many other French artists of the highly talented generation that was born in the final decade of the sixteenth century spent some time in Italy, especially Rome, among them François Perrier, Claude Vignon, Jacques Stella, Charles Mellin, Simon Vouet, Claude Mellan and Jacques Blanchard. Unlike Claude Lorrain and Poussin, they moved back to France and to the enthusiastic patronage of Louis XIII (1601-43). There was room for different personalities, but after his return from Italy in 1627, Simon Vouet (1590-1649) can be said to have dominated the scene until his death in 1649.

Vouet started his career in 1611 as a portrait painter to the French ambassador in Constantinople. From 1613 he was in Rome, and he formed his style there. In Rome he painted portraits in the style of Ottavio Leone, but these have all been lost. There are hardly any drawings from this period, but the surviving paintings indicate that Vouet studied Caravaggio as well as the early baroque masters Lanfranco and Guercino, besides being influenced by the more advanced manner of Domenichino and Guido Reni. Returning to France, Vouet developed a temperate form of baroque, which was informed by a certain classical balance that suited French taste, which found Italian baroque, with its roots in religious ecstasy, too emotional.

The drawings of Vouet represent a classical tradition, recalling the manner of Annibale Carracci. The medium, usually black chalk, is used with assured virtuosity from an early stage. Vouet was very systematic – the drafts, usually finished drawings, were transferred to the canvas with great exactitude. Most of the sheets are direct studies of figures and drapery.

Vouet can be said to have started the tradition of academic drawing that persisted, almost unchanged, in France for well over a century. Its hallmark is assurance, primarily in the arrangement of the individual figures and in the habit of lighting them to get the utmost clarity, showing every form on the trunk and limbs. The assurance is also evident in the use of close parallel strokes in a range of lighter and darker values which gives the figures a plastic appearance, while avoiding a distracting pattern of surfaces. Finally there is an impressive precision in outlines – in the representation of such awkward details as hands and feet – a precision that ultimately gives the impression of elegance and even ease of execution.

This impression of simplicity is, of course, an illusion. Such supreme command of the chalk demands constant practice. Exercises accordingly became an essential part of academic training, above all in drawing after models or classical sculptures. While still in Rome, Vouet had opened a studio, for which he engaged live models, in 1621 and he was appointed president of the St Luke Academy there in 1624. He had an extensive repertoire: in Paris he was showered with commissions for easel pictures from royal and private patrons, for altarpieces from religious orders and for illusionistic decorations. It was primarily the latter, with their complex compositional problems, that obliged Vouet to develop his systematic approach.

Although there was no lack of artistic talent in Paris, Vouet's official standing was not challenged. On his death it was inherited almost at once by Charles Le Brun.

Claude Mellan (1598–1688) was only eight years younger than Vouet, for whom he worked 1624–7, chiefly as an engraver. This period was presumably instructive in other respects, too, but there are indications that Mellan started to draw portraits before he went to Rome, where he lived 1610–28. With great economy – sometimes he indicates just the main features and the suggestion of a cheek – he is able to capture the essence of a personality. This portraiture is a specifically French art handed down from Clouet. The strength of Mellan lies in his psychological insight and in his ability to come close to the model. This is particularly evident in the restrained vitality of his portraits of children. Mellan also produced engravings, but the subtle values in his art could not be transferred to the plate, partly because the official nature of the portraits called for technical perfection.

Jacques Sarrasin (1592–1660) also had connections with Vouet while in Rome in 1610–28, as well as after his return to France, where the two artists were often engaged on the same projects in the period 1630–45. As a sculptor, he forms a trio with Vouet the painter and Mellan the engraver (and it has been shown by Jacques Thuillier[1] that Sarrasin did also work as a painter).

Sarrasin was the foremost French sculptor of his day. Judging from the few definitely attributable drawings, he also seems to have been a notable draughtsman. This combination is not unusual – drawing can be an important initial phase in the creation of sculpture. It is interesting to note that while Sarrasin shared the stylistic ideals of Vouet and strove for classical harmony, his drawings are executed much more freely than those of Vouet. These drawings, invariably connected with his sculpture, seem to serve not so much to establish the shape and plasticity of the object as to try out its effect in interaction with light and atmosphere.

Jacques Blanchard (1600–38) was the only painter to threaten briefly the position of Vouet in Paris. Like the other young artists of his generation, he had gone to Rome, in 1624, but was dissatisfied and moved to Venice (1625–8). The colours and affirmative attitude of Venetian art made a lasting impression on him. Contemporary accounts express particular admiration for his paintings of nude women. He is also known for gracious, attractive representations of the Virgin and the penitent Magdalen. The lack of preparatory drawings for documented paintings by Blanchard makes it difficult to attribute any drawings to him with certainty. It is generally accepted, however, that the freedom of execution exhibited in his paintings had a counterpart in the drawings and that he worked mainly with a generous wash on a light sketch in black or red chalk.

The generation of artists that studied in Italy was followed by one who relied on the tradition that France had to offer. Roman baroque, which was most ebullient in the second quarter of the century, may have been a deterrent that outweighed the attractions of classical and Renaissance Rome.

Laurent de La Hyre (1606–56) was one of these artists. Predecessors at Fontainebleau sufficed for his studies: Primaticcio and Dubois evidently made an impression on him. He also had access to Venetian paintings in the royal collections. La Hyre was not one of the outstanding painters of his generation but is definitely one of the more interesting draughtsmen. He started by developing a painterly style, usually working with black chalk and white heightening on grey-tinted paper in order to have a complete register for the wealth of tonal values which he used.

The drawings are not primarily studies of details for paintings. They are large, finished compositions in which the figures have been finalized, the lighting has been studied and every problem has been resolved before – as generally seems to have been the case – the composition has been transferred to

1 P. Rosenberg, *French master drawings of the 17th & 18th centuries in North American collections*, Toronto, Ottawa, San Francisco and New York 1972–3, p. 210.

a large canvas. Indeed, the creative process appears to have been completed in this initial phase – the drawing. When the ideas are transformed into painting, one gets the impression that La Hyre worked more as a craftsman.

The figures are drawn with confidence. Their appearance is classical, but the proportions – long limbs and small heads – suggest that the tradition of Fontainebleau mannerism was still alive. The technique of composition is highly sophisticated. Intricate relations between the figures tend to pose very complex problems. The solutions, however, radiate simplicity and harmony. A closer analysis reveals a delicate rhythm in the interaction between figures and architecture.

Born in Brussels, Philippe de Champaigne (1602–74) did not go to Italy either. We know of just a few drawings by his hand: detailed drafts for paintings. Champaigne is the antithesis of La Hyre; his paintings command attention, but his drawings lack personality.

Eustache Le Sueur (1617–55) was a pupil of Vouet from a very early age and could not avoid being influenced by him. Le Sueur never went to Italy, but his work shows that Raphael, known to him through engravings, made a strong impression on him. As a draughtsman, Le Sueur followed his teacher and adopted his technique, working with black chalk, preferably on grey paper to gain the effect of white heightening, to produce finished studies with a plastic effect for his paintings. Like Vouet, he studied each figure systematically before arranging it with others in a composition.

The art of Le Sueur underwent a change, brought about by the influence of Poussin, who stayed in Paris 1640–2. The ideals of classicism are now embraced wholeheartedly, leading to compositions that are more earnest, nobler and purer. The figures, placed on a three-dimensional stage, so that the action is easy to grasp, have a dignified, poised appearance, reinforced by the heavy, placid folds of their garments. The compositional drawings also reveal the influence of Poussin: the black chalk is supplemented with a generous wash that brings out the contrast between light and shade.

The austere mood is even more evident in later works by Le Sueur, and it was entirely in keeping with his ideals that he was one of the founders of the Royal Academy of Painting and Sculpture in 1648. Le Sueur became the foremost proponent of academicism and after his early death in 1655 this role passed to Le Brun.

His contemporaries admired Le Sueur greatly, not least for the impressive *Life of St Bruno* series that he painted for the Chartreux of Paris in *c.* 1648. Despite his classicist leanings and academic ambitions, there is a fastidious sensibility in the hand of Le Sueur that clearly places his draughtmanship between that of Vouet and that of Le Brun. It is as though the rules and a self-imposed frigidity serve to contain an unruly expressiveness.

Sébastien Bourdon (1616–71) had a lively, adventurous nature, unlike Le Sueur. From Montpellier, where he was born, he moved with equal ease to Rome and Stockholm and became a very versatile draughtsman. He was eclectic, imitating the painting styles of Claude Lorrain and Poussin, besides borrowing freely from the great masters in his drawings, chiefly in the arrangement of the composition. Compared with most of his contemporaries, Bourdon drew in a freer manner. The spontaneity of his line and his dashing application of the wash demonstrate the strength of his execution. In their individual ways, Le Sueur and Bourdon were in a position to express personal preferences in the choice between a severely classicist principle and a less solemn tradition. Changes on the political front led, however, to different conditions for art in France.

30 Claude Lorrain
CHAMPAGNE 1600–ROME 1682
FIGURES IN A LANDSCAPE
Pen and brown ink
12.8 × 9.5
No watermark
NM 252/1982
Verso: A standing peasant woman

This drawing, and nine others in the national museum acquired on the same occasion, are considered by Kitson to belong to Claude's 'Early sketchbook' of *c.* 1630.[1] The leaf has clearly been removed from the sketchbook undamaged and, unlike all the previously known leaves from this book, is untrimmed; it therefore provides a guide to the original page-size.

Kitson relates this drawing to a similar scene on the back of a sheet in the Hermitage, Leningrad.[2]

This group of drawings that Kitson believes came from the 'Early sketchbook' differs in many respects from the earlier known sheets from that source; the majority (seventeen) of these are in the British Museum and twelve are at Windsor. They are all fairly finished landscape and architectural drawings, whereas the group in Stockholm are figure studies, tree studies or very hasty sketches.

PROVENANCE
Thomas Atkinson. George Mayer. London, Sotheby's sale, 18 November 1982, no. 43

BIBLIOGRAPHY
M. Kitson, 'A small sketchbook by Claude', *Burlington Magazine*, 124, 1982, pp. 698–703, no. 37.
Bjurström 1986, no. 1827

[1] M. Roethlisberger, *Claude Lorrain, The Drawings*, Berkeley/Los Angeles 1968, p. 57 and nos 1–38.

[2] Ibid., no. 48, verso.

31 Claude Lorrain
TREES

Pen and brown ink
12.8 × 9.4 (untrimmed)
Watermark: Fragment of ring, letter M and
bird (?)
NM 261/1982
Verso: A kneeling saint. Pen and brown ink
(right of the saint a face in pencil, drawn by a
child)
Inscribed: *Calustanus*

From the 'Early sketchbook', this drawing is
similar in style and handling to the
preceding item.

PROVENANCE
Thomas Atkinson. George Mayer. London,
Sotheby's sale, 18 November 1982, no. 43

BIBLIOGRAPHY
M. Kitson, 'A small sketchbook by Claude',
Burlington Magazine, 124, 1982, pp. 698–703,
no. 52
Bjurström 1986, no. 1836

32 Claude Lorrain
VIEW WITH TREES

Black chalk, pen and brown ink, brown wash
31.6 × 22.4
Watermark: IHS and cross in oval
NM 87/1984

This is one of a series of nature studies, all of
much the same large size, that
Roethlisberger dates to 1635–7.[1] They all
show a forest scene with huge trees and
dominating foliage, through which the
daylight filters. Some of these bear the same
numbers and together they form part of what
Roethlisberger calls 'The Campagna book'.

Claude has confined his penwork to a tree
on the left and a hatched foreground zone
that counterbalances the clear sky. The
foreground gives way to a representation of
the foliage in a subtle play of values in
brown; there are no outlines, except where
the trees meet the bright sky.

The chalk is wielded with the same feeling
for values and it also seems to have been
applied on top of the wash to enhance the
light effects. The picture acquires its
particular atmosphere from the solitary figure
emerging from the shadows on the left,
running as though to catch a butterfly.

This sheet, with a minimum of effects and
a strong feeling for nature, is one of the most
painterly of Claude's nature studies.

PROVENANCE
Galerie Kornfeld, Bern, sale 22 June 1984, cat.
no. 92

BIBLIOGRAPHY
M. Roethlisberger, 'Dessins inédits de Claude
Lorrain', *L'Œil*, 226, May 1974, pp. 30 f.
Bjurström 1986, no. 1838

EXHIBITIONS
Nancy, Musée des Beaux-Arts, *Autour d'une
acquisition: Cent dessins de Claude Gellée, dit le
Lorrain*, 1980, no. 4
Nancy, Musée des Beaux-Arts, *Claude Gellée et les
peintres lorrains en Italie au XVII siècle*, 1982,
Addendum II
Munich, Haus der Kunst, *Im Licht von Claude
Lorrain, Landschaftsmalerei aus drei Jahrhunderten*,
1983, no. 31

[1] M. Roethlisberger, *Claude Lorrain, The
Drawings*, Berkeley/Los Angeles, 1968, nos 92–
94, 291–301, 330. The British Museum, as usual,
has most of these sheets, but the one (no. 294) that
is closest to the present drawing is in the Boston
Museum of Fine Arts.

C. L

33 Claude Lorrain
A ROUND TEMPLE AND TREES ON A HILLSIDE

Black chalk and brown wash
12.9 × 18
No watermark
NM 269/1982
Verso: A veiled elderly woman seated and at right-angles to this a fragment of a figure composition. Black chalk

This drawing appears to form the initial stage of the conception of a composition that then matured in finished drawings or paintings. The composition can be associated with the drawing of Hagar and the Angel,[1] which, without being directly related to another rendering of the same theme (*Liber Veritatis*, 140), no doubt dates from approximately the same time (1655). The characteristic feature is the construction of a landscape with reflecting water and a round temple, an arrangement with which Claude had experimented before.[2]

The inspiration for the temple is the building in Tivoli, which Claude reproduced in some direct landscapes[3] as well as in a modified form in a number of paintings[4] and in a drawing from the early 1640s.

It is worth noting that Claude clearly begins by striking a chord and indicating a mood. Although the picture is simply sketched in with a hasty rhythm, it displays a dramatic involvement that, in the final version, has become calmer, more elegiac.

PROVENANCE
Thomas Atkinson. George Mayer. London, Sotheby's sale, 18 November 1982, no. 43

BIBLIOGRAPHY
M. Kitson, 'A small sketchbook by Claude', *Burlington Magazine*, 124, 1982, pp. 698–703, no. 28
Bjurström 1986, no. 1839

[1] M. Roethlisberger, *Claude Lorrain, The Drawings*, Berkeley/Los Angeles, 1968, no. 800.

[2] Ibid., no. 507.

[3] Ibid., nos 87, 430, 431. Cf. also *Liber Veritatis*, 181.

[4] *Liber Veritatis*, 55, 62, 65, 67, 79; Roethlisberger, op.cit., no. 558.

34 Claude Lorrain
LANDSCAPE WITH ROME IN THE
BACKGROUND
Pen and brown ink, brown and grey wash,
with touches of white heightening
12.3 × 18.3
Watermark: Bird
Verso: Landscape with dance. Pen and brown
ink, brown and grey wash
NM 143/1985

The drawing was engraved by Richard
Earlom, when it was in the collection of Earl
Spencer, for the so-called third volume of the
Liber Veritatis, published by Boydell in
1819.[1] Michael Kitson has suggested that
this drawing dates from *c.* 1640 and that,
although it may have been done for an
unexecuted painting, it might possibly be
connected with Claude's *Landscape with
Rebecca and Eleazar*.[2] This identification is
improbable, however, as the town in the
background obviously represents Rome, with
Porta S. Paolo and the Cestius pyramid in the
right background.

The drawing verso seems to be connected
with the etching *La danse sous les arbres* and
the preparatory study for this in Oxford.[3] Of
special interest is the possibility of the sheet

being one of the missing pages of the
Nationalmuseum sketchbook. The size is the
same, although this sheet is slightly
trimmed. The paper is similar and the
watermark, a bird, the same as on ff. 10, 11,
13, 16, 18 and 19 in the sketchbook.

Stylistically this sheet is very close to f. 7
r. in the sketchbook. It is more finished,
however: a reason for its once having been
removed from the sketchbook.

Another sheet from the collection of Earl
Spencer has supposedly the same source.[4]
The most probable date for these drawings
would therefore be the 1640s.

PROVENANCE
Earl Spencer (L 1530) 'RAB'. George Hibbet.
Clark. London, Sotheby's sale, 4 July 1985, no.
67.

BIBLIOGRAPHY
M. Roethlisberger, *Claude Lorrain, The Drawings*,
Berkeley/Los Angeles, 1968, no. 1174 (Earlom's
engraving)
Bjurström 1986, no. 1843

[1] M. Kitson, *Claude Lorrain: Liber Veritatis*,
London 1978, p. 30 (for an explanation of volume
III).

[2] *Liber Veritatis*, 52, now in the Nationalmuseum,
NM 6544. Cf. M. Roethlisberger, 'A painting by

Claude', *Burlington Magazine*, 115, 1973,
pp. 652 ff.

[3] A. Blum, *Les eaux-fortes de Claude Gellée dit le
Lorrain*, Paris 1923, no. 35; M. Roethlisberger,
Claude Lorrain, The Drawings, Berkeley/Los
Angeles, 1968, no. 131.

[4] Roethlisberger, op.cit., no. 109. Ashmolean
Museum, Oxford.

35 Claude Lorrain
LANDSCAPE WITH THE LANDING OF AENEAS IN LATIUM

Pen and brown ink, grey wash
26.1 × 33
Laid down
NM 358/1969
Inscribed at the bottom left: *Claudio / Gille / I.V.F. / Roma / 1673 / Oc^{bre}*; at the bottom centre: *l'arrivo d'Anea (a palante) / al monte Evantino*. Squared with diagonals in black chalk

This is one of three preliminary studies in the Nationalmuseum for the painting *The Arrival of Aeneas at Pallantium* of 1675 (*Liber Veritatis*, 185), done for Prince Gaspare Altieri (today at Anglesey Abbey, National Trust). An inscription on the verso of one of the other sheets (NM 360/1969) indicates that it was the prince who decided on the motif, which is based on the *Aeneid*, VIII, 79–123. A large number of other studies for

the painting exist.[1] According to A. Zwollo, the painting may have been commissioned as early as 1670.[2]

In this sheet from 1673, Virgil's text has been followed. The two ruined cities of Janiculum and Saturnia are included on the right; moreover, the two ships have been placed further into the picture than in the earlier version and some changes have been made to the group of trees. Roethlisberger has shown that another drawing,[3] probably from 1673, comes between those from 1672 and this one. It is an exploratory sheet; the group of trees is still reminiscent of the earlier version, the ruined cities have been added, with inscriptions above to identify them, and various positions have been tried out for the ships. For Aeneas' vessel there is a detail study from 1673.[4] The British Museum has another from 1675 for the ships and the central group of figures.[5]

In the present drawing a shepherd and his flock have been added in the left foreground.

PROVENANCE
Coll. Camuccini, Rome early nineteenth century. London, Sotheby's sale, Florence, 18 October 1969, cat. no. D 23

BIBLIOGRAPHY
M. Roethlisberger, *Claude Lorrain, The Paintings*, New Haven, 1961, I, p. 437
M. Roethlisberger, *Claude Lorrain, The Drawings*, Berkeley/Los Angeles, 1968, no. 1081
Statens konstsamlingars tillväxt och förvaltning, 94, 1969, p. 6, pp. 18 f.
Apollo, vol. 90:2, 1969, p. 551, no. 16
An Zwollo, 'An Additional Study for Claude's Picture "The Arrival of Aeneas at Pallantium"', *Master Drawings*, 8, 1970, p. 274
Bjurström 1976, no. 542

EXHIBITION
Washington, Fort Worth, San Francisco 1985–6, no. 41

[1] Roethlisberger, op.cit., nos 1077–1086.
[2] An Zwollo, op. cit., p. 247.
[3] Roethlisberger, op. cit., no. 1079.
[4] Ibid., no. 1082.
[5] Ibid., no. 1083.

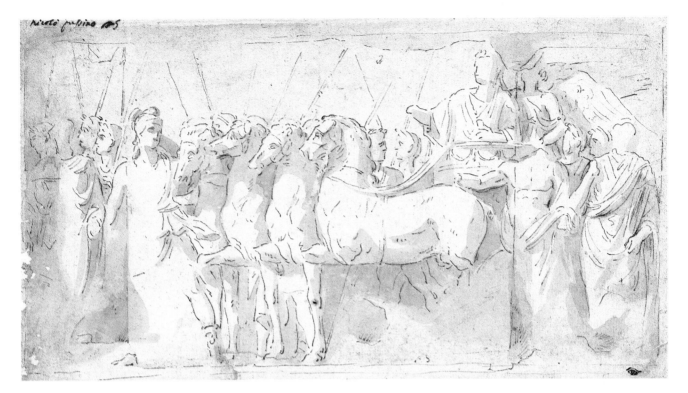

36 Nicolas Poussin

LES ANDELYS 1593/4–ROME 1665
THE TRIUMPH OF TITUS
Pen and brown ink, wash
15.1 × 27.7
Small holes at left
Laid down
NM 1571/1875
Inscribed at upper left: *nicolò pussino 25*

During the period 1640–45 Poussin's
drawings after the antique are of two types,
most of them being simply factual notes.
This drawing after one of the bas-reliefs on
the arch of Titus in Rome is quite different, a
record of a sculpture that the artist admired
as a work of art. It is not measured or
detailed; Poussin was more interested in the
play of light on the surface.

PROVENANCE
N. Hone (Lugt 2793). J. T. Sergel

BIBLIOGRAPHY
G. Wengström, *Nicolas Poussin, Dix-huit fac-similés
en couleurs . . .* (Collection de dessins du Musée
National 2), Malmö 1935, no. 1
U. Christoffel, *Poussin und Claude Lorrain*, Munich
1942, p. 50
H. Ladendorf, *Antikenstudium und Antikenkopie*,
Berlin 1953, p. 180
A. Blunt, *Nicolas Poussin*, New York, 1967,
p. 229
Bjurström 1976, no. 629

EXHIBITIONS
Paris, Louvre, *Nicolas Poussin*, 1960, no. 184
New York, Boston, Chicago 1969, no. 87
Dresden, Kupferstichkabinett, *Dialoge*, 1970,
no. 75

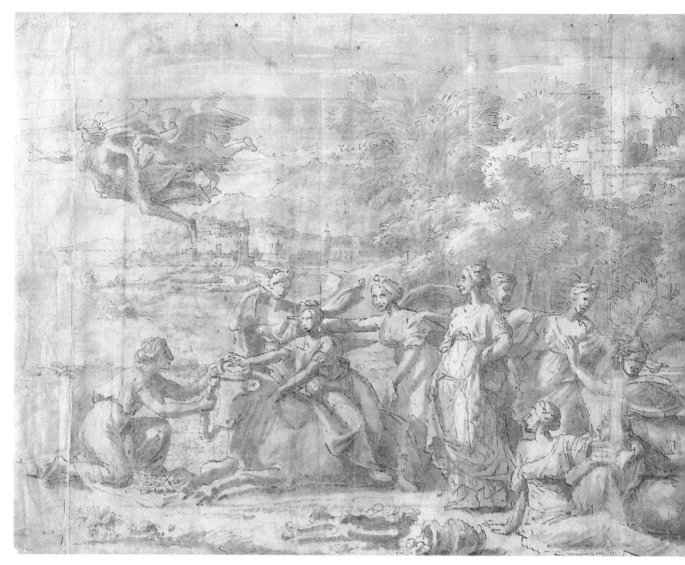

37 Nicolas Poussin
THE RAPE OF EUROPA

Pen and brown ink, brown wash
26.2 × 59
The sheet put together from three pieces of
paper. A great number of vertical folds,
several repairs
Watermark: Star (close to Heawood 3882: no
source indicated)
NM 68/1923

The first mention of a painting of the Rape of
Europa occurs in a letter from Poussin to
Chantelou, dated 22 August 1649,[1] in which
he agrees to do a picture on this subject for
M. Pucques, a friend of Chantelou. He
writes that the motif is very beautiful and has
a wealth of striking episodes; the dimensions
indicate that the painting's width was to be
twice its height. The present drawing is
probably the final draft for this canvas as its
exceptional proportions agree with those
mentioned in the letter. The date is

confirmed by the Moses on the verso, this
being a study for a painting (now in the
Hermitage).

The drawing has much in common with
Orpheus and Eurydice (Louvre), which was
probably painted in 1650. The fleeing girl in
the drawing is recoiling in almost exactly the
same way as the girl in the painting. Both
works include a building resembling Castel
S. Angelo, with smoke rising from it. In
view of these likenesses and the circumstance
that no painting of the Rape of Europa was
known to exist, Mahon assumed that the
Europa project was transformed into the
Louvre painting. This hypothesis proved
superfluous, however, when a right-hand
fragment of a Europa painting was
discovered, depicting the group with the
river god.

The Uffizi has a drawing which shows an
earlier version of the motif.[2] The sheet has
clearly been cut on the right, as the knee of
the reclining river god occurs on the right-

hand edge. Otherwise it is very like the final version, except that the landscape is different and it lacks the group with Mercury and Cupid riding Jupiter's eagle.

The part of the sheet which has the right-hand part of the composition on its recto has two sketches for the same on its verso. One of these is for the left part of the composition and shows Europa and the bull added somewhat loosely to the cluster of standing nymphs; on the right is the kneeling nymph, who, as she rises, recoils from the snake – a movement which, in the other verso sketch, has been anchored more logically in the action by making the nymph rise from a group of seated maidens. As in the Uffizi drawing, however, the group is so compact that it tends to conceal what is happening. The various sketches lead up to the differentiated and dramatically convincing grouping of the final version.

The motif of Europa seated on the bull, helping one of the maidens to place a floral wreath on its horns, comes from Ovid's *Metamorphoses*, II, 861, and features in an engraving after Primaticcio.[3] The shepherd playing a flute appears in an engraving by Bonasone[4] showing a similar scene with Europa crowning the bull. No earlier work is known in which a girl fleeing from a snake has been included in the story of Europa but in the Louvre there is a *cassone* painting of this subject by Francesco di Giorgio in which one of the attendant maidens is making a similar movement.[5]

Snakes feature in several of Poussin's paintings. The likeness with the nymph and snake in the Louvre painting caused Blunt to interpret the picture as an allegorical fusion of the stories of Europa and Eurydice. The nymph on the right, wringing the water from her hair, is taken to be a symbol of fertility and alludes to Europa, the progenitor with Jupiter of the kings of Crete; she is contrasted with Eurydice, fated to languish in the underworld. The antitheses of life and death, fertility and sterility appear in various mythological guises in Poussin's late works. The interpretation rests on the identification of the nymph as Eurydice, though Badt holds her to be a maidservant on the grounds that, according to Virgil, *Georgics*, IV, 457–9, Eurydice did not actually notice the snake.

PROVENANCE
Collector's mark: P.F. (à sec). The drawing is probably from the collection of Per Floding, since it was found pasted onto the verso of his engraving *The Birth of St John the Baptist* (C. U. Palm, *Per Gustaf Floding*, Stockholm 1896, no. 42), dated 1762.

BIBLIOGRAPHY
G. Wengström, 'En studie om en nyupptäckt handteckning', *Kunstmuseets aarsskrift 1921–1923*, Copenhagen 1924, pp. 341–50
G. Wengström, 'Teckningar av Poussin i Nationalmuseum', *Nationalmusei Årsbok*, 6, 1924, pp. 143 f., 146, no. 15
G. Wengström, *Nicolas Poussin, Dix-huit fac-similés en couleurs . . .* (Collection de dessins du Musée National 2), Malmö 1935, no. 15, no. 11a (verso c), no. 19 (verso d)
W. Friedländer, *The Drawings of Nicolas Poussin*, 1, London 1939, no. 25, pl. 14 (verso d), no. 52, pl. 32 (verso c)
A. Blunt, 'The Heroic and Ideal Landscapes of Nicolas Poussin', *Journal of Warburg and Courtauld Institutes*, 7, 1944, p. 165
W. Friedländer and A. Blunt, *The Drawings of Nicolas Poussin*, 3, London 1953, no. 166, pl. 137, nos 167, 168, pl. 138 (the verso sketches for no. 166)
D. Mahon, 'Réflexions sur les paysages de Poussin', *Art de France*, 1, 1961, p. 125
D. Mahon in *L'ideale classico* (exhibition catalogue), Bologna 1962, p. 208
A. Blunt, *The Paintings of Nicolas Poussin*, London 1966, no. 153:2, no. 23:2 (verso d)
A. Blunt, *Nicolas Poussin*, New York 1967, p. 120, pp. 319 f., 346, fig. 252
E. Knab, 'Über ein Fragment von Nicolas Poussin', *Albertina-Studien*, 1967/8, pp. 44 ff., pl. 6
K. Badt, *Die Kunst des Nicolas Poussin*, Cologne 1969, pp. 236 f., 260, pl. 33 (verso c), p. 602
Bjurström 1976, no. 631

EXHIBITIONS
Stockholm 1958, no. 197
Paris, Louvre, *Nicolas Poussin*, 1960, no. 219

[1] Ch. Jouanny, 'Correspondance de Nicolas Poussin', *Archives de l'Art Français*, Nouv. Pér., 5, 1911, p. 402.
[2] W. Friedländer and A. Blunt, *The Drawings of Nicolas Poussin*, 3, London 1953, no. 169.
[3] L. Dimier, *Le Primatice* Paris 1900, p. 489, no. 15.
[4] A. Bartsch, *Le peintre graveur*, Vienna 1803–21, 15, 109.
[5] Cf. A. S. Weller, *Francesco di Giorgio*, Chicago 1943, pp. 118 f., pls 34–40.

38 Nicolas Poussin
THE TRIUMPH OF GALATEA
Black chalk, brown wash
14.2 × 20.2
Old fold at right
Laid down
NM 2446/1863
Numbered at lower right in pen and brown
ink: 63 (struck out)

This sheet exemplifies Poussin's early style of
drawing, in which the key principle is the
distribution of light and shade over the
composition. The drawings tend to have the
appearance of reliefs and demonstrate a fresh,
spontaneous imagination.

There are two closely connected drawings
of this subject in the Nationalmuseum. This
is the more concentrated of the two and
seems to be the more mature work. At first
sight it appears to be connected with the
Triumph of Amphitrite, executed for Richelieu
at the end of the 1630s and today in the
Philadelphia Museum of Art. As Blunt has
pointed out, the likeness can be well
accounted for on the grounds of a common
ancestry in Raphael's and Annibale Carracci's
versions of the theme. There is no motif that

exactly links the drawing to the painting.
The drawing may, however, have been
executed in the same period, *c.* 1635.

PROVENANCE
Crozat (Mariette, no. 971). C. G. Tessin (List
1739–42, p. 43 r.; Cat. 1749, livré 13, no. 18 or
19). Kongl. Biblioteket (Cat. 1790, no. 2345).
Kongl. Museum (Lugt 1638).

BIBLIOGRAPHY
G. Wengström, 'Teckningar av Poussin i
Nationalmuseum', *Nationalmusei Årsbok*, 6, 1942,
pp. 140 f., p. 146, no. 13
G. Wengström, *Nicolas Poussin, Dix-huit fac-similés
en couleurs . . .* (Collection de dessins du Musée
National 2), Malmö 1935, no. 13
W. Friedländer and A. Blunt, *The Drawings of
Nicolas Poussin*, 3, London 1953, no. 216, pl. 166
K. Badt, *Die Kunst des Nicolas Poussin*, Cologne
1969, p. 255
Bjurström 1976, no. 625

EXHIBITIONS
Stockholm 1958, no. 183
Bern, Kunstmuseum, *Das 17. Jahrhundert in der
Französischen Malerei*, 1959, no. 168
Paris, Louvre, *Nicolas Poussin*, 1960, no. 137
New York, Boston, Chicago, 1969, no. 86

39 Simon Vouet

PARIS 1590–PARIS 1649

ST JOHN MOURNING AT THE
CROSS OF CHRIST

Black chalk, heightened with white chalk,
on grey paper
28.3 × 19.4
Laid down
NM 2421/1863
Numbered at lower right in pen and brown
ink: 2322 (Sparre)

This is a study for St John in the *Crucifixion*
(Hermitage).[1] The composition was engraved
by Daret in 1638. Crelly notes that the
composition is clearly that which Vouet
painted for Anne of Austria but is rather
doubtful about the Hermitage painting,
which he finds somewhat awkward and stiff
in execution. The fact that the painting is
not the reverse of the engraving is of no
consequence, however, now that this
drawing has been brought to light, as it
shows that the composition was envisaged
from the start as it appears in the painting in
the Hermitage.

PROVENANCE
N. Tessin jun. (?). C. G. Tessin (Cat. 1749,
p. 172). Kongl. Biblioteket (Cat. 1790, no.
2322). Kongl. Museum (Lugt 1638).

BIBLIOGRAPHY
Bjurström 1976, no. 740

[1] W. R. Crelly, *The painting of Simon Vouet*, New
Haven/London 1962, p. 169, no. 48.

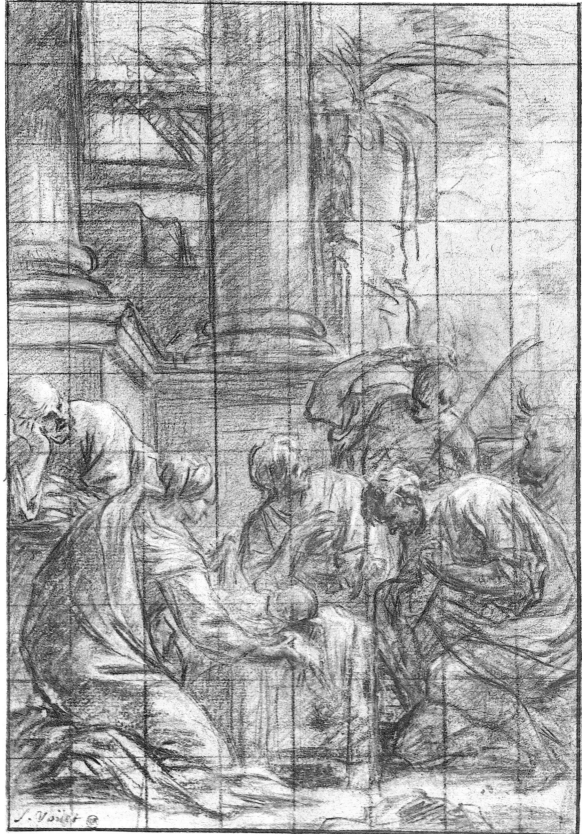

40 Simon Vouet

ADORATION OF THE SHEPHERDS
Black chalk, heightened with white chalk,
on grey paper
26.6 × 19.0
Laid down
NM 2422/1863

Inscribed in pen and brown ink at bottom,
left: *S. Voüet*, squared in black chalk.
Numbered on mount in lower right corner:
2323 (Sparre)

PROVENANCE
C. G. Tessin (List 1739–42, p. 43 r.; Cat. 1749,
livré 13, no. 152). Kongl. Biblioteket (Cat 1790,
no. 2323). Kongl. Museum (Lugt 1638).

BIBLIOGRAPHY
Bjurström 1976, no. 742

41 Claude Mellan

ABBEVILLE 1598–PARIS 1688
ANNE OF AUSTRIA, INFANTA OF
SPAIN AND QUEEN OF FRANCE
Black, white and red chalk on brownish-grey
paper
10.7 × 10.7
No watermark
NM 2621/1863
Numbered at lower right in pen and brown
ink: *2516* (Sparre)

The drawing is dated by Wengström to the
period after 1642. It appears to be an initial
study drawn straight from the model. There
is no direct link with the engraving,[1] in
contrast to another sketch which seems to be
the final draft. In the latter the psychological
aspect has been subordinated to more formal
problems – the artist's interest in the
subject's features is replaced by concern for
the details of the composition.[2]

PROVENANCE
Crozat (Mariette, no. 1005 or 1006). C. G. Tessin
(List 1739–42, p. 37 v. no. 19; Cat. 1749, livré
17, no. 223). Kongl. Biblioteket (Cat. 1790, no.
2516). Kongl. Museum (Lugt 1638).

BIBLIOGRAPHY
G. Wengström, 'Claude Mellan, his drawings and
engravings', *Print Collector's Quaterly* 11, 1924:1,
pp. 10–43, no. 35, p. 24
Bjurström 1976, no. 578

[1] A. de Montaiglon, *Catalogue raisonné de l'oeuvre de
Claude Mellan*, Abbeville 1856, no. 245.

[2] J. Vallery-Radot, 'Dessins de Mellan et de
Nateuil appartenant à des collections particulières
d'Angleterre', *Bulletin de la société de l'histoire de l'art
français*, 1954 (printed 1955), pp. 25 ff. Also repr.
Burlington Magazine, 109:1, 1967, pp. 373 (ill.),
375, as exhibited at Colnaghi's, London.

2532

2527.

42 Claude Mellan

HENRIETTA ANNE OF ENGLAND
Black chalk
19 × 14.2
Laid down
NM 2632/1863
Numbered at lower right in pen and brown
ink: 2527 (Sparre)

Henrietta Anne of England was born in
1644, the year in which her mother, Queen
Henrietta Maria, had fled with her children
to France to escape the civil war in England
which eventually culminated in the
execution of Charles I. In 1661, Henrietta
Anne was married to the brother of Louis
XIV, Philippe d'Orléans; she died less than a
decade later, in 1670.

The portrait is interesting because of its
lack of royal splendour; the tiny pearl
necklace is Henrietta Anne's only ornament.
Mellan depicts her as a child, not as an adult
in miniature. Wengström dates the drawing
to c. 1657, when the princess was thirteen;
Vallery-Radot to c. 1649, when she was five.
The correct date must be c. 1653, when she
was eight or nine years old.

PROVENANCE
Crozat (Mariette, no. 1005 or 1006). C. G. Tessin
(List 1739–42, p. 38 r., no. 28; Cat. 1749, livré
17, no. 233). Kongl. Biblioteket (Cat. 1790), no.
2527). Kongl. Museum (Lugt 1638).

BIBLIOGRAPHY
G. Wengström, 'Claude Mellan, his drawings and
engravings', *Print Collector's Quarterly*, 11, 1924:1,
pp. 10–43, no. 51, p. 26, pl. 14
P. Lavallée, *Le dessin français*, Paris 1948, p. 40.
J. Vallery-Radot, *Le dessin français au XVIIe siècle*,
Lausanne 1953, p. 192, pl. 56
Bjurström 1976, no. 596

EXHIBITIONS
Paris, Gazette des Beaux-Arts, *Le dessin français
dans les collections du XVIIIe siècle*, 1935, no. 66
Paris, Musée Carnavalet, *La Suède et Paris*, 1947,
no. 367
Brussels, Rotterdam, Amsterdam, *Le dessin français
de Fouquet à Cézanne*, 1949–50, no. 24
Vienna, Albertina, *Meisterwerke aus Frankreichs
Museen*, 1950, no. 32
Leningrad 1963
New York, Boston, Chicago 1969, no. 92

43 Claude Mellan

**STUDY FOR A FRONTISPIECE FOR
THE NEW TESTAMENT IN GREEK**
Black chalk, grey wash, heightened with
white, on grey paper
34 × 21.8
Laid down
NM 2663/1863
Inscribed at lower left in pen and brown ink:
Claude Mellan. (Tessin). Numbered: 2558

The drawing is described by Tessin as 'La
Renommée gravant sur une Pyramide, ou il y a
un Cœur, Dessein un peu différent de
l'Estampe'.

After Mellan had engraved frontispieces in
1640–41 for a number of sumptuous
volumes after drawings by Jacques Stella and
Nicolas Poussin, he was commissioned by M.
Desnayers, Secrétaire d'Etat, to make this
one, dated 1642, independently.

In contrast to the portrait drawings,
Mellan produced this sheet with the
engraving entirely in mind, clearly
indicating the various degrees of shading.

PROVENANCE
Crozat (Mariette, no. 1005 or 1006). C. G. Tessin
(List 1739–42, p. 43 r.; Cat. 1749, livré 13, no.
156). Kongl. Biblioteket (Cat. 1790, no. 2558).
Kongl. Museum (Lugt 1638).

BIBLIOGRAPHY
G. Wengström, 'Claude Mellan, his drawings and
engravings', *Print Collector's Quarterly*, 11, 1924:1,
pp. 10–43, no. 36
P. Rosenberg, *Mostra di disegni francesi da Callot à
Ingres*, Cabinetto disegni e stampe degli Uffizi 29,
1968, p. 31, no. 20
Bjurström 1976, no. 579

44 Lagneau

ELDERLY MAN
Black chalk, pastels
42.7 × 28.4
Laid down
NM THC 5381
Numbered at upper right in pen and black
ink: 2920. (Sparre) and at lower right 69
(struck out)

Lagneau is not the name of a known artist
but is applied to a number of portraits
executed by different hands during the first
decades of the seventeenth century. They are
all executed in a rough and realistic style for a
bourgeois public.

This drawing belongs to a series of thirty
in the Nationalmuseum. There are examples
in many other collections, chiefly the Louvre
and the Bibliothèque Nationale in Paris.

The motif and the realistic detail in
particular are reminiscent of the pictures of
old women which Blunt locates in Lorraine
in the early seventeenth century.[1]

PROVENANCE
C. G. Tessin. Kongl. Biblioteket (Cat. 1790, no.
2920). Kongl. Museum (Lugt 1638)

BIBLIOGRAPHY
Bjurström 1976, no. 465

[1] A. Blunt, 'Georges de la Tour at the Orangerie',
Burlington Magazine, 114, 1972, p. 524, figs. 9,
12. Cf. also *Burlington Magazine*, 114, 1972,
p. 876 and fig. 107 (old man, Lorraine school).

45 Jacques Sarrasin

NOYON 1592–PARIS 1660
GROTESQUE MASK
Black chalk on grey paper, heightened with
white
21.6 × 20
Laid down
NM 2602/1863
Inscribed at lower left in black chalk, filled
in with pen and black ink: *Sarasin*.
Numbered at lower right in pen and brown
ink: 9:*co*. On the old mount in black ink:
2497 (Sparre) and 81 (struck out)

This is a study for the decoration of
Lemercier's wing of the Louvre; it was
probably intended for the keystone in an arch
of a ground-floor arcade on the side facing the
Place du Carrousel.[1]

A summary of Sarrasin as a graphic artist,
with information about extant sheets by him
in Rennes, Darmstadt and the Louvre, is
given by Pierre Rosenberg in the comments
on *Study for Autumn*, now in the Cooper-
Hewitt Museum in New York.[2]

PROVENANCE
C. G. Tessin (Cat. 1749, livré 18, no. 81). Kongl.
Biblioteket (Cat. 1790, no. 2497). Kongl. Museum.

BIBLIOGRAPHY
J. Vallery-Radot: *Le dessin français au XVIIe siècle*,
Lausanne 1953, no. 83, pl. 83
A. Ananoff, 'Les cent "petits maîtres" qu'il faut
connaître', *Connaissance des arts*, 148, 1964:1,
p. 56
Bjurström 1976, no. 659

EXHIBITIONS
Paris, Brussels, Amsterdam 1970–71, no. 36

[1] Suggested by M. Pradel, Conservateur du
Département de sculpture, Louvre, to J. Vallery-
Radot (op. cit., p. 187).

[2] Rosenberg 1972, no. 133.

46 Jacques Blanchard

PARIS 1600–PARIS 1638
ST MAGDALEN PENITENT
COMFORTED BY AN ANGEL
Red chalk, pen and brown ink, brown wash
20.6 × 28
Watermark: Three mounts and cross in
shield
NM 2434/1863

The motif with the penitent Magdalen in the
cave occurs elsewhere in Blanchard's *œuvre*, as
is known from an engraving by Charles
David.[1] The composition is dated by Sterling
to 1631–3, when impressions from Venice
were still fresh.

 This drawing, which has the same
provenance as most of the sheets by Poussin
and his school in the Nationalmuseum,[2]
bears such a close technical and stylistic
resemblance to another drawing (*Paris and
Œnone*) in the Nationalmuseum[3] that it
would seem to be by the same hand. The
luminosity is clearly Venetian and the sheet
may therefore be dated 1626–8, when
Blanchard was in that city.

 The watermark on the paper is exactly the
same as the one on *Paris and Œnone*. Its
closest parallels come from northern Italy.

PROVENANCE
Crozat (Mariette, no. 971, as Poussin). C. G.
Tessin (List 1739–42, p. 43 r; Cat. 1749, livré 13,
no. 8). Kongl. Biblioteket (Cat. 1790, no. 2334).
Kongl. Museum (Lugt 1638).

BIBLIOGRAPHY
Bjurström 1976, no. 134

[1] Ch. Sterling, 'Les peintres Jean et Jacques
Blanchard, *Art de France*, 1, 1961, pp. 77 ff.,
no. 36.

[2] Mariette, no. 971, as Poussin.

[3] Bjurström 1976, no. 133.

47 Jacques Blanchard

CHARITY
Black chalk
34.2 × 27
Laid down
NM 2691/1863
Inscribed at lower right in pen and brown ink: *La hire*. Numbered at lower right on the old mount in pen and brown ink: *2585* (Sparre) and *193* (struck out)

Although traditionally attributed to La Hyre, the drawing should probably be included – as pointed out in a personal communication by Pierre Rosenberg – among Blanchard's works. A Louvre drawing of the Madonna and Child[1] has many compositional and stylistic features in common with this sheet, but the latter is less spontaneous and somewhat vague in its design, being regarded as a copy by Bacou and Bean as well as by Sterling.[2]

In about 1635–7 Blanchard produced a number of compositions with the same motif. Some are still extant and some are documented by engravings.[3] One like the present sheet, used to be attributed to La Hyre.[4]

Sterling links the motif to the contemporary activities of St Vincent de Paul (1581–1660) on behalf of foundlings, which resulted in the establishment of a home for these in 1638 by Les Dames de la Charité.[5]

These external factors make it most probable that the present sheet dates from the same period.

PROVENANCE
C. G. Tessin (List 1739–42, p. 43 v.; Cat. 1749, livré 13, no. 167, as La Hyre). Kongl. Biblioteket (Cat. 1790, no. 2585). Kongl. Museum (Lugt 1638).

BIBLIOGRAPHY
Bjurström 1976, no. 135

[1] J. G. Guiffrey and P. M. Marcel, *Inventaire général des dessins du Louvre et du Musée de Versailles, Ecole française, 1*, Paris, 1907, 1, no. 285.

[2] R. Bacou and J. Bean, *Dessins français du XVIIe siècle, XXVe exposition du cabinet des dessins*, Paris 1960, no. 18 (mentioned by Ch. Sterling, Les peintres Jean et Jacques Blanchard, *Art de France*, 1 (1961), no. 27 (p. 87).

[3] Sterling, op.cit., nos 52, 53, 54, 56.

[4] Ibid., no. 58.

[5] Ibid., no. 52.

48 Philippe de Champaigne

BRUSSELS 1602–PARIS 1674
ST GERVAIS AND ST PROTAIS
REVEAL THEMSELVES TO
AMBROSE OF MILAN
Point of the brush, grey ink, grey wash
15 × 28.2
Laid down
NM 2773/1863
Numbered at lower right in pen and brown
ink: 28. (struck out); verso: *m cotteone*
[colleone?] *j.p.l.*

Ambrose is presented to the two saints by St
Paul, the scene being watched from the
background by the congregation of the
Basilica of St Felix and St Nabor.

Two other detail studies are known,[1] one
of Ambrose (National Gallery, Edinburgh),
the other of the two saints (private collection,
Paris). The composition was developed by
the artist in a larger drawing (point of the
brush, Louvre)[2] and was realized in a
painting, which was started in 1657
(formerly in the chapel of Lycée Henri IV in
Paris, now in the Louvre). The painting was
originally the fourth in a set of six by various
artists (Le Sueur, Théodore Goussé, Sébastien
Bourdon and Philippe de Champaigne) for
the choir of Saint-Gervais in Paris. Tapestries
were made from the paintings and hung in
the church on festive occasions.[3]

A sketch for the third composition in the
set, now in the Louvre, has exactly the same
format and technique as the present sheet.[4]

They both have the immediacy and life of a
first attempt, with the same interest in the
dramatic penetration of light into the
church.

PROVENANCE
P. J. Mariette(?). C. G. Tessin (List 1739–42,
p. 70 r.; Cat. 1749, livré 14, no. 28, as
Champagne). Kongl. Biblioteket (Cat. 1790, no.
2660, as J. B. Champagne). Kongl. Museum
(Lugt 1638).

BIBLIOGRAPHY
K. Andrews, 'Etudes préparatoires de Philippe de
Champaigne pour les tapisseries de Saint-Gervais',
Revue de l'Art, 14, 1971, pp. 76–9
Bjurström 1976, no. 301

[1] Repr. Andrews, op. cit., figs 8, 9.

[2] F. Lugt, *Musée du Louvre, Inventaire général des
dessins des écoles du Nord, Ecole Flamande*, 1, Paris
1949, no. 517.

[3] M. Dumolin, 'Nouveaux documents sur l'église
Saint-Gervais', *Bulletin de la société de l'Histoire de
l'art français*, 1933, pp. 56–65.

[4] Lugt, op.cit., no. 518; *Musée du Louvre, Dessins
Français du XVIIe siècle, XXVe exposition du Cabinet
des dessins*, Paris 1960, no. 31.

49 Laurent de La Hyre

PARIS 1606–PARIS 1656
HERCULES TAKING CERBERUS
FROM THE UNDERWORLD
Black chalk heightened with white on
greyish brown paper
30.3 × 42.2
Laid down
NM 116/1974

Hercules and Cerberus are seen on the left;
the other figures have not been identified.
The drawing is close in style and inspiration
to three drawings representing episodes from
Tasso's *La Gerusalemme Liberata* in the
collection at Ann Arbor, University of
Michigan Museum, which originally formed
part of a series of twelve.[1] It is known from
the inventory made at La Hyre's death that
he left several series of drawings dealing with
subjects such as 'Renaud et Armide, 14
dessins, Tancrède et Clorinde, 12 dessins,
Admète et Alceste, 12 dessins'.[2] It is possible
that this drawing belonged to an unrecorded
series on the Twelve Labours of Hercules.

Pierre Rosenberg dates the Ann Arbor
drawings and some sheets in the

Rijksmuseum, Amsterdam, the Kunsthalle,
Hamburg and the Louvre to the artist's
youth, before 1630, when he was still
strongly influenced by the painters of the
second school of Fontainebleau;[3] it is a date
that is relevant to this drawing also.

PROVENANCE
Unidentified collector's mark, AF monogram
within a circle (false Mariette mount and
collector's mark). Acquired at Christie's sale, 26
June 1974, no. 28.

BIBLIOGRAPHY
Bjurström 1976, no. 460

[1] Hamilton Easter Field sale, Anderson, New
York, 10 December 1918, lot 112. Like the
present sheet, the Ann Arbor drawings are on false
Mariette mounts.

[2] G. Wildenstein, 'Inventaire de Laurent de la
Hire (1657)', *Gazette des Beaux-Arts*, 6:49, 1957,
pp. 341–3.

[3] Rosenberg 1972, no. 70, pl. 26.

50 Eustache Le Sueur

PARIS 1617–PARIS 1655
KNEELING SHEPHERD
Black chalk on grey paper, heightened with white
35.5 × 22
Laid down
NM 2703, 2704/1863
Numbered at lower right in pen and brown ink: *37* (struck out) and *2595* (Sparre).
Verso: Young man walking. Black chalk.

This is a drawing for one of the shepherds in the artist's painting *The Adoration of the Shepherds*[1] in the museum in La Rochelle, commissioned in 1653. The drawing is an example of Le Sueur's late style.

PROVENANCE
Crozat (Mariette, no. 1019). C. G. Tessin (List 1739–42, p. 43 v.) Kongl. Biblioteket (Cat. 1790, no. 2595). Kongl. Museum (Lugt 1638).

BIBLIOGRAPHY
P. Rosenberg, 'Dessins du National Museum de Stockholm', *Revue de l'Art*, 11, 1971, p. 100, pl. 4
Bjurström 1976, no. 534

[1] M. L. Vitet, *Eustache Le Sueur*, Paris 1849, pl. 11.

51 Eustache Le Sueur
THE MEETING OF KING SOLOMON AND THE QUEEN OF SHEBA

Black chalk, pen and brown ink, brown wash. Squared with red chalk
28.5 × 33.4
Laid down
Inscribed at lower centre in pen and brown ink: *Eustache Le Sueur*. Numbered in lower right corner *8* and *2596* (Sparre)

Two versions of this composition are reproduced by Vitet. One of them corresponds to the present drawing, in reverse and described as *pré pensé*; the other corresponds with the painting in the Barber Institute of Fine Arts, Birmingham.[1] The present drawing is clearly a preliminary study for the painting, with only minor

discrepancies concerning the figures in the background. Another preliminary study is in the Staedelsches Institut, Frankfurt.[2]

PROVENANCE
Crozat (Mariette, no. 1019). C. G. Tessin (List 1739–42, p. 43 v.; Cat. 1749, livré 13, no. 166). Kongl. Biblioteket (Cat. 1790, no. 2596). Kongl. Museum (Lugt 1638).

BIBLIOGRAPHY
Bjurström 1976, no. 535

[1] M. L. Vitet, *Eustache Le Sueur*, Paris 1849, pls 6 and 5 respectively. It is stated in *Mémoires inédits sur la vie et les ouvrages des membres de l'académie royale* (published by L. Dussieux, E. Soulié, Ph. de Chennevières, P. Mantz, A. de Montaiglon), Paris 1854, 1, p. 167 ('Guillet de Saint-Georges, Eustache le Sueur, lu à l'Académie le 5 aôut 1690'), that Le Sueur painted this motif for Mme la Comtesse de Tounay Charante at her hôtel in the Rue de Neuve de Saint-Médric: 'Le tableau d'un

dessus de cheminée represente l'entrevue de Salomon et de la reine de Saba.' The painting which is now in the Barber Institute used to be in the Chatsworth collection; it was sold at Christie's on 27 June 1958.

[2] 25.8 × 16.5 Inv. no. 1281.

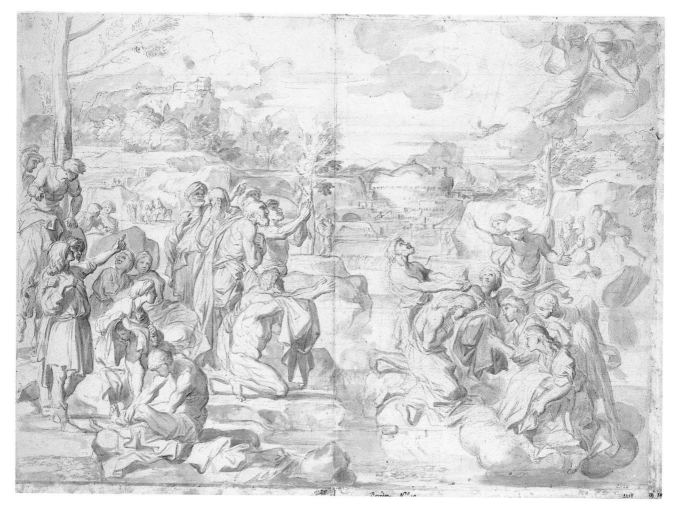

52 Sébastien Bourdon

MONTPELLIER 1616–PARIS 1671

THE BAPTISM OF CHRIST

Pencil, brown wash. Squared with black
chalk

43.4 × 60.3

Central vertical fold

Watermark: Figure (close to Heawood 1345;
not specified)

NM 2458/1863

Inscribed in pen and brown ink at lower
right: *Bourdon No 10*; on the verso inscribed
at lower left: *Bourdon fecit*, and at lower right
numbered: *2356* (Sparre)

A painting with this subject is now in the
Musée d'Avignon[1] and the same motif occurs
in a drawing in the Musée Atger, Montpellier.[2]

The drawing exemplifies the subtle,
luminous style of the artist's mature period.

PROVENANCE

Unidentified collector's mark (letters: MAPS). N.
Tessin jun. (Cat. 1730, p. 8). C. G. Tessin (Cat.
1749, livré 16, no. 90). Kongl. Biblioteket (Cat.
1790, no. 2356). Kongl. Museum (Lugt 1638).

BIBLIOGRAPHY

Bjurström 1976, no. 169

[1] C. Ponsonailhe, *Sébastien Bourdon, Sa vie et son
œuvre*, Montpellier 1883, p. 295.

[2] Inv. no. 8, coll. Xavier Atger. Cf. Ch. Saunier,
'Le Musée Xavier Atger à Montpellier', *Gazette des
Beaux-Arts*, 5:64, 1922, 1, pp. 38–40. Cf. also
catalogue of the exhibition *French drawings.
masterpieces from seven centuries*, Chicago,
Minneapolis, Detroit, San Francisco 1955–6,
no. 43.

53 Thomas Blanchet

PARIS 1614 (1617?)–LYONS 1689
THE DEATH OF DIDO
Red chalk, pen and brown ink, grey wash.
Squared in pencil
17.6 × 21.4
Laid down
NM THC 4032
Inscribed at the centre of the right side in
pen and brown ink: *drapier*, and in the lower
left corner, *Blanchet f*
Verso: Drawing for a trophy. Pencil, pen and
brown ink, brown wash, heightened with
white on a sheet of green paper stuck on the
back of the other sheet

Blanchet was trained in Paris by the sculptor
Jacques Sarrasin. He spent the years 1649–
53 in Rome, where he was in Poussin's
circle. He then returned to Lyons to be the
city's official painter.

PROVENANCE
C. G. Tessin (from a Tessin album: cahier 63).
Kongl. Biblioteket. Kongl. Museum (Lugt 1638).

BIBLIOGRAPHY
Jennifer Montagu, 'Thomas Blanchet: Some
drawings in the National Museum, Stockholm',
Gazette des Beaux-Arts, 6:66, 1965, p. 107, fig. 3
(the verso)
Bjurström 1976, no. 141

IN THE SERVICE OF ABSOLUTISM

When Cardinal Mazarin died in 1661, the youthful Louis XIV announced his remarkable decision to take over the reins of government. Backed up by Jean-Baptiste Colbert, whom Mazarin had trained, the king constructed a highly centralized administration, which was to handle every aspect of politics, religion and economics. France prospered and a complicated system of privileges kept various groups contented. The nobles were lured to the court, the bourgeoisie was engaged in business, the Church demonstrated its independence of Rome and the army was involved in a restricted but aggressive military policy. The peasants lived in poverty.

A corresponding change occurred in the intellectual and artistic spheres. Artists were required above all for the decoration of Versailles, which was converted during the reign from an insignificant hunting lodge to a magnificent monument to French absolutism.

In 1663 the Royal Academy of Painting and Sculpture was reorganized. Founded in 1648, the Academy had been modelled on the Academy of St Luke in Rome; its main function was to supervise artists working for the court and render them independent of the guilds. The new constitution was more autocratic; a Protector (Colbert) and a Director (Le Brun) presided over a hierarchy of professors, members, associates and students.

All academic training was based on drawing, from classical works of art as well as from life. Instead of copying nature, students were to adapt what they saw to the rules of proportion, distilled from the most famous sculptures in Rome – such as *Apollo di Belvedere* and *Laocoön*. Importance was attached to clear, distinct forms and to appropriate, uniform lighting. This followed from Cartesian principles, which asserted the primacy of form as an intellectual description of an object, whereas colour was only perceived as an indistinct sensation. The professors and teachers who supervised and regulated drawing classes were distinguished for their knowledge of the rules rather than for artistic talent: Charles Errard, Louis de Boullongne the elder, Michel Dorigny and Noël Coypel. The approved technique was derived from Vouet and Le Sueur: a confident outline balanced a plastic representation by means of parallel shading, supplemented with white heightening if the paper was tinted.

In 1666 a French Academy was also founded in Rome. Its first director was Charles Errard and the principles were largely the same as those that had been established in Paris.

A similar institution for training artisans was set up at Les Gobelins, likewise with Le Brun as Director. In this way Colbert established a monolithic system for supplying the monarchy with everything that was needed to furnish the royal palaces with paintings, sculptures, tapestries, embroideries, furniture and metal objects, all created in a style which accorded with the prevailing taste.

The whole of this artistic complex was soon dominated by Charles Le Brun (1619-90), whose talent was combined with prodigious energy. It was largely

Le Brun who was responsible for the rigid system of rules and instructions which was imposed on artists and craftsmen; he even wrote a treatise on the physical expression of every conceivable emotion.

This type of instruction produced artists who were resourceful practitioners but not much more. A student would hardly develop his talent without breaking the rules. Le Brun himself was particularly faithful to the doctrines he preached. Starting as a pupil of Perrier and Vouet, he had gone in 1642 to Rome, where he learned a great deal from Poussin and contemporary Roman painters. He adapted the lessons he learned from Poussin to the freer style of composition of the Italian artists, preferring a more dramatic mood to the heroic stoicism of Poussin. His strength lay in his ability to seize on the wealth of the compositions and designs in Italian baroque and put them to a different use. These instruments, created for religious purposes, served his ambition to glorify an absolute monarch. In doing so, he adapted them to French taste, with its more rational tradition.

Le Brun's success is a measure of his skill as an artist. He has had the reputation, particularly in France, of being excessively rhetorical. This is understandable when one looks at his finished paintings, but his drawings, of which thousands have been preserved, show great creative force.

In the early drawings it is the line that predominates, running with almost calligraphic freedom and repeated until it is perfect. This is supplemented with parallel shading, usually rather faint, with a few stronger accents which enhance the three-dimensional effect. In the compositional drawings of the same period one notes much the same freedom in Le Brun's search for a satisfactory organization of the surface, as well as in his unconventional combination of different chalks with pen and ink.

The drawing by Le Brun for the tapestry commemorating the visit to the Gobelins of Louis XIV (Musée des Gobelins, Paris)

Later drawings by Le Brun are less calligraphic. The figures have more weight and are represented in a more summary fashion as large, simple forms. There is also a lively interest in chiaroscuro and tonal values.

Pierre Mignard (1612–95) was Le Brun's rival and inherited many of his functions on the death of Colbert in 1683. Mignard shared most of Le Brun's ideals. He had spent twenty years in Italy, studying the same artists, such as Annibale Carracci and Poussin, and obtained royal commissions on his return to France in 1657. His most original paintings are his portraits. His drawings, however, are considerably less subservient to the academic tradition. They are done predominantly on tinted paper in three chalks (black, red and white), but these are not used systematically: although Mignard normally uses red chalk for the face and black for the figure, he often used red for the figure. Unlike his predecessors, Mignard allows his personal hand to emerge. In his sketches one can discern how he hesitates, reinforces a successful line and impatiently tries out different positions for hands and different versions of folds in clothing. Mignard's drawings presage the transition to the free technique of the early eighteenth century.

54 Charles Le Brun

PARIS 1619–PARIS 1690

LION OVERCOMING THE THREE-
HEADED CERBERUS

Red chalk, pen and brown ink

29.7 × 44.5

No watermark

NM CC 1803

To the left of the lion and Cerberus there are
a cornucopia and Fouquet's heraldic beast,
the squirrel: on the right is a plan of the
group in pen and brown ink. The group was
probably designed for Vaux-le-Vicomte,
where sculptures of lions for the cave were
made by Lespagnandelle in 1659.

PROVENANCE

C. J. Cronstedt and descendants. E. Langenskiöld.
Gift to the Nationalmuseum in 1941.

BIBLIOGRAPHY

Bjurström 1976, no. 500.

EXHIBITION

Versailles, *Versailles et les châteaux de France*, 1951,
no. 295

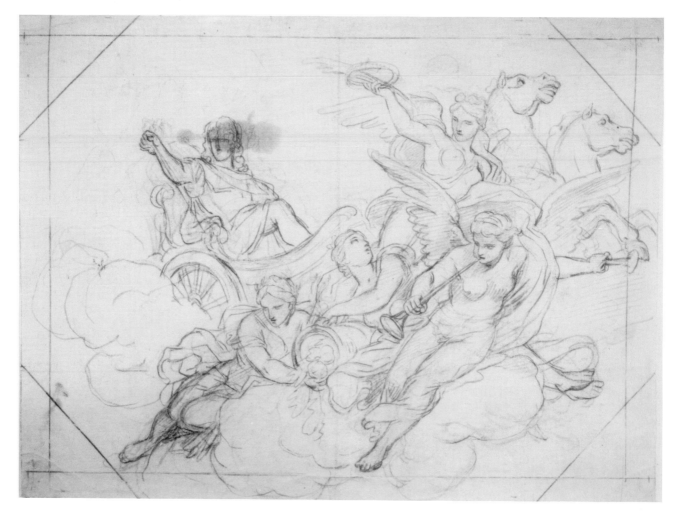

55 Charles Le Brun

LOUIS XIV GOVERNING THE
STATE
Black chalk
33.3 × 43.3
Brown spot 7 × 2.5 (oil?) over the king's
head
NM CC VI:109

This is a study for a painting in the Petite
Chambre du Roi, datable *c.* 1654. Little but
the downward glances of the figures suggest
that it was designed for a ceiling. The degree
of foreshortening differs from one figure to
the next, and even within the figure of the
king the body is more foreshortened than the
head. While in Rome in 1642–6, Le Brun
was no doubt greatly influenced by Pietro da
Cortona, who taught him to organize the
large surfaces of a ceiling and not to attach
too much importance to making the
perspective of the entire composition correct
from one particular viewpoint.[1]

PROVENANCE
C. J. Cronstedt and descendants. E. Langenskiöld.
Gift to the Nationalmuseum in 1941.

BIBLIOGRAPHY
J. Montagu, 'The early ceiling decorations of
Charles Le Brun', *Burlington Magazine*, 105:2,
1963, pl. 22, p. 401.
Bjurström 1976, no. 504

EXHIBITIONS
Paris, Brussels, Amsterdam 1970–71, no. 46

[1] Cf. L. Hautecœur, *Histoire des châteaux du Louvre
et des Tuileries*, Paris 1927, p. 58, and C. Aulanier,
*Histoire du Palais et du Musée du Louvre, 7, Pavillon
du Roi,* Paris 1958, p. 47; cf. also engraving by A.
J. Renard and Saint-André, D. Wildenstein, 'Les
œuvres de Charles Le Brun d'après les gravures',
Gazette des Beaux-Arts, 6:66, 1965, pp. 30–31, no.
175.

56 Pierre Mignard

TROYES 1612–PARIS 1695
LOUIS XIV ON HORSEBACK
Red chalk, heightened with white, on grey
paper
33.2 × 26
Laid down
NM CC 496

Apart from minor differences, this drawing
reproduces the artist's painting of Louis XIV
being crowned by Victory.[1] The sheet is a
preliminary study in which the position of
the monarch has not been settled. The
Louvre has another study in which the design
of the clothing and the attitude are closer to
the final version.[2]

PROVENANCE
C. J. Cronstedt and descendants. E. Langenskiöld.
Gift to the museum in 1941.

BIBLIOGRAPHY
Bjurström 1976, no. 611

[1] Château de Versailles, no. 2156 (Cat. Soulié).

[2] J. Guiffrey and P. Marcel, *Inventaire Général des
dessins du Louvre et du musée de Versailles, École
française*, Paris 1907–38, 10, no. 10114.

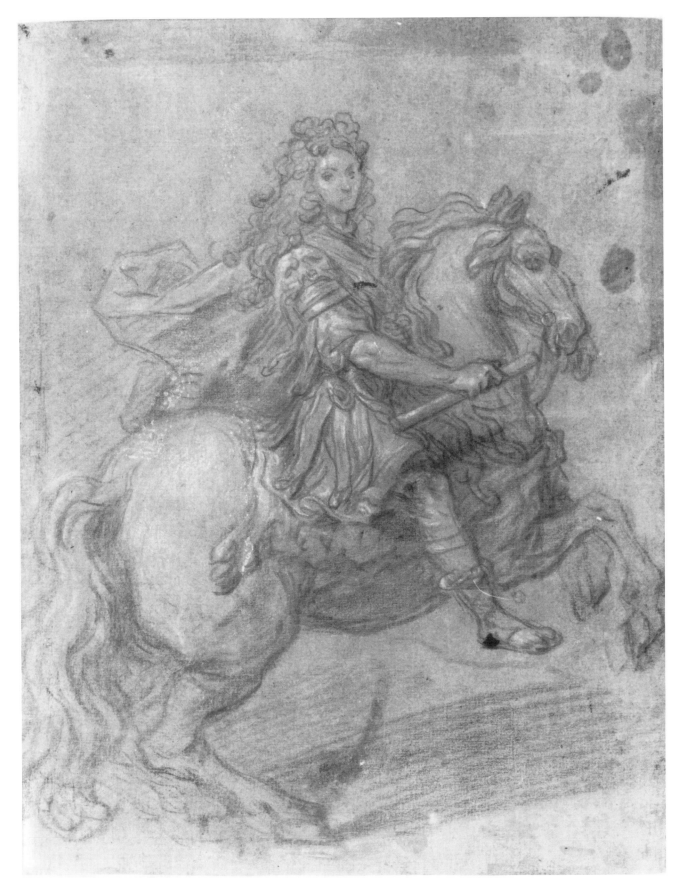

COLOUR OR DESIGN: AN ACADEMIC DISPUTE

In the late 1660s the French Academy's doctrine that drawing or form predominated over colour began to be questioned. The doctrine rested on the idea that a line or form is an intellectual phenomenon which engages the mind, whereas colour satisfies only one of the senses: sight. Against this it was argued that painting is nonetheless a visual art and colour is essential for a convincing imitation. The first phase of the battle had been concluded by Le Brun declaring the supremacy of design.

Roger de Piles, who was not a member of the Academy, then advanced Rubens as the great example: he not only possessed all the academic skills but was also a colourist. The Academy's authority was shaken and, worse still, many members were practising a manner of painting which conflicted with its doctrine.

Somewhat surprisingly, the new tendencies are perhaps most apparent in drawings. These, unlike paintings, could perfectly well be monochrome. But as we saw in the work of Mignard, artists now started to use different coloured chalks and tinted paper.

The initiator of this trend was in fact Charles de La Fosse (1636–1716). Le Brun had been his first teacher, but it was Rome and, above all, Venice (where he lived 1658–63) which made the strongest impression on him. La Fosse preferred brown-tinted paper and used the combination of black, red, and white crayons in a manner that soon became a rule for artists, attributing to each colour its own significance. With rapid strokes he 'paints in' surfaces with different values, so that the contours of landscape and figures dissolve into an expressive pattern. The colours are used to underscore the content – human figures being rendered usually in red chalk, landscape elements and details of dress in either black or a mixture that gives brown hues; white chalk is used to lighten the skin colour, particularly on faces. La Fosse also has a freer approach to the classical rules of composition. An exponent of baroque art, he simplifies its arrangements but adheres to its impression of plasticity. His drawings clearly presage the airy rococo technique.

La Fosse soon inspired a following, but he seems to have retained the initiative in this new development. The gradual dissolution of the academic rules admitted a greater variety in the means of artistic expression. The death of Colbert in 1683 marked the end of Le Brun's virtual dictatorship of the arts. Once Le Brun's rigid discipline could be questioned, it seems to have evoked lively opposition and a desire to experiment.

Jean Jouvenet (1644–1717), who worked under Le Brun, is an interesting example of this transition. At first his drawings are in the spirit of his master, showing the same technique and an effective, assured style. From this starting-point in the ideals of classicism his art then takes a more realistic turn. The early influence of Carracci gives way to Rubens as a source of inspiration. This is particularly evident in Jouvenet's drawings, which display a preference for black chalk, often on grey paper, with heightening in white to achieve a painterly effect. Working in a spare style, he creates figures that

express vigour and strength in compositions which radiate simplicity and seriousness.

François de Troy (1645–1730) belonged to the same generation. In his drawings there is likewise a tendency to greater realism and simplicity; he exploits the colouristic effects which a tinted ground provides.

Michel Corneille the younger (1642–1708) seems to make the most of the new opportunity to try out different techniques, and his style witnesses to the changing ideals of the period. His brother, Jean-Baptiste Corneille (1649–95), combines a rather watery pen with a generous wash in a manner that is reminiscent of contemporary Venetian drawings.

It is Antoine Coypel (1661–1722) who definitely establishes the transition to a new epoch. La Fosse taught him to work *aux trois crayons* – using black, red and white chalk on a tinted ground – and he developed this technique, looking, like other artists following the same trend, to the Venetians and to Rubens for inspiration. Both Titian and Veronese as well as the Antwerp master had practised drawing on a coloured ground (blue or pale brown), and it was this painterly tradition that Coypel continued.

He also looked for fresh subjects – such as mythological scenes with an erotic flavour – and the long era dominated by masculine ideals started to give way to a period when studies of the female nude became generally accepted. A lighter atmosphere accompanies this change. Black chalk is played down in the studies of women, whose beauty Coypel conjures up in light tones of red and white on light-brown paper.

In addition to nude studies, Coypel did a number of portrait studies of women that profess a gentler ideal of beauty than had prevailed hitherto. This was a new subject, which grew to be a dominant theme in French art during the following century.

The turn of the seventeenth century is often cited as a dividing-line in the history of art, but in reality it was a period of change. Louis XIV was over sixty, the work on Versailles had come to an end and court life was stifled by the bigoted Mme de Maintenon. The aristocracy withdrew, isolating the royal family. The magnificent ceremonial of *Le Roi Soleil* had the sole purpose of elevating the sovereign. An uncomfortable style, with little consideration for human needs and convenience, it had little appeal to persons outside the royal circle. Almost imperceptibly, this grandiose, ostentatious fashion shifted into something more gracious and pleasing. The tendency is most discernible in the decorative features of interior design. The principal hand behind the transformation was that of Claude Audran III (1658–1734), who took over in this field from Jean Bérain.

Audrun worked for the court, but it is significant that he also obtained commissions from financiers and wealthy connoisseurs, two groups that now grew in importance as patrons of the arts and accordingly as arbiters of taste.

The outstanding genius of French rococo is undoubtedly Antoine Watteau (1684–1721). His sense of loneliness is expressed in pictures of an enchanted life of music, love and poetry. In striving to escape from the compulsion of artistic rules he created new means of expression, which provided the starting-point for developments in the decades ahead.

Gersaint, Watteau's patron, wrote that he (Gersaint) 'definitely preferred Watteau's drawings to his paintings, an opinion which Watteau shared. He was more pleased with his drawings than his paintings and I can assure you that in this respect his love did not conceal any of his faults. He derived greater satisfaction from drawing than from painting. I often saw him mortified because his painting lacked the spirituality and truth of which he was capable with the crayons.'[1]

1 E. F. Gersaint, abrégé de la vie d'Antoine Watteau, in *Catalogue raisonné des divers curiosités du cabinet de feu M. Quentin de l'Orangère*, Paris 1744. Published by P. Champion, *Notes critiques sur les vies anciennes d'Antoine Watteau*, Paris 1921, p. 65.

Watteau was able to benefit from the progress which La Fosse and Coypel had made in drawing *aux trois crayons*. Having introduced this technique, they left it for a younger generation to bring it to perfection. In his youthful work, however, Watteau made do with red chalk and was soon a master of form, able to capture a line with the utmost certainty at the first attempt. Still more characteristic is the luminosity of his drawings. Having caught the main features of the model or subject with a few rapid strokes, he pauses to allow the brightness of the paper to do its work. The red crayon remained his favourite, and one marvels at the precision with which he ranges between heavy accents and hairline touches.

Watteau assembled his drawings in large bound volumes and then drew on this treasure when composing his paintings. He depicted two worlds: *fêtes galantes* (gatherings of young men and women in pleasant parks, with music, dancing and an amorous mood), and theatrical scenes, inspired by but hardly reproducing contemporary drama. Watteau drew unceasingly. His patron Julienne relates that even when Watteau was out walking he would jot down his impressions as soon as he took a rest.[1] Many of his drawings have been lost, but we still have about a thousand.

Valenciennes, in Flanders, Watteau's birthplace, had been ceded to France by the treaties of Nijmegen in 1678. It was therefore only natural that when Watteau moved to Paris *c.* 1702, he associated mainly with Flemish artists. After a year or so he joined Claude Gillot (1673–1722) as collaborator and pupil; it was probably Gillot who introduced him to the theatrical world which was to play such a prominent part in his art.

Early drawings by Watteau are not always easy to distinguish from work by Gillot, though the latter does make greater use of smooth, elegant curves and unbroken lines. Watteau has a quicker rhythm right from the start, barely suggesting hands and feet but suddenly introducing accents that articulate the picture and help us to read it.

In *c.* 1707 Watteau broke away from the life of the theatre, and left Gillot to work for the decorative painter Claude Audran III referred to above. Watteau was employed to paint the figures in Audran's mural compositions, but there are many indications that he also acquired a decorator's skills. He modified Audran's language of form in favour of lighter designs and airier surfaces. At the same time, Audran taught Watteau to discipline his work. Drawings from this period clearly show the latter's cautious attempts at precision and a delicate line. Even at this stage one also finds examples of Watteau's personal manner in the ornamental language, peculiarities that recur in decorative drawings from his more mature period *c.* 1715.

The careful manner that Watteau assumed under Audran was then gradually superseded. In the studies for *Les figures de modes* done from *c.* 1709 the resultant precision is combined with the formal imagination which he had acquired from Gillot. His pictures still have a certain flatness. The figures tend to stand out against a backdrop of lighter tones.

In *c.* 1713 Watteau started to work *aux trois crayons* – tentatively at first, augmenting the red chalk when rendering detail. Two years later he had mastered this complicated technique, using black as well as red for dramatic accents, modelling his forms with white, drawing with long, confident strokes and creating a dynamism which underscores the impression of catching his models on the move. In many of his drawings from this period his subjects are nude or lightly dressed figures, whose limbs are liberated from the trunk in uninhibited movement.

The drawings become increasingly bold. In some the contours are simply suggested with a few vigorous black strokes, and the modelling is indicated

1 J. de Julienne, abrégé de la vie d'Antoine Watteau, preface to *Figures de différents caractères*, Paris 1726. Published by P. Champion, op. cit., p. 52.

with some groups of hasty zig-zag lines. This is also the case when he exploits light and the paper itself as active elements in the composition.

Watteau now had the entire repertoire of forms and technical skills at his command. Quick sketches alternate with more finished studies. The latter in particular show how Watteau has matured, in the sense of becoming more and more economical with his means of expression. He also becomes more prone to repeat a subject in order to arrive at a solution or an interesting pose, perhaps enjoying variation for its own sake. It is chiefly these late drawings which witness to Watteau's highly personal, nervous and subtle use of the pen. At the same time they display the mature master's command of the medium and his ability to achieve effects with a minimum of means.

The visions are transferred to the paper with an unfailing touch. For although they feature in the paintings as elements of *fêtes galantes* and theatrical fictions, they are conceived as fragments of reality. The sheets accordingly represent the borderland between fantasy and reality, providing inspiration for the staging of dreams. Each drawing represents a metamorphosis. From reality Watteau distils just those substances which appeal to his sense and from which he can conjure up the realms of imagination.

57 Charles de La Fosse

PARIS 1636–PARIS 1716

PRESENTATION OF THE VIRGIN

Black, red and white chalk on grey paper.
Squared with red chalk
34.1 × 46.6
Lined
NM 2753/1863
Numbered at lower right in pen and brown
ink: *2641* (Sparre) and *14* (struck out)

The main features of this composition also
occur in a painting in the Musée des
Augustins in Toulouse, signed and dated
1682.[1] The drawing is in reverse but differs
so much from the painting, particularly in
the secondary figures, that it cannot be a
copy after an engraving.

PROVENANCE
Crozat (Mariette, no. 1052). C. G. Tessin (List
1739–42, p. 43 v.; Cat. 1749, livré 14, no. 20).
Kongl. Biblioteket (Cat. 1790, no. 2641). Kongl.
Museum (Lugt 1638).

BIBLIOGRAPHY
F. H. Dowley, 'Three drawings by Charles de La
Fosse', *Master Drawings*, 2, 1964, pp. 50 f., pl. 44
M. Stuffmann, 'Charles de La Fosse', *Gazette des
Beaux-Arts*, 6:64, 1964, p. 101, no. 20
Bjurström 1976, no. 441

[1] Originally painted for the church of the
Carmelites at Toulouse, destroyed during the
Revolution. Cf. Dowley, op. cit., p. 50, fig. 1 and
M. Stuffmann, op. cit., pp. 56 f.

58 Charles de La Fosse

ACIS AND GALATEA
Black, red and white chalk on grey paper.
Squared with red chalk
26.8 × 22
No watermark
NM 2750/1863 and 2751/1863 (verso)
Numbered at lower right in pen and brown
ink: 2639 (Sparre) and 59 (struck out)
Verso: Acis and Galatea. Black, red and
white chalk

This drawing and its verso are clearly
connected with a painting of the same
subject in the Prado,[1] engraved by Edmé
Jeaurat in 1722.[2] The groups of figures in the
recto version and the main features of the
landscape agree entirely with the painting.
The verso picture, in reverse, is closer to the
painting in the draping of the figures, but
the landscape is more diffuse. The drawings
show Polyphemus on the rock with his back
turned, playing, whereas in the painting he
has stopped playing and has discovered the
couple, so that Galatea is gesturing to Acis to
flee.

The painting corresponds to one that was
exhibited in the Salon of 1704, except that in
the latter Polyphemus is described as playing
on his flute.[3] This he is also doing in a
tapestry in the series *La Tenture des
Métamorphoses*, which Les Gobelins produced
between 1704 and 1718.[4]

The arched lower border suggests that the
drawing was associated with a decorative
commission.

PROVENANCE
Crozat (Mariette, no. 1052). C. G. Tessin (List
1739–42, p. 43 v.; Cat. 1749, livré 14, no. 18).
Kongl. Biblioteket (Cat. 1790, no. 1639). Kongl.
Museum (Lugt 1638).

BIBLIOGRAPHY
F. H. Dowley, 'Three drawings by Charles de La
Fosse', *Master Drawings*, 2, 1964, pp. 51 f., pl. 45
M. Stuffmann, 'Charles de La Fosse', *Gazette des
Beaux-Arts*, 6:64, 1964, p. 108, no. 53
Bjurström 1976, no. 440

[1] *Catálogo de los Cuadros*, Madrid 1949, no. 2251.
Repr. Dowley, op. cit., p. 51, fig. 2.

[2] Ch. Le Blanc, *Manuel de l'amateur d'estampes*, Paris
1854–89, 50.

[3] J. Guiffrey, *Collections des livrets des anciennes
expositions depuis 1673 jusqu'en 1800*, Paris 1869, 3,
p. 14.

[4] Repr. Dowley, op. cit., p. 52.

59 Jean Jouvenet
ROUEN 1644–PARIS 1717
THE HOLY FAMILY WITH ST
JOHN AND ST ELIZABETH
Black chalk, pen and brown ink, grey wash,
heightened with white
37.9 × 21.7
Watermark: Name (close to Heawood 3295:
Paris, seventeenth century (?))
NM 2766/1863
Numbered at lower right 9. Inscribed:
Jouvenet, and numbered 2653 (Sparre)

There is no known painting by Jouvenet with
this motif. The style, technique and to some
extent the content (putti with fruit baskets)
are very similar to those of the drawings for
the parliament in Rennes, and this sheet was
presumably made at much the same time.

PROVENANCE
Crozat (Mariette, no. 1058). C. G. Tessin (List
1739–42, p. 43 v.; Cat. 1749, livré 13, no. 191).
Kongl. Biblioteket (Cat. 1790, no. 2653). Kongl.
Museum (Lugt 1638).

BIBLIOGRAPHY
A. Schnapper, '"Les compositions" of Jean
Jouvenet', *Master Drawings*, 5, 1967, p. 139, pl. 5
Bjurström 1976, no. 396

EXHIBITION
Rouen, Musée des Beaux-Arts, *Jean Jouvenet 1644–
1717*, 1966, dessin no. 3

60 Jean Jouvenet
MAN ON A LADDER
Black chalk heightened with white on brown
paper
42.5 × 27.7
No watermark
NM 2760/1863
Inscribed at lower left in pen and brown ink:
M Jouvenet, numbered at lower right 2648
(Sparre) and 3

The Nationalmuseum has three sheets with
studies for a Descent from the Cross, which
Jouvenet painted in 1697 for the Capuchin
church in Place Louis-le-Grand, Paris.
 This drawing is a study for the man to the
left of Christ in the painting. At bottom
right are studies of the man's arms.

PROVENANCE
See no. 59.

BIBLIOGRAPHY
Schönbrunner and Meder, no. 1063
A. Schnapper, '"Les compositions" of Jean
Jouvenet', *Master Drawings*, 5, 1967, p. 135
Ch. Sells, review of exhibition at Paris, Claude
Aubry, *Burlington Magazine*, 114, 1972, p. 113
Bjurström 1976, no. 398

EXHIBITIONS
Rouen, Musée des Beaux-Arts, *Jean Jouvenet 1644–
1717*, 1966, dessin no. 13, repr.
Paris, Brussels, Amsterdam, *Dessins du
Nationalmuseum de Stockholm*, 1970–71, no. 43

61 François de Troy

TOULOUSE 1645–PARIS 1730
PORTRAIT OF JULES HARDOUIN
MANSART
Black chalk on grey paper, heightened with white
35.2 × 25.2
Lined
NM 2783/1863
Numbered at lower right on the mount in pen and brown ink: 90 (struck out) and 2670. (Sparre)

This is a draft for the portrait of Jules Hardouin Mansart in Versailles, engraved by Ch. Simonneau in 1710.[1] The portrait was painted for l'Académie Royale de Peinture in 1699, the year of Mansart's appointment as Surintendant des bâtiments.

PROVENANCE
C. G. Tessin (Cat. 1749, livré 18, no. 90). Kongl. Biblioteket (Cat. 1790, no. 2670). Kongl. Museum (Lugt 1638).

BIBLIOGRAPHY
J. Vallery-Radot, *Le dessin français au XVIIIe siècle*, Lausanne 1953, p. 206, pl. 133
Bjurström 1976. no. 702

EXHIBITIONS
Stockholm 1922, no. 3
Toulouse, Musée Paul-Dupuy, *Le Dessin toulousain de 1610 à 1730*, 1953, no. 59

[1] No. 3586. Ch. Le Blanc, *Manuel de l'amateur d'estampes*, Paris 1854–89, 19.

62 Michel Corneille the Younger

PARIS 1641–PARIS 1708
HEAD AND FIGURE STUDIES
Black, white and red chalk on blue paper
27.2 × 24.7
Laid down
NM THC 4018
Colour notes in black chalk at upper centre: *Les culot / de velour bleu / comme Le manteau / avec de'agrement / dor La veste de / velour Rouge avec / Les agrement dargent / Les Botine Rouge.* In the left margin: *Le blanc du turban / . . . blanc un peu Jaunatre / . . . toile de Caton / . . . sent de bonet de / . . . velour noir avec un / dargent de sens*

The drawing consists of three studies of the head of Christ in black chalk, red chalk and three chalks respectively; a full-length study of an oriental in black chalk, and the upper half of an oriental in more detail. The Louvre has a similar drawing[1] in three chalks, with inscriptions in the same handwriting.

PROVENANCE
N. Tessin jun. (Cat. 1730, p. 61, 72 *Desseins de divers Maitres*) (?). C. G. Tessin (cahier 63). Kongl. Biblioteket. Kongl. Museum (Lugt 1638).

BIBLIOGRAPHY
Bjurström 1976, no. 331

[1] J. Guiffrey and P. Marcel, *Inventaire général des dessins du Louvre et du Musée de Versailles, Ecole française*, Paris 1907–38, 3, no. 2680, ill.

63 Jean-Baptiste Corneille

PARIS 1649–PARIS 1695
JOHN THE BAPTIST PREACHING
IN THE DESERT
Pen and grey ink, brown wash
38.6 × 30.8
No watermark
NM 2839/1863
Numbered at lower right in pen and brown
ink: 2629. Inscribed verso in pen and brown
ink: *Corneille le Jeune*

This is a direct counterpart in execution and
format of the drawing of Christ and the
Canaanite Woman in the collection of Mr
and Mrs Germain Seligman, New York.
 Drawings by J. B. Corneille are extremely
rare and, like the one in New York, this is an
example of the artist's nervous, dramatic line
in a magnificent composition.
 E. Dubois, who is completing a thesis on
Corneille, dates this sheet late in the artist's
life – that is, to the first half of the 1690s.

PROVENANCE
N. Tessin jun. (Cat. 1730, p. 8). C. G. Tessin
(Cat. 1749, livré 14, no. 7). Kongl. Biblioteket
(Cat. 1790, no. 2629). Kongl. Museum (Lugt
1638).

BIBLIOGRAPHY
Bjurström 1976, no. 323

64 Antoine Coypel

PARIS 1661–PARIS 1722
THE BIRTH OF VENUS
Black and red chalk
25.9 × 41.5
Laid down
NM THC 4023

This fair-drawn draft was sent on 2/12
February 1700 to Nicodemus Tessin the
younger on the initiative of Daniel
Conström, who, while in Paris as an
ambassador, had particularly taken to
Coypel's art and did all he could to get Tessin
interested in it. In 1695 he had already tried
to persuade Tessin to commission a work
from Coypel on behalf of the Swedish king,
Karl XI, but nothing came of the plan until
both the king and his court painter,
Ehrenstrahl, were dead. When the matter
was raised again in 1699 and three subjects
were suggested – Sacrifice d'Andromaque,
Naissance de Venus and Reconnaisance de
Thesée – the young king, Karl XII, opted for
a draft for a Birth of Venus with a view to
confirming a commission. War intervened,
however, and the idea came to nothing. The
drawing, which should have been returned to
Coypel, remained in Sweden.
 In placing the sheet in its context in art
history, Reuterswärd notes that Coypel used
the background landscape in a Triumph of
Venus, known from an engraving by Ch.
Simmoneau.

PROVENANCE
D. Cronström. N. Tessin jun. C. G. Tessin.
Kongl. Biblioteket. Kongl. Museum (Lugt 1638).

BIBLIOGRAPHY
R. A. Hernmarck and C. Weigert, ed., *Les
relations artistiques entre la France et la Suède 1639–
1718. Extraits d'une Correspondance entre Nicodème
Tessin le jeune et Daniel Cronström*, Stockholm 1964,
pp. 242, 243, 245, 248, 253, 263, 268, 270,
273, 275
P. Reuterswärd, 'Venus' födelse. Kring en
teckning av Antoine Coypel med en märklig
svensk anknytning', *Konsthistorisk tidskrift*, 40,
1971, pp. 107–25
Bjurström 1976, no. 338

A. Coipel.

65 Antoine Coypel
YOUNG WOMAN LOOKING OVER
HER SHOULDER
Black, red and white chalk, pink pastel, on
brown paper
35 × 26.8
Laid down
NM 2851/1863
Inscribed at lower right *A Coipel* (Tessin)

This drawing is part of a series of studies of
the same woman in four different positions.
The quality of the paper is the same
throughout and the drawings were most
probably done on one and the same occasion.

PROVENANCE
Crozat (Mariette, no. 1059). C. G. Tessin (List
1739–42, p. 39 r.; Cat. 1749, livré 17, no. 275).
Kongl. Biblioteket (Cat. 1790, no. 2746). Kongl.
Museum (Lugt 1638).

BIBLIOGRAPHY
Bjurström 1976, no. 344

66 Antoine Watteau
VALENCIENNES 1684–NOGENT SUR
MARNE 1721
STANDING OFFICER FACING LEFT
Red chalk
11.5 × 7.5
No watermark
NM 2821d/1863

This is a preparatory drawing for the etching,
done by Watteau himself and 'terminé au
burin par Thomassin fils', for *Figures de modes*,
executed *c.* 1709–10.[1]

PROVENANCE
C. G. Tessin (List 1739–42, p. 43 v.; Cat. 1749,
livré 14, no. 36). Kongl. Biblioteket (Cat. 1790,
no. 2707d). Kongl. Museum (Lugt 1638).

BIBLIOGRAPHY
G. Engwall, 'Catalogue descriptif des dessins de
Watteau du Musée National de Stockholm',
Gazette des Beaux-Arts, 6:13, 1935, 1, pp. 336–
44, no. 8
K. T. Parker and J. Mathey, *Antoine Watteau,
Catalogue complet de son œuvre dessiné*, Paris 1957, 1,
no. 167
Bjurström 1982, no. 1293

EXHIBITIONS
Stockholm, 1922, no. 18
Paris 1935, no. 81
Paris, Brussels, Amsterdam 1970–71, no. 50
Watteau, Paris, Grand Palais, 23 October 1984–
20 January 1985, no. 8

[1] E. Dacier and A. Vuaflart, *Jean de Jullienne et les
graveurs de Watteau au XVIIIe siècle*, Paris 1921–9,
3 and 4, no. 46.

67 Antoine Watteau
MONKEY PLAYING DRUMS
Red chalk, pencil; left half partly
counterproof
34.2 × 50.1
No watermark
NM CC II: 161

The drawing is closely related to a sketch for
a wall painting at Marly for which Watteau's
master, Claude Audran III, was paid in
1709.[1] Audran's own version of the same
composition also belongs to the
Nationalmuseum.[2]

It was the different styles of the two sheets
that prompted Parker and Mathey to regard
the present drawing as Watteau's work, since
he was assisting Audran at the time. The
attribution has been rejected by Margaret
Morgan Grasselli on the grounds that
Audran would hardly have entrusted the
planning of this royal project to an assistant,
that the drawing is dry in its style of
execution, and that, in fact, it lacks every
characteristic that would warrant such an
identification.[3]

These arguments are not convincing. As

the style is evidently not Audran's, the hand
must surely be that of some assistant, and the
reason for suggesting Watteau is primarily
the correspondence in the decorative details
with arabesques in Watteau's graphic work –
a characteristic combination of spiralling
vegetation and rhombic moulding. The
decorative nature of the project calls for a
certain precision – and therefore dryness – in
the representation. It is, moreover, difficult
to think of an alternative hand for the deft
rendering of the monkey.

PROVENANCE
Claude Audran III. C. J. Cronstedt and
descendants. E. Langenskiöld. Gift to the museum
in 1941.

BIBLIOGRAPHY
C. Nordenfalk, 'Kärlekslektionen av Watteau',
*Antoine Watteau och andra franska
sjuttonhundratalsmästare i Nationalmuseum*,
Stockholm 1953, pp. 123–7, fig. 42
K. T. Parker and J. Mathey, *Antoine Watteau,
Catalogue complet de son œuvre dessiné*, Paris 1957, 1,
no. 187
Bjurström 1982, no. 1253

[1] 'A Claude Audran . . ., pour un tableau
représentant un berceau où des singes sont à table,

posé à Marly en 1709', *Comptes des bâtiments*, éd. J.-
J. Guiffrey, 5, col. 340.

[2] CC IV: 133. This drawing was inspired by an
engraving after Jean Bérain I (Paris, Bibliothèque
Nationale, Ed. 65, fol. p. 88).

[3] *Watteau 1684–1721*, exhibition catalogue,
Washington, Paris, Berlin, 1984–5, French
version, p. 56.

68 Antoine Watteau
WOMAN IN PROFILE, FACING RIGHT, HER RIGHT HAND HOLDING UP HER SKIRT

Black, red and white chalk on brownish paper
26 × 14.8
Watermark: Grapes in double circle (cf. Heawood 2427–2432)
NM 21/1897
Numbered in black chalk at upper right: *420* (?, struck out). Inscribed at lower right in pen and pale brown ink: *Watteau*

Engwall has identified this drawing as a study for the lost painting *L'Amour paisible*.[1] The figure also occurs in a variant with the same title in the Neues Palais, Potsdam. The sheet seems to date from *c.* 1715.

PROVENANCE
Unidentified collector's mark (relief-printing). Ahlstrand.

BIBLIOGRAPHY
G. Engwall, 'Catalogue descriptif des dessins de Watteau du Musée National de Stockholm', *Gazette des Beaux-Arts*, 6:13, 1935, 1, pp. 336–44, no. 28
K. T. Parker and J. Mathey, *Antoine Watteau, Catalogue complet de son œuvre dessiné*, Paris 1957, 2, no. 559
Bjurström 1982, no. 1302

EXHIBITIONS
Stockholm 1922, no. 16
Stockholm 1933, no. 67
London, Arts Council, *French drawings from Fouquet to Gauguin*, 1952, no. 171
Stockholm 1958, no. 223

[1] H. Adhémar, *Watteau, sa vie, son œuvre*, Paris 1950, no. 126.

69 Antoine Watteau
FOUR STUDIES OF A YOUNG
WOMAN'S HEAD
Black, white and red chalk on brownish-grey
paper
34 × 24.5
No watermark
NM 2836/1863

Engwall considered that Watteau made this
drawing *c.* 1718–19, during his last stay
with his friend the picture-dealer Pierre
Sirois (1665–1726), and that it portrays
Sirois' daughter Marie-Louise Sirois (1696/7–
1725), wife of Edmé-François Gersaint
(1694–1750) in various poses. He further
indicated that one of the heads was used for
Sous un habit de Mezzetin, in the Wallace
Collection.[1]

Parker and Mathey, however, do not
accept these identifications and compare the
sheet with two drawings in which the same
woman is likewise depicted in four poses.[2] In
their view all three sheets depict the same
model, in whom they see a strong likeness
with the woman behind the counter in
L'Enseigne de Gersaint.

PROVENANCE
Crozat (Mariette, no. 1063: 'Ce sont les Desseins
que ce Peintre légua en mourant à M. Crozat, en
reconnoissance de tous les bons offices qu'il en
avoit reçût.'). C. G. Tessin (list 1739–42,
p. 38 v.; Cat. 1749, livré 17, no. 164). Kongl.
Biblioteket (Cat. 1790, no. 2722). Kongl.
Museum (Lugt 1638).

BIBLIOGRAPHY
Schönbrunner and Meder, no. 1110 (as Lancret)
E. Dacier and A. Vuaflart, *Jean de Jullienne et les
graveurs de Watteau au XVIIIe siècle*, Paris, 1921–9,
I (*Notices et documents biographiques* by J. Hérold and
A. Vuaflart), p. 9
K. T. Parker, *The Drawings of Antoine Watteau*,
London 1931, p. 22
G. Engwall, 'Catalogue descriptif des dessins de
Watteau du Musée National de Stockholm',
Gazette des Beaux-Arts, 6:13, 1935, I, pp. 336–
44, no. 29
K. T. Parker and J. Mathey, *Antoine Watteau,
Catalogue complet de son œuvre dessiné*, Paris 1957, 2,
no. 787
Bjurström 1982, no. 1308

EXHIBITIONS
Stockholm 1922, no. 17
Stockholm 1933, no. 66
Paris 1935, no. 82
Copenhagen, Charlottenborg, *L'Art français au
XVIIIe siècle*, 1935, no. 543
Paris 1947, no. 380
London, Arts Council, *French Drawings from
Fouquet to Gauguin*, 1952, no. 173
Stockholm 1958, no. 227
New York, Boston, Chicago 1969, no. 98
Paris 1984–5, no. 125

[1] Dacier and Vuaflart, op. cit., 3, no. 131.
[2] Parker and Mathey 1957, nos 783 (P. Bordeaux-
Groult, Paris) and 788 (British Museum).

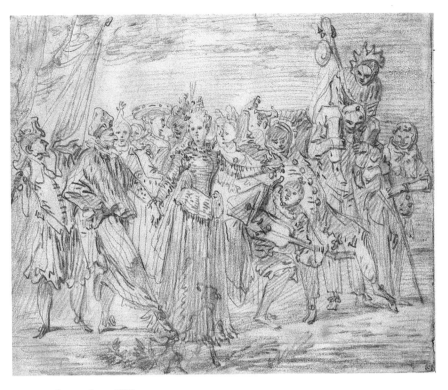

70 Antoine Watteau
TROUPE OF TRAVELLING
COMEDIANS
Red chalk
18.6 × 22.5
No watermark
NM Z 27/1958

This sheet, which probably comes from
Tessin's collection, had a traditional
attribution to Gillot, who did indeed study
the world of comedians. But it was also
through Gillot that Watteau became
acquainted with such subjects.

In establishing Watteau's early *oeuvre*,
Parker and Mathey ascribed to him many
sheets which previously carried Gillot's
name. In many instances, of which this is
one, it is considered that the drawings were
done in Gillot's workshop and under his eye.
The drawing was attributed to Gillot in
Tessin's collection and recently attributed to
Quillard by Margaret Morgan Grasselli.

PROVENANCE
C. G. Tessin (?). Kongl. Museum (Lugt 1638).

BIBLIOGRAPHY
K. T. Parker and J. Mathey, *Antoine Watteau,
Catalogue complet de son œuvre dessiné*, Paris 1957, 1,
no. 120
M. Eidelberg, Watteau and Gillot: A point of
contact, *Burlington Magazine*, 115, 1973, p. 236
Bjurström 1982, no. 1283

EXHIBITIONS
Leningrad 1963
Paris, Brussels, Amsterdam 1970–71, no. 49

71 Antoine Watteau

TWO STUDIES OF A YOUNG
WOMAN
Black, white and red chalk
26 × 20.5
Laid down
NM 280/1980
Inscribed at lower right

The two studies, of a model who has been
identified as Watteau's servant, are done
from life and involve commonplace
occupations. René Huyghe suggests that on
the left the woman is shown hanging
washing; on the right, dressing.

The drawings belong to the category of
studies of models which Watteau assembled
in his sketchbooks and later drew on for his
compositions.

The figure on the left occurs in *La Leçon
d'amour*, Nationalmuseum, Stockholm,
which Nordenfalk dates to *c.* 1716, thereby
providing a *terminus ante quem*. In that
painting the woman is picking roses in the
background; the gesture is the same, but its
implications are different.

The theme of the right-hand study, on the
other hand, is alien to Watteau's paintings
and has more in common with the few extant
nude studies by him. Caylus gives two
reasons for their rarity, one being that
Watteau seldom worked in this way and the
other that, shortly before his death, Watteau
destroyed a number of sheets which he
considered excessively free.[1]

PROVENANCE
Villenave (Lugt 2598; sale, 1842, no. 611).
Watson (Lugt 2599)? James (sale, 1891, no. 307).
Josse (sale, 1894, no. 473). Crosnier (sale, 1905,
no. 47). Dormeuil (Lugt 1146 a; sale, 13 June
1978, no. 9). A. Stein.

BIBLIOGRAPHY
Société de reproduction, 3e année, no. 29
K. T. Parker, *The drawings of Antoine Watteau*,
London 1931, no. 58
R. Huyghe, 'L'univers de Watteau', in H.
Adhémar, *Watteau, sa vie – son œuvre*, Paris 1950,
p. 31
K. T. Parker and J. Mathey, *Antoine Watteau,
Catalogue complet de son œuvre dessiné*, Paris 1957, 2,
no. 632
C. Nordenfalk, 'The Stockholm Watteaus and
their secret', *Nationalmuseum Bulletin*, 3, 1979: 3,
p. 111
Bjurström 1982, no. 1503

EXHIBITIONS
London, Royal Academy, *Exhibition of French Art*,
1932, no. 727
Copenhagen, Charlottenborg, *L'art français du
XVIIIe siècle*, 1935, no. 547
Paris, Galerie Cailleux, *Les dessins français de
Watteau à Prudhon*, 1950, no. 154
Washington, Fort Worth, San Francisco 1985/6,
no. 58

[1] Parker 1931, p. 22.

RÉGENCE AND ROCOCO

Louis XIV died on 1 September 1715 and was succeeded by his five-year-old great-grandson, with Philippe, Duke of Orléans, as regent. Of greater significance was Cardinal Fleury, who had wielded great political power during the last years of Louis XIV's reign. He was tutor to the young Louis XV and his chief minister 1726–43. The new reign started prosperously, not least for artists and artisans. The monolithic art of the *Le Roi Soleil* gave way to greater variety. Louis XV himself preferred a less pompous style, the aristocracy left Versailles and built magnificent residences in Paris, and there was also patronage to be had among wealthy members of the bourgeoisie.

The wider circle of patrons implied a greater demand for art and decorative objects. New categories also joined the field in the form of collectors who were connoisseurs, and financiers who invested in art. The art trade flourished, for transactions as well as advice. Huge auctions of new work were arranged to secure the co-operation of persons of wealth in the production of art.

These tendencies had already been apparent in the early years of the century. Watteau had found most of his customers among the collectors and amateurs who were now beginning to supersede the court as arbiters of taste.

The works of Watteau, not least his drawings, were highly congenial to contemporary ideals. In 1726, only five years after his death, engravings of his principal drawings were published as *Figures de différents caractères*, followed eight years later by *Recueil Julienne*, comprising engravings of his paintings. By that time the paintings themselves had all been sold at very high prices to collectors, not only in France but in Germany, England, Russia and elsewhere.

As one might expect, Watteau's success attracted imitators of both the drawings and the paintings. The publication of the drawings as a commercial venture is one indication of the interest they had already aroused among amateurs. The most successful follower of Watteau was Nicolas Lancret (1690–1743), who tried to imitate his master in everything. Besides working *aux trois crayons* on tinted paper, Lancret adopted Watteau's practice of combining several studies on a single sheet, generally choosing the master's most attractive subject: portraits of young women.

Lancret also acquired the expressive use of chalk for placing telling accents around the nostrils or the mouth, but in his hands the technique becomes more schematic. His portraits also lack psychological depth – they are more reminiscent of fashion plates.

A stranger in this context, but worth mentioning, is Jean Dumont (le Romain) (1701–81), a history painter who profited from Watteau's technical achievements, modifying them for the representation of a considerably more realistic world. He, too, uses a single sheet for a series of studies – for instance of children's heads – showing a range of expressions, from curiosity and contemplation to fatigue and shyness.

Jean Baptiste Oudry (1686–1755) belonged to a different circle of artists. He was the pupil of a portrait painter, Nicolas de Largillière, who inspired

him to study Flemish art. Studies from life are therefore a natural ingredient in work by Oudry. A series of animal studies also displays his virtuosity in catching characteristic movements and expressions of animals, alluding to their hair or fur, and so on. Of course, Oudry was also influenced by the tradition of descriptive illustration for scientific publications. His drawings, however, are composed artistically and serve as studies for the large hunting scenes that were his speciality.

The drawings have a tangibility and realism that would be hard to achieve without a study of anatomy. This links Oudry to the academic tradition, which is also evident in the balance between contours and the shading that brings out the plastic form.

Oudry produced designs for the Beauvais tapestry factory – pastoral compositions drawn in black and white chalk on blue paper. There is a lighter, more playful atmosphere about these drawings, with their expressive line and hatched accents jotted in. In book illustrations, such as those for the *Metamorphoses* of Ovid and the *Fables* of La Fontaine, Oudry's skill in drawing animals is combined with his talent for composition.

Pictures of battles underwent their own separate development in the seventeenth century. Many of the artists who practised this genre took part in the military campaigns of the period and accordingly moved from country to country, which gave rise to an international style in this particular field. It is often difficult to distinguish the personal contributions of the various artists, not least in the case of drawings. Charles Parrocel (1688–1752) was taught by his father, Joseph, who had been a pupil of Jacques Bourguignon (1621–76), an artist who had accompanied the Spanish armies in Italy and depicted the reality of war in lively scenes which have the atmosphere of reportage. At one remove, Charles Parrocel inherited this convention, with its stock of images of rearing horses, stricken soldiers and fighting warriors. At the same time he drew in the contemporary manner, mostly in red chalk, of which he had a good command. There is therefore a discrepancy in his work between form and content – between the reality of a battlefield and the elegant manner in which it is drawn.

The great depicter of everyday life was Jean-Baptiste-Siméon Chardin (1699–1779), in contrast to the world of dreams created by Watteau. Chardin turned commonplace scenes and simple objects into a lasting record of a homely existence. He could convey a modest, tranquil mood in compositions of an almost abstract beauty that owes much to his sparing use of effects. Some simple geometric forms summarized a few figures in a room. His manner of painting was described by Diderot as 'stabbing' daubs of solid colour side by side, producing an impasted surface that reflected the light – not like a mirror, but rather as a plastered wall.

The compositions of Chardin continued a French tradition whose chief representatives in the previous century had been Georges de la Tour and Louis le Nain, neither of whom left any drawings that are known today. The same is virtually true of Chardin, in that the only four sheets attributable to him for certain are most probably works of his early youth. They are large drawings with large figures, cartoons for paintings rather than studies. Three of them are scenes with figures on a scale that could well be much the same as that of the finished work. Chardin applies the chalk with broad, vigorous strokes, taking pains to establish the positions of the figures, place them firmly on the ground and give their movements their full force. The large scale of the drawings is as remarkable as the small scale of Chardin's paintings. Chardin drew in the contemporary technique – black and/or red chalk, heightened with white on brownish-grey paper. The composition is set out clearly and

Jean-Baptiste Oudry, *Jupiter changed into a Bull, c.* 1732 from *Métamorphoses d'Ovide* (Nationalmuseum, Stockholm)

distinctly, with no hesitation. Although the method appears to be ideal, it seems that Chardin abandoned it. According to Mariette, 'Lacking sufficient thoroughness in his drawing and an ability to make his studies and his sketches on paper, Chardin is obliged to have the object he is painting continuously in sight.'[1]

It is likely that Chardin abandoned drawing as an independent medium; instead, he probably worked out compositions in his head and then painted from a drawing – similar to the examples in Stockholm – done directly on the canvas. In order to achieve his aim of creating a balanced whole, Chardin was also obliged to work with the effect of colour continually in mind. The dearth of drawings by Chardin is also indicated by the fact that when Carl Gustaf Tessin tried to obtain some sheets from him in 1739–40, what he received were remnants of work done almost twenty years earlier, rather than fresh examples of the mature master's output.

In his vigorous drawing style, Chardin had no direct successor, but there is an affinity with his manner in some of the work by Jérôme-François Chantreau (c. 1710–57). Of only slight importance as a painter, Chantreau is of interest as a draughtsman, concentrating – like Chardin – on everyday themes and apparently documenting ordinary life in order to incorporate his impressions in his compositions. Thus he worked in much the same way as Watteau, but his drawings are sketches from life rather than from posed models.

Like his predecessors, Chantreau drew with three chalks on pale brown paper, but his chalk was considerably looser and he also used a stump or fingers to soften the line and make patches of shading and accents more diffuse. He was also less doctrinaire, allowing two or three colours to intermingle. The line, though heavy and slightly hesitant, suddenly explodes into accents and a shower of strokes. The figures are sometimes out of proportion. As drawn by Chantreau, however, peasants and soldiers invariably express a mood, serious and dignified. When the studies are composed into scenes, they are supplemented with a sense of atmosphere that heralds romanticism.

François Le Moyne (1688–1737), only four years younger than Watteau, marks the transition to a new style and a new epoch. Late in his career, after Watteau's death, Le Moyne went to Italy, where he was fascinated by Pietro da Cortona and the Venetian masters of the baroque. Returning with his head full of classical mythology, he depicted contemporary beauties dressed – or rather undressed – as goddesses of love, and adapted the ponderous system of baroque composition to the airy language of rococo. He accordingly represents the continuation of the academic tradition, and there are numerous nude studies which he used systematically for large decorative commissions. He was an exceptionally versatile draughtsman, using chalk and wash with equal skill. The nervous impatience that characterizes his hand, combined with an elegant air, does tend to rob his drawings of personality.

Charles-Joseph Natoire (1700–77), one of Le Moyne's pupils, became the fiercest rival of another pupil, François Boucher. Their development followed much the same lines, both as regards choice of subjects and drawing techniques; figure studies *aux trois crayons* alternate with wash sketches of compositions. Figures by Natoire are, however, slightly heavier than those by Boucher and his compositions are more complex. Moreover, in 1751 Natoire moved to Rome as director of the French Academy there, a post he held for twenty-three years before retiring to Castel Gandolfo. Natoire was therefore supremely significant for the succeeding generations of French artists, all of whom encountered him sooner or later in Rome.

François Boucher (1703–70) dominated French art in the mid-eighteenth

1 J. P. Mariette, *Abécédario* (1749), ed. Ph. de Chennevières and A. de Montaiglon, Paris 1851–3, I, p. 360.

century in drawing as well as in painting. His output was remarkable for its volume and versatility as well as for its quality. His claim to have executed about ten thousand drawings is probably an exaggeration, but even the surviving number is very large. In his heyday he had many assistants, including members of his family (his wife, his son Juste-Nathan and his two sons-in-law, Deshayes and Baudoin), many pupils (Huet, Charlier, Pierre and Saint Quentin), not to mention Mme de Pompadour, his pupil and friend. When considering Boucher as an artist one must therefore bear in mind that his reputation has suffered from being associated with a motley group of studio products, copies, imitations and direct forgeries.

After a brief period as a pupil of Le Moyne Boucher started to earn a living under François Cars, an engraver, devoting several years mainly to the production of engravings for *Figures de différents caractères*, the title under which drawings by Watteau were published from 1726 onwards. In this way Boucher became acquainted with more than one hundred drawings by Watteau and he developed a remarkable ability to arrive at congenial interpretations of them. It was only natural that Watteau's spontaneous, expressive style greatly influenced Boucher's manner in his earliest drawings.

In 1734, when Boucher obtained a commission to illustrate a sumptuous edition of Molière, Watteau served as a prototype, though Boucher did bring the costumes up to date and most of his compositions stem from the unassuming illustrations in the 1682 edition. Watteau's expressive manner can be discerned when Boucher represents Molière's protagonists, particularly the women, with lightly drawn contours, spirited shading and some chalk accents, well aware that the spontaneity of such a style could be caught in an engraving. The man who did so, in a masterly fashion, was Laurent Cars, son of Boucher's former employer.

Before that, however, Boucher had been in Italy from 1727 to 1731 and was influenced by what he saw there to a greater extent than is often realized. On the way to Rome he stayed in Genoa, Bologna and Ferrara, presumably taking every opportunity to become acquainted with Italian art, though Corregio and Tiepolo no doubt interested him more than the Renaissance masters.

A specialist in *fêtes galantes* and pastorals, Boucher also produced many mythological pictures, some of which are also charmingly indelicate, as well as religious and history paintings, landscapes and so on. He prepared all this work in numerous drawings that really belong to a purely academic tradition. Some very early sketches of this type do have traces of the nervous energy he learnt from Watteau, but his manner settles down after the return from Rome. Boucher evidently worked from live models, employing the traditional method of drawing what he saw, balancing the volumes in a figure, distributing light and shade and suggesting an abstract background. The use of hatching, crossed in the darkest segments, and the method of achieving a plastic effect with shading that repeats the nearest contour, are applications, with some modifications, of a very strong tradition.

Boucher also observed the academic tradition in his direction of drawing lessons with male models at the Royal Academy of Painting and Sculpture, as assistant professor from 1735 and full professor from two years later. Dry, detailed studies to guide the pupils gave way to the freer nude studies, likewise from models, that he used later in many of his compositions.

However, it is women, not men, who dominate pictures by Boucher and one can say that he created his own female type. Studies of nude models were also the starting-point here, but this subject did not have the academic status of the male nude. The studies were confined to Boucher's private studio, frequently with his wife as the model.

At the Academy, male models were drawn in principle from life, with the great classical prototypes as a modifying influence. Boucher also seems to have modified his impressions, adapting studies of women to ideals which did not come from antiquity. His female figures are slender, long-legged and sufficiently plump to conceal the muscles associated with male nudes. This way of drawing female models is common to Boucher and Rubens, but otherwise there is no resemblance between them. The anaemic type favoured by Boucher stands for values that he initiated.

There is a consistent line in Boucher's development as a draughtsman. He used the means at his command with increasing virtuosity for larger pictures and finished compositions, in which he turned the colour effects of the three chalks and tinted paper to good account.

The charm of drawings by Boucher generated a demand for them outside the limited circle of connoisseurs and collectors. Boucher was in fact the first to exhibit drawings at the Salon, in 1745. In this way he introduced drawings as a decorative element for intimate surroundings. The drawn *oeuvre* of Boucher also includes sketches in which he tackles compositional problems, often with some hesitation. These sheets largely have to do with subjects he was unaccustomed to handling – scenes from history or religious compositions. The execution is often spontaneous and bold as Boucher tries out different ideas and underscores the main elements with heavy accents. In particular, the drawings of religious subjects are quite numerous; many of them were greatly influenced by Italian masters from earlier centuries. Only a few of these compositions were turned into paintings.

Boucher continued to draw from early youth until 1767, three years before he died. In that year he completed a set of illustrations for the *Metamorphoses* of Ovid. This theme had engaged him earlier, and he still commanded the necessary technique, but his hand was now becoming shaky and his creative imagination was failing. He had been appointed First Painter to Louis XV in 1765 but was being increasingly criticized as the representative of out-dated ideals.

Another artist of Boucher's generation, besides Charles-Joseph Natoire, was Carle van Loo (1705–65), who, after ten years in Italy, became the foremost representative of the academic tradition. As director of the Academy he had an important influence on the coming generation, adapting traditional academic studies to contemporary ideals, which favoured naturalism at the expense of classicism.

Many artists made a name for themselves as illustrators. Charles-Nicolas Cochin (1715–90) obtained the largest and most prestigious commissions, while Hubert Gravelot (1699–1773) was one of the most active in this group. Cochin in particular made preparatory drawings whose spontaneity and freedom single him out as one of the more interesting draughtsmen of his day.

Edmé Bouchardon (1698–1762) was a sculptor who spent ten years in Rome (1723–33). He obtained a number of public commissions – the Neptune fountain at Versailles, the Fontaine de Grenelle in Paris and an equestrian statue of Louis XV – but his fame rests chiefly on his drawings. While in Rome he had systematically drawn the classical and baroque sculptures in red chalk and acquired an astonishing deftness in catching their essence. He used the academic technique of long, uniform contours enclosing the various forms, and of shading achieved with groups of long, almost mechanically diagonal strokes. In studies of enclosed sculpture that had to be viewed from below, he had a remarkable ability to shift the perspective in his mind's eye. The low sight-line is almost eliminated and one is given the impression that he stood on practically the same level as the work.

The assured, sweeping calligraphy contributes to the representation of the subject in big, reposeful forms. The method is also effective in the red-chalk studies of models – drawings of immense importance for academic instruction in the following decades.

Bouchardon was a contemporary of Boucher and Chardin but represented very different ideals. His art was rational rather than passionate and it upheld the 'simplicity and nobility of classical taste' as Cochin expressed it.[1] This departure from the French tradition tallied with the views of the Comte de Caylus, an archaeologist and man of letters, but its origin lay in Bouchardon's personality. The drawings represent a very important preparatory forum for the encounter between a receptive phase – the thousands of studies, chiefly after sculptures from earlier generations – and the creative process, evidenced in the hundreds of sheets for his own work on, for instance, the equestrian statue of Louis XV. This laborious process yielded a sort of perfection that helped to make Bouchardon so highly appreciated by his contemporaries both as a sculptor and as a draughtsman. At his death, according to Mariette, the sheets were sold for prices that equalled their weight in gold.[2]

Whereas the reputation of his contemporaries waned as they grew older, Bouchardon became increasingly renowned. Having been ahead of the times, at the beginning of the 1760s his cool, yielding style was seen as the start of a new epoch, looking forwards to the ideals of neoclassicism.

1 *Mémoires inédits de Nicolas Cochin*, Paris 1880, pp. 83–119.
2 J. P. Mariette *Abécédario* (1749), ed. Ph. de Chennevières and A. de Montaiglon, Paris 1851–3, 1, p. 360.

72 Nicolas Lancret

PARIS 1690–PARIS 1743

FOUR STUDIES OF A YOUNG
WOMAN

Black, white and red chalk on brownish
paper
22.3 × 22
Watermark: Fleur de lis and letters
NM 2837/1863
Inscribed at lower centre in pen and brown
ink: *Lancret fecit*. Numbered at lower right:
2722 changed to 2723

As Tessin lists four sheets by Lancret in the
catalogue which was compiled *c.* 1730, his
first acquisitions of drawings by this artist
were presumably made during his stay in
Paris in 1728. The inventory from *c.* 1749
lists five Lancret sheets, divided into two
lots. The two sheets in one of these lots (nos
1003 and 1004) have been identified for
certain, but for the three in the other lot
(Cat. 1749, livré 18, nos 95–97) there are no
direct equivalents in the Lancret sheets which
can be traced back to 1790. To arrive at such
an identification one has to accept that 'deux'
was written instead of 'six' in the case of no.
95, that no. 96 is described inaccurately and
that no. 97 has been cut into three (2841–
2843). Considering Tessin's general
precision, such errors are hardly credible.

There is no evidence that Tessin enlarged
his Lancret collection while in Paris 1739–
42. Still, it seems most likely that the
Lancret drawings which have Kongl.
Biblioteket in their provenance did all come
from Tessin. The studies on this sheet have
been used by Lancret in a number of
paintings: the head lower right in *l'Enfance*
(National Gallery, London)[1] and in *La Danse
entre les deux fontaines* (Dresden)[2] the head
lower left in *Jeu de Collin-Maillard*
(Stockholm)[3] in *Jeu de Quilles* (Berlin)[4] and in
Le Repas au village (Angers)[5] and both the
upper heads in *Jeu de Colin-Maillard*, the left
one also in *La Ronde*,[6] the right in *Le Repas au
village*.

PROVENANCE
C. G. Tessin (?). Kongl. Biblioteket (Cat. 1790,
no. 2723). Kongl. Museum (Lugt 1638).

BIBLIOGRAPHY
Schönbrunner and Meder, no. 1004
Bjurström 1982, no. 1001

EXHIBITIONS
Stockholm 1922, no. 35
Paris 1935, no. 62
Paris, Palais national des arts, *Chefs d'oeuvre de l'art
français*, 1937, no. 554

[1] G. Wildenstein, *Lancret*, Paris 1924, no. 19.

[2] Ibid., no. 143.

[3] Ibid., no. 229.

[4] Ibid., no. 254.

[5] Ibid., no. 515.

[6] Ibid., no. 238.

73 Nicolas Lancret

YOUNG WOMAN SEATED
HOLDING A MUSICAL SCORE
Red chalk on brownish paper
18.6 × 18.2
Upper corners cut
Watermark: Coat of arms, three stars over
lion
NM 16/1897

PROVENANCE
Ahlstrand

BIBLIOGRAPHY
Bjurström 1982, no. 1011

EXHIBITION
Stockholm 1958, no. 230

74 Jean Dumont (le Romain)

PARIS 1701–PARIS 1781

SIX HEADS, FOUR OF YOUNG WOMEN, TWO OF A CHILD

Red chalk, heightened with white, on grey paper

42.5 × 26

Laid down

NM 2970/1863

Signed at lower right in red chalk: *duMont le R*. Numbered in pen and brown ink on the old mount at lower right: *1863*.

This sheet is possibly preliminary work for a girl on the right in *St François de Paule accueilli par Louis XI au Plessis-lès-Tours 1730*, Château de Plessis-lès-Tours.[1]

PROVENANCE

C. G. Tessin (List 1739–42, p. 67 v.; Cat. 1749, livré 18, no. 100). Kongl. Biblioteket (Cat. 1790, no. 2863). Kongl. Museum (Lugt 1638).

BIBLIOGRAPHY

Bjurström 1982, no. 940

[1] B. Lossky, 'Oeuvres anciennement connues ou nouvellement retrouvées de Jacques Dumont le romain aux musées de Tours', *Gazette des Beaux-Arts*, 6:64, 1964, pp. 225–36, fig. 2.

75 Jean-Baptiste Oudry

PARIS 1686–BEAUVAIS 1755
WOLF CAUGHT IN A TRAP
Black and white chalk on blue-green paper
30.6 × 44.8
Laid down
NM 8/1866

This and four more drawings in the Nationalmuseum belong to a series of fourteen animal drawings in Tessin's possession. Eleven of the drawings were engraved by Rehn and Le Bas while Tessin was in Paris as Sweden's ambassador and Rehn was learning to engrave there under Le Bas. Tessin took nine of the drawings that were engraved and three others back with him to Stockholm. It is not known when he transferred them to Queen Lovisa Ulrica but in the inventory of her estate they are listed among the drawings as nos 78–89.

The Nationalmuseum's quintet was most probably included in the Nils Barck sale, notwithstanding some discrepant details: slight differences in the technique, the absence of a signature and Barck's collector's mark, and the addition of an attribution to Riedinger. A likely explanation is that the sheets were cut and given an attribution which might enhance their value.[1]

The two sheets that were engraved, but which Tessin does not seem to have brought back to Sweden, depict a boar and a badger (Rehn, nos 5 or 8 and 6). Four of the others which Rehn engraved have not been traced,[2] and another, of a tiger (Rehn, no. 12, as a 'leopard'), appeared at an auction in 1959.[3] The remaining two in the original series, depicting a cow and two sheep, have not been heard of since the Thibaudeau sale.[4]

PROVENANCE
C. G. Tessin (List 1739–41, no. 8 among framed objects). Lovisa Ulrica of Sweden (Inventory 1782, no. 82). Fredric Adolph and Sophia Albertina. Count Gustaf Harald Stenbock. Count Magnus Stenbock. Count Nils Barck (sale, 1852?). Count A.-N. Thibaudeau (sale, 20–25 April 1857, no. 673). G. A. Schuknecht.

BIBLIOGRAPHY
P. Lespinasse, 'L'Art français en Suède de 1686 à 1816', *Bulletin de la société de l'histoire de l'art français*, 1911, p. 324
J. Locquin, 'Catalogue raisonné de l'œuvre de Jean-Baptiste Oudry, peintre du roi', *Archives de l'art français*, n.p. 6, Paris 1912, pp. 1–209, nos 816, 828, 836
O. Antonsson, 'Fem återfunna skisser av Oudry', *Nationalmusei årsbok*, 11, 1929, pp. 81–8
H. N. Opperman, 'Some animal drawings by Jean-Baptiste Oudry', *Master drawings*, 4, 1966, pp. 392–409, 405, note 37, no. 4

H. N. Opperman, *Jean-Baptiste Oudry*, New York/London 1977, 2, p. 781, no. D. 736
Bjurström 1982, no. 1083

[1] Cf. H. N. Opperman, op. cit., 2, pp. 778 f.
[2] Rehn, nos 9 (*Chien courant*), 11 (*Mulet*), 7 (*Loup-cervier*) and 8 or 5 (*Sanglier*).
[3] Paris, Galérie Charpentier, 16 March 1959, no. 140.
[4] Tessin's list of 1739–42, nos 1 and 4, inventory of Lovisa Ulrica, nos 85 and 86, Locquin, op. cit., 809/823 and 812–813/825.

76 Pierre-Jean Mariette

PARIS 1694–PARIS 1775
VIEW FROM A PARK
Pen and brown ink, brown wash
25.5 × 38.2
Laid down
NM 273/1968
Numbered at lower right in pen and brown
ink: *128*

We know of very few drawings by Mariette,
whose reputation is that of a connoisseur and
collector. The auction of his estate included
only four drawings done from nature[1] and
eight copied after landscapes by Guerchin.[2]
One sheet from the former group, the same
size as the present drawing, is now in the
Institut Néerlandais, Paris.[3] It is inscribed as
having been done in 1724 'Dans les Jardins
de. M. Crozat a Montmorenci', and one is
tempted to give the present sheet the same
date and location. Mariette frequently called
on Pierre Crozat (1665–1740), the great
collector, and was, moreover, in charge of
the auction after Crozat's death.

 The present sheet has the characteristic
Mariette mount, though the space reserved
for the artist's name is occupied by an oval
stamp with D and an inverted B.

PROVENANCE
Pierre Crozat. P. J. Mariette (Lugt 1852 and
characteristic Mariette mount). Unknown
collector, 'DB'. H. M. Calmann.

BIBLIOGRAPHY
Bjurström 1982, no. 1063

[1] F. Basan, auction catalogue, Paris 1775, p. 195,
no. 1284.

[2] Ibid., no. 153.

[3] F. Lugt, *Le dessin français dans les collections
hollandaises*, Paris (Institut Néerlandais) and
Amsterdam (Rijksmuseum) 1964, no. 76, pl. 57.

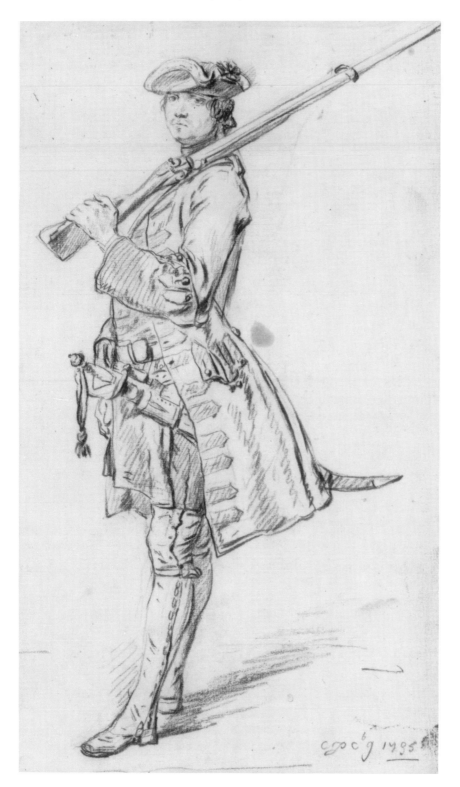

77 Charles Parrocel

PARIS 1688–PARIS 1752
SOLDIER WITH A GUN ON HIS
SHOULDER
Red chalk
41.8 × 23.5
Watermark: Letters (illegible) ix
NM THC 5054
Signed in red chalk at lower right: *c p cb g
1735*

PROVENANCE
C. Hårleman (Lugt 2751). Kongl. Biblioteket.
Kongl. Museum (Lugt 1638).

BIBLIOGRAPHY
Bjurström 1982, no. 1102

78 Jean-Baptiste-Siméon Chardin

PARIS 1699 – PARIS 1779
LA VINAIGRETTE (THE SEDAN
CHAIR)
Black chalk, heightened with white, on
brownish grey paper
26.3 × 38.3
Grey stains at upper left
No watermark
NM 2960/1863
Inscribed at lower right in pen and brown
ink: *Chardin* (Tessin). Numbered *2854*
(Sparre), *108* (Tessin)
Verso: Fragment of nude male figure. Black
and white chalk

This drawing can be connected with
Chardin's first known work, a sign for a
surgeon, which is known only from an
engraved illustration in the study of Chardin
by the Goncourt brothers. Supposedly
executed in the 1720s and traceable to the
collection of the engraver Le Bas, the sign
was acquired by a nephew of Chardin after
the death of Le Bas in 1783; it then
disappeared. Jules de Goncourt etched the
illustration for *L'Art au dix-huitième siècle*,
Paris, 1880–82, after a sketch of the sign
once in the Hôtel de Ville but destroyed by
fire in 1871. The *vinaigrette* is on the far right
in the reversed engraving by Goncourt. This
modification of the sedan chair – fitted with a
pair of wheels so that it could be pulled by
one man instead of being carried by two –
derived its name from the similar vehicle
used by itinerant vinegar sellers.

Pierre Rosenberg finds further support for
the attribution in the fragmentary study of a
model on the reverse.[1] He argues that the
technique is very close to the recto drawing,
besides being related to the model studies by
Pierre-Jacques Cazes, who was Chardin's first
teacher.[2] This drawing would then be the
only direct evidence of Cazes' influence on
Chardin.

PROVENANCE

C. G. Tessin (List 1739–42, p. 69 v.; Cat. 1749, livré 14, no. 106). Kongl. Biblioteket (Cat. 1790, no. 2854). Kongl. Museum (Lugt 1638).

BIBLIOGRAPHY

Emilia F.-S. Dilke, 'Chardin et ses oeuvres à Potsdam et à Stockholm', Gazette des Beaux-Arts, 3:22, 1899, p. 390
Schönbrunner and Meder, no. 914
J. Guiffrey, Catalogue de l'Oeuvre de Chardin, Paris 1908, no. 247
H. Furst, Chardin, London 1911, p. 137, pl. 42
A. Gauffin, Konstverk och människor, Stockholm 1915, p. 146
O. Benesch, 'Rembrandts Vermächtnis', Belvedere, August 1924, p. 167
J. Mathey, 'Jeaurat, Cochin, Durameau et les dessins de Chardin', Bulletin de la société de l'histoire de l'art français, 1933, pp. 82 ff.
J. Robiquet, 'Notice sur les "brouettes", "roulettes", ou "vinaigrettes"' Nationalmusei årsbok, n.s. 8, 1938, pp. 130 ff.
E. Goldschmidt, J. B. S. Chardin, Stockholm 1945, pp. 62 ff.
E. Goldschmidt, J. B. S. Chardin, Copenhagen, 1947, pl. 15
P. Lavallée, Le Dessin français, Paris 1948, p. 73
D. Sutton, French drawings of the XVIIIth century, London 1949, pl. 49
F. Boucher and P. Jaccottet, Le Dessin français au XVIIIe siècle, Lausanne 1952, no. 44

J. Mathey, 'Les dessins de Chardin', Albertina-Studien, 1 and 2, 1964, pp. 17 ff.
F. Valcanover, Jean Siméon Chardin ('Maestri del colore', 124) Milan 1966, fig. 3.
A. Ananoff, 'Chardin', Connaissance des arts, 153 (February 1967), p. 61
T. Pignatti, Longhi, Venice 1968, p. 53, fig. 10
P. Bjurström, letter to the editors, Master drawings, 7:1, 1969, pp. 58–61
J. Wilhelm, '"La partie de billard" est-elle une œuvre de jeunesse de Chardin?', Bulletin du Musée Carnavalet, 22, 1969, p. 10
O. Benesch, Collected writings, 1, Rembrandt, New York 1970, pp. 74 f.
Bjurström 1982, no. 907

EXHIBITIONS

Stockholm 1922, no. 42
London, Royal Academy, French Art 1200–1900, 1932, no. 764
Stockholm 1933, no. 73
Paris 1935, no. 56
Copenhagen, L'Art français au XVIIIe siècle, 1935, no. 333
Paris, Palais National des Arts, Chefs-d'oeuvre de l'art français, 1937, no. 520
Paris, Musée de l'Orangerie, Le Dessin français de Fouquet à Cézanne, 1950, no. 77 bis
Vienna, Albertina, Meisterwerke aus Frankreichs Museen, 1950, no. 97
London, Arts Council, French Drawings from Fouquet to Gauguin, 1952, no. 18

Munich, Residenz, Europäisches Rokoko, 1958, no. 263
Leningrad 1963
New York, Boston, Chicago 1969, no. 103
Paris, Grand Palais, Chardin 1699–1779, 1979, no. 1

[1] P. Rosenberg, catalogue of exhibition, Paris, Grand Palais, Chardin 1699–1779, p. 103.

[2] Five sheets in the collection of the Ecole des Beaux Arts, Paris.

79 Jérôme-François Chantereau

c. 1710–PARIS 1757

DEAD HARE HANGING BY THE
HIND LEGS

Black, white and red chalk on brown paper
29.4 × 20.5
No watermark
NM 2812/1863
Numbered in pen and brown ink in the right
margin: *2698.* (Sparre), at lower right: *80.*
Inscribed at lower right: *Chantreau* (Tessin)

Of the thirty or so known drawings by this
artist, almost one third are in the
Nationalmuseum. Little is known about
Chantereau, but his manner of drawing
seems to be influenced by Chardin and
Watteau. His subjects are taken mostly from
the life of peasants and soldiers.

PROVENANCE
C. G. Tessin (List 1739–42, p. 68 r; Cat. 1749,
livré 20, no. 84, mistakenly as Chardin). Kongl.
Biblioteket (Cat. 1790, no. 2698). Kongl.
Museum (Lugt 1638).

BIBLIOGRAPHY
R. Rey, *Quelques satellites de Watteau*, Paris 1931,
p. 178
P. Bjurström, 'F.-J. Chantereau, dessinateur',
Revue de l'art, 14, 1971, pp. 80–85, no. 16, fig. 15
Bjurström 1982, no. 904

EXHIBITIONS
Stockholm 1922, no. 47
Stockholm 1933, no. 75
Paris 1935, no. 55

80 Jérôme-François Chantereau

HUNTERS RESTING

Black chalk, pastel, wash
24 × 37.8
Laid down
NM 2814/1863
Inscribed at lower right in pen and brown
ink: *Chantreau* (Tessin). Numbered 2700.
(Sparre) and *83* (struck out)

PROVENANCE
C. G. Tessin (List 1739–42, p. 68 r). Kongl.
Biblioteket (Cat. 1790, no. 2700). Kongl.
Museum (Lugt 1638).

BIBLIOGRAPHY
Schönbrunner and Meder, no. 1020
R. Rey, *Quelques satellites de Watteau*, Paris 1931,
p. 178
P. Bjurström, 'F.-J. Chantereau, dessinateur',
Revue de l'art, 14, 1971, pp. 80–85, no. 18, fig.
17
Bjurström 1982, no. 905

EXHIBITIONS
London, Royal Academy, *France in the 18th century*,
1968, no. 124
Paris, Brussels, Amsterdam 1970–71, no. 65

81 François Le Moyne

PARIS 1688–PARIS 1737
VIEW OF VENICE, WITH THE
TOWER OF I CARMINI IN THE
BACKGROUND
Red chalk
19.6 × 20.7
Watermark: Letters J N
NM 92/1966
Inscribed at lower left in pen and brown ink:
le Moyne

Le Moyne came to Italy late in his career
(1723) and stayed chiefly in Venice, whose
art he greatly admired. The present sheet

obviously dates from this visit.

Landscape drawings by Le Moyne are rare;
there is one in the collection of Queen's
University in Kingston, another in a private
collection, Los Angeles.[1]

PROVENANCE
Martin Carlsson

BIBLIOGRAPHY
Bjurström 1982, no. 1053

[1] The latter was exhibited in Northridge
(California), *A collection without walls*, October
1967, no. 28. These drawings are both inscribed
Le Moyne in the same hand as the present sheet.

82 François Le Moyne
SOLOMON'S SACRIFICE TO
ASHTORETH (ASTARTE)
Black chalk, heightened with white, on blue
paper
26 × 33.5
Laid down
NM 2732/1863
Numbered on the old mount at lower right in
pen and brown ink: 2622 and 53 (struck out)

This scene, presaging the downfall of
Solomon, is mentioned in Kings 1:11 as an
example of how Solomon's heart was turned
by his seven hundred wives and three
hundred concubines. Ashtoreth (Astarte) was
the Phoenician goddess of love, the
equivalent of the Greek Aphrodite.

PROVENANCE
C. G. Tessin (List 1739–42, p. 44; Cat. 1749,
livré 14, no. 53). Kongl. Biblioteket (Cat. 1790,
no. 2622). Kongl. Museum (Lugt 1638).

BIBLIOGRAPHY
Ch. Saunier, François Lemoine, in L. Dimier, *Les
peintres français du XVIIIe siècle*, I, Paris/Brussels
1928, p. 89, no. 10, pl. 18
Bjurström 1982, no. 1051

EXHIBITION
Paris, Brussels, Amsterdam 1970–1971, no. 54

83 Charles-Joseph Natoire

NÎMES 1700–CASTEL GANDOLFO 1977
PROFILE OF YOUNG LADY IN
LOW-CUT BODICE
Red chalk, heightened with white, on
brownish grey paper
20.3 × 13.3
Laid down
NM 2923/1863
Inscribed at lower right in pen and brown
ink: *Natoire*. Numbered *2816*. (Sparre)

This is possibly a preliminary study for
Cleopatra in the draft for *The Banquet of
Anthony and Cleopatra* (*c.* 1753) in the Musée
d'art et d'industrie, Saint-Etienne.[1]

PROVENANCE
Kongl. Biblioteket (Cat. 1790, no. 2816). Kongl.
Museum (Lugt 1638).

BIBLIOGRAPHY
F. Boyer, 'Catalogue raisonné de l'œuvre de
Charles Natoire', *Archives de l'art français, nouvelle
période*, 21, 1946–9, no. 466
Bjurström 1982, no. 1072

EXHIBITION
Stockholm 1922, no. 52

[1] *Charles-Joseph Natoire*, catalogue of exhibition,
Troyes, Nîmes, Rome 1977, p. 71, no. 25.

84 Charles-Joseph Natoire

DULCINEA SEATED
Red chalk, heightened with white, on
brownish grey paper
33.7 × 23.3
Laid down
NM 2921/1863
Signed at lower left in red chalk: *c. natoire*.
Numbered on the old mount at lower left:
2814 (Sparre)

This is a preliminary study for the figure of
Dulcinea in one of thirteen tapestries
depicting the story of Don Quixote. A
peasant girl riding a mule is brought by
Sancho Panza to the Don, who readily
accepts her as his beloved Dulcinea.

The composition appears in one of thirteen
cartoons which Natoire did in 1735. Nine
have been preserved in the Château de
Compiègne and there is a fragment in the
Louvre.

The thirteen compositions were woven at
Beauvais 1736–44 and nine are extant in
Archevêché d'Aix-en-Provence (they do not
tally exactly with the nine extant cartoons).

The cartoons and tapestries had been
ordered by a Parisian financier, Pierre
Grimond du Fort.[1] As the tapestry in which
the figure features seems to have been woven

c. 1736–7, the drawing should be somewhat
earlier than this.[2]

PROVENANCE
C. G. Tessin (Cat. 1749, livré 14, no. 82). Kongl.
Biblioteket (Cat. 1790, no. 2814). Kongl.
Museum (Lugt 1638).

BIBLIOGRAPHY
F. Boyer, 'Catalogue raisonné de l'œuvre de
Charles Natoire', *Archives de l'art français, nouvelle
période*, 21 (1946–9), no. 528
O. Picard Sébastiani, *Don Quichotte vu par un peintre
du XVIIIe siècle: Natoire*, catalogue of exhibition,
Compiègne, Aix-en-Provence 1977, p. 32
Bjurström 1982, no. 1070

EXHIBITIONS
Stockholm 1922, no. 51
Pau, *Exposition don Quichotte*, 1955, no. 28
London, Royal Academy, *France in the 18th century*,
1968, no. 488
Paris, Brussels, Amsterdam 1970–71, no. 57

[1] P. Rosenberg and A. Schnapper, *Bibliothèque
municipale de Rouen, Choix de dessins anciens*,
catalogue of exhibition, Rouen 1970, nos 32–33.
[2] Picard Sébastiani, op. cit., pp. 15–16.

85 François Boucher

PARIS 1703–Paris 1770
VENUS INTOXICATING CUPID
WITH NECTAR
Black chalk, heightened with white, on blue
paper
19.3 × 40.1
Laid down
NM 2947/1863
Inscribed in pen and brown ink at lower left:
pour l'Hôtel Mazarin, and at lower right:
Boucher (Tessin). Numbered at lower right:
2841 (Sparre)

This drawing was engraved by Dupont as
Venus enivrant l'Amour. There is also an
engraving entitled *L'Amour s'ennyvrant de
nectar*, published by and probably the work of
F. Basan. A study of Venus in this position is
also known.[1]

The drawing is one in a series which also
contains three similar sheets in the
Nationalmuseum. The composition and the
format suggest that they are sketches for
tympanum paintings. They are all inscribed
pour l'Hôtel Mazarin, which might refer to
the building that was also known as Hôtel de
Brienne and lay where the Ecole des Beaux-
Arts now stands on the Quai Malaquais.

The present sheets have not been linked
with any paintings, nor are any documents
known which indicate that the compositions
were ever painted.

PROVENANCE
C. G. Tessin (List 1739–42, p. 44 v.; Cat. 1749,
livré 14, no. 100). Kongl. Biblioteket (Cat. 1790,
no. 2841). Kongl. Museum (Lugt 1638).

BIBLIOGRAPHY
R. Hoppe, *François Boucher*, Malmö 1930, p. 10,
no. 3
A. Ananoff, *L'oeuvre dessiné de François Boucher*,
Paris 1966, 1, no. 794, fig. 126
A. Ananoff, *François Boucher, peintures*, Lausanne/
Paris 1976, 1, pp. 287, 367
Bjurström 1982, no. 850

EXHIBITIONS
Stockholm 1922, no. 73
Paris 1935, no. 40

[1] Red chalk. 30.5 × 42.2 cm. Sold at Christie's 8
July 1975, no. 82, pl. 23. A counterproof is in the
David Daniels coll., New York.

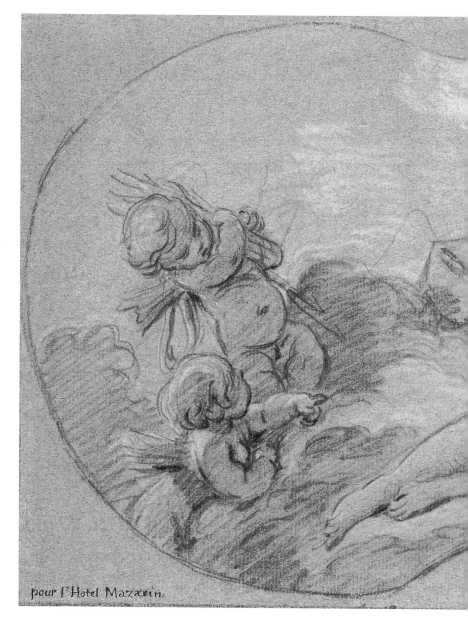

pour l'Hôtel Mazarin

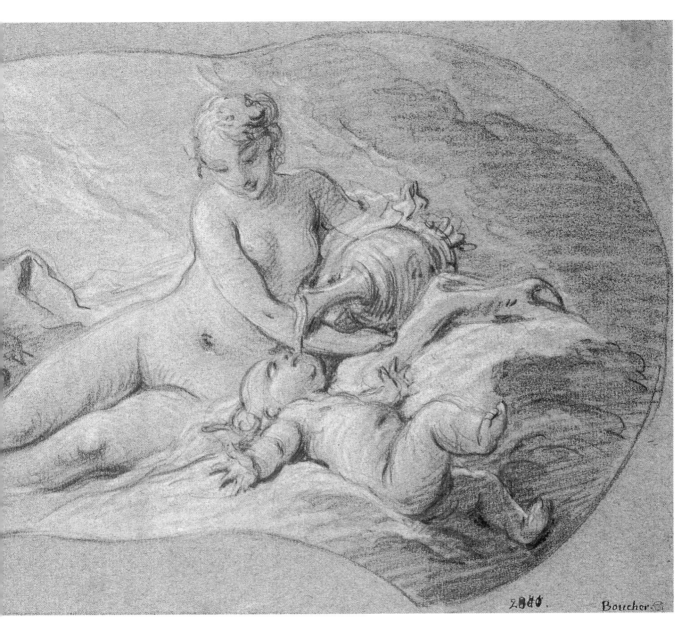

français: De Fouquet à Cézanne, 1949–50, no. 71
London, Royal Academy, *European masters of the eighteenth century*, 1954–5, no. 422
Stockholm 1958, no. 239
London, Royal Academy, *France in the 18th century*, 1968, no. 83

[1] *Le Mariage forcé*, Cabinet des estampes, Bibliothèque nationale; *Prologue de Psyché*, Musée Fabre, Montpellier. Both are in pen and ink and wash.

[2] The whole set of 33 drawings (in black chalk) are in the Coll. de J. Rothschild, départment des manuscrits, Bibliothèque Nationale, Paris.

87 François Boucher
MALE NUDE STUDY
Black chalk, heightened with white on blue paper
33.4 × 26
Laid down
NM Anck. 65

Boucher developed a great capacity for the rendering of nude figures. In his figure studies his affinity with Rubens is too close to be explained merely in terms of influence. Ananoff links this drawing with *La Chasse au crocodile*, where a hunter in a similar stance is thrusting a staff between the crocodile's jaws.

This comparison is not convincing, however, as the man in the present study is clearly holding a piece of cloth in both hands. In this detail and in his attitude, the figure displays a great similarity, though not complete agreement, with Boucher's Chiron, the skilful centaur, in *Allégorie sur l'éducation de Louis XV* (1752).[1]

PROVENANCE
M. G. Anckarsvärd. A. Michelson. K. Michelson. Acquired by the museum in 1896.

BIBLIOGRAPHY
R. Hoppe, *François Boucher*, Malmö 1930, p. 16, no. 31 (repr. p. 9)
A. Ananoff, *François Boucher, peintures*, Lausanne/Paris 1976, 1, p. 251, as no. 126/3
Bjurström 1982, no. 856.

EXHIBITION
Washington, Fort Worth, San Francisco 1985–6, no. 45

[1] Ananoff 1976, 2, pp. 91 ff., no. 391.

86 François Boucher
NICOLE IN 'LE BOURGEOIS GENTILHOMME'
Red chalk on brownish paper
27.5 × 21.8
Laid down
NM 4/1897
At lower left fragments of signature in black chalk: *f b*[oucher]

The works of Molière were published in 1734 in a magnificent edition with illustrations by Boucher, most of them engraved by Laurent Cars. In choosing his scenes Boucher often relied on an earlier edition (1682), but he worked on the compositions so thoroughly that the link is often difficult to discern.

Two compositional sketches are extant,[1] but the great majority of preliminary studies are red-chalk drawings like this one, probably after models for the individual figures.

A third stage in the work is represented by the final drafts for the engraver. These were probably done by P. Q. Chedel to Boucher's instructions.[2]

PROVENANCE
F. Renaud (Lugt 1042). Unidentified collector (Lugt 1499). Ahlstrand.

BIBLIOGRAPHY
R. Hoppe, *François Boucher*, Malmö 1930, p. 13, no. 15
P. Bjurström, 'Les illustrations de Boucher pour Molière, Idea and Form', *Figura*, n.s. 1 (1959), p. 152
Bjurström 1982, no. 841

EXHIBITIONS
Stockholm 1922, no. 62
London, Royal Academy, *French art 1200–1900*, 1932, no. 755
Paris, Palais national des arts, *Chefs-d'oeuvre de l'art français*, 1937, no. 512
Brussels, Palais des Beaux-Arts, Rotterdam, Museum Boymans, Paris, Orangerie, *Le dessin*

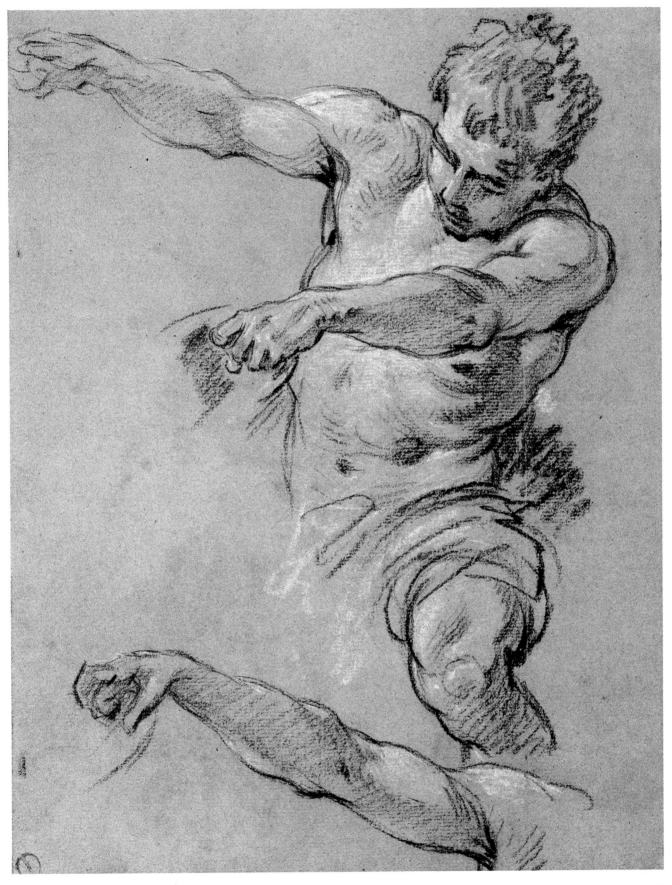

88 François Boucher
STUDY OF A ROOSTER
Black, red and white chalk on brownish-grey
paper
17 × 20
Laid down
NM 2953/1863
Numbered on the old mount at lower right
in pen and brown ink: *2847* (Sparre)

This rooster occurs in the foreground of the
two paintings, *Noé entrant dans l'arche* and
Femmes à la fontaine.

PROVENANCE
C. G. Tessin (List 1739–42, p. 69 v.; Cat. 1749,
livré 20, no. 77). Kongl. Biblioteket (Cat. 1790,
no. 2847). Kongl. Museum (Lugt 1638).

BIBLIOGRAPHY
R. Hoppe, *François Boucher*, Malmö 1930, p. 16,
no. 33
A. Ananoff, *François Boucher, peintures*, Lausanne/
Paris 1976, 1, pp. 169, 183 f.
Bjurström 1982, no. 824

EXHIBITIONS
Stockholm 1922, no. 78
London, Royal Academy, *France in the 18th century*,
1968, no. 76
Paris, Brussels, Amsterdam 1970–71, no. 63

89 François Boucher
YOUNG PEASANT GIRL
Red chalk, heightened with white, on
brownish-grey paper
35.3 × 22.4
No watermark
NM 2927/1863
Signed at lower right in red chalk: *f. boucher*.
Numbered in pen and brown ink on the old
mount: *2820* (Sparre)

This is a figure study for *Le retour du marché* or
Le marchand de légumes, dated by Ananoff
from 1732.[1] The figure is reversed in relation
to the painting. The composition recurs in an
engraving by Cochin the younger entitled
Triomphe de Pomone.

PROVENANCE
C. G. Tessin (Cat. 1749, livré 14, no. 91). Kongl.
Biblioteket (Cat. 1790, no. 2820). Kongl.
Museum (Lugt 1638).

BIBLIOGRAPHY
R. Hoppe, *François Boucher*, Malmö 1930, p. 15,
no. 23
A. Ananoff, *L'œuvre dessiné de François Boucher*,
Paris 1966, 1, no. 131, fig. 27
A. Ananoff, *François Boucher, peintures*, Lausanne/
Paris 1976, 1, pp. 214, 216
Bjurström 1982, no. 836

EXHIBITIONS
Stockholm 1922, no. 65
London, Royal Academy, *France in the 18th century*,
1968, no. 78
Paris, Brussels, Amsterdam 1970–71, no. 58

90 Marie-Jeanne Boucher

PARIS 1716–PARIS *c.* 1785
PAN AND SYRINX
Pen and black ink, watercolour, heightened
with white, over pencil
25.7 × 31
Laid down
NM 2931/1863
Inscribed in pen and brown ink at lower
right on the old mount: *Boucher* (Tessin).
Numbered *106* (struck out) and *2824*.
(Sparre)

Mme Boucher was not only Boucher's
favourite model; she was also his devoted
pupil. The traditional attribution of this
drawing to François Boucher cannot be
maintained and the similarity in pen-work to
a drawing in the Nationalmuseum,[1]
inscribed by Tessin *Madame Boucher d'après*,

followed by the signature of Boucher,
suggests the hand of Mme Boucher. There is
the same linework in the figures, just as
another drawing by Marie-Jeanne Boucher, a
pastoral, has the same characteristic way of
drawing foliage and clouds. Nor is there any
reason to suppose that the colouring is by
another hand.

It may seem incomprehensible that
Tessin, who apparently acquired this sheet
from Boucher himself, should have accepted
them as work by the master and even written
Boucher's name on them. It is probable that
he was in fact aware of the true state of
affairs, indicated by the note on the drawing
mentioned above. For that note concerns a
sheet which Boucher himself had signed, so
that an explanation may have seemed
necessary.

PROVENANCE
C. G. Tessin (List 1739–42, p. 44 v.; Cat. 1749,
livré 14, no. 105). Kongl. Biblioteket (Cat. 1790,
no. 2824). Kongl. Museum (Lugt 1638).

BIBLIOGRAPHY
R. Hoppe, *François Boucher*, Malmö 1930, p. 11,
no. 7 (as François Boucher)
A. Ananoff, *L'Œuvre dessiné de François Boucher*,
Paris 1966, no. 726, 1, fig. 121 (as François
Boucher)
Bjurström 1982, no. 871

EXHIBITIONS
Stockholm 1922, no. 70
Paris 1935, no. 42

[1] Bjurström 1982, no. 869.

91 Charles-André (Carle) Van Loo

NICE 1705–PARIS 1765
MALE NUDE STANDING WITH A
WRITING TABLET
Red chalk
41 × 29.2
Laid down
NM 2913/1863
Signed at lower left in pen and brown ink:
Carle Vanloo. Numbered at lower right: 2807
(Sparre) and 76 (struck out)

The drawing was engraved as the title page of
*Six figures / académiques / Dessinées et Gravées /
Par / Carle Vanloo / Peintre ord^{re} du Roy / et
Professeur en / son Académie Royale / de Peint^{re} et
Sculpture / A.P.D.R. / A Paris chez Beauvais
rue / S^t Jacques à l'Image S^t Nicolas.* [1]

PROVENANCE
C. G. Tessin (List 1739–42, p. 42 r.; Cat. 1749,
livré 19, no. 76). Kongl. Biblioteket (Cat. 1790,
no. 2807). Kongl. Museum (Lugt 1638).

BIBLIOGRAPHY
M.-Ch. Sahut, *Carle Vanloo, premier peintre du roi*,
catalogue of exhibition, Nice, Musée Chéret,
Clermont-Ferrand, Musée Bargoin, Nancy, Musée
des Beaux-Arts 1977, no. 567
Bjurström 1982, no. 1231

[1] Sahut, op. cit., no. 626.

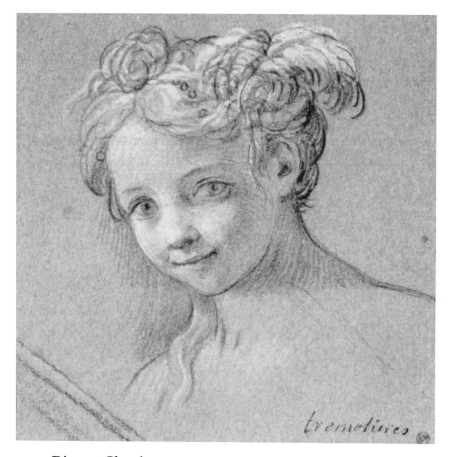

92 Pierre-Charles Trémolières

CHOLET 1703–PARIS 1739
HEAD OF A GIRL, LA COMÉDIE
Black, red and white chalk on blue paper
13.5 × 13.4
Laid down
NM 2888/1863
Signed at lower right: *tremolieres*.
This is a preparatory study for a painting in
the Cholet museum. A companion piece,
Tragedy, in the same museum, is dated 1736.
The Salon of 1738 included a painting by the
artist entitled *Comedy*.[1] A preliminary version
of the painting is in the Metropolitan
Museum, New York.

PROVENANCE
C. G. Tessin (List 1739–42, p. 67 v.; Cat. 1749,
livré 18, no. 105). Kongl. Biblioteket (Cat. 1790,
no. 2783). Kongl. Museum (Lugt 1638).

BIBLIOGRAPHY
A. Ananoff, 'Les cent "petits-maîtres" qu'il faut
connaître', *Connaissance des arts*, July 1964, p. 59
Bjurström 1982, no. 1217

EXHIBITION
Cholet, Musée, *Pierre-Charles Trémolières*, 1973,
p.164, no. 25

[1] Cf. catalogue in the Cholet museum, pp. 67 f.,
nos 13, 14.

93 Charles-Nicolas Cochin the Younger

PARIS 1715–PARIS 1790
STUDY OF A MAN IN SIMPLE
ATTIRE
Pencil
17.9 × 11.2
Watermark: Name, DUPUY (close to
Heawood 3303: Paris 1744)
NM 117/1970

This is a quick preparatory study for a figure
in almost a dancing attitude – possibly a
detail in *La Charbonnière*, which was one of a
series of six fashion pictures done in 1737.[1]

This item comes from a volume that was
broken up and sold at Sotheby's in 1970.
The Louvre has another volume with partly
the same provenance, containing fifty studies
for *Histoire Métallique de Louis XV*.[2]

PROVENANCE
L. D. Seguin. Comte Bezborodko (Lugt 1629). J.
P. v. Suchtelen (Lugt 2332). Eugène von
Wassermann (sale, Brussels 1921, lot 954).
Acquired at London, Sotheby's, sale 9 April 1970,
lot 117.

BIBLIOGRAPHY
Bjurström 1982, no. 913

[1] C. A. Jombert, *Catalogue de l'Œuvre de Charles
Nicolas Cochin fils*, Paris 1770, no. 36.

[2] Inv. nos RF 5472–5524. Cf. R. Bacou, *Il
settecento francese* (I disegni dei maestri', 13), Milan
1970, p. 93, fig. 31.

94 Charles Nicolas Cochin the Younger
STUDY FOR A PORTRAIT OF A WOMAN
Black chalk
12.3 × 9.8
No watermark
NM 118/1970

PROVENANCE
L. D. Seguin. Comte Bezborodko (Lugt 1629). J. P. v. Suchtelen (Lugt 2332). Eugène von Wassermann (sale, Brussels, 1921, lot 954). Acquired at London, Sotheby's, 9 April 1970, lot 129

BIBLIOGRAPHY
Bjurström 1982, no. 914

95 Edmé Bouchardon
CHAUMON EN BASSIGNY 1698–PARIS 1762
BULL'S HEAD
Red chalk
60.7 × 45.4
Watermark: Grapes
Konstfackskolan (NM) 506

BIBLIOGRAPHY
Bjurström 1982, no. 806B

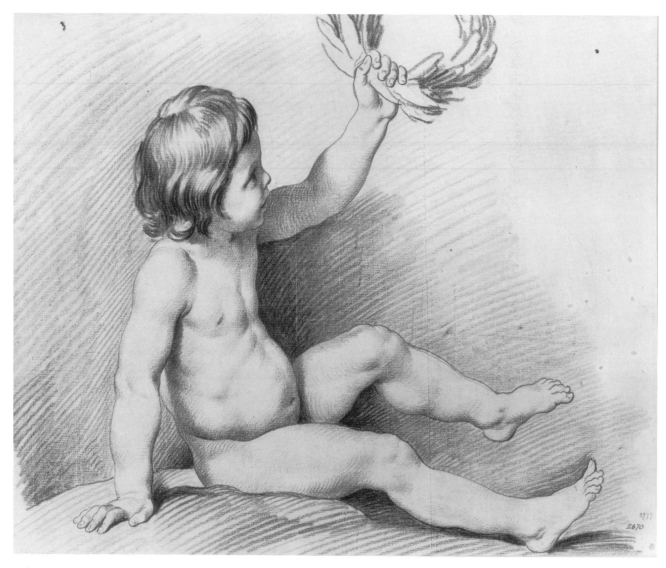

96 Edmé Bouchardon
SMALL CHILD SEATED, HOLDING A LAUREL WREATH

Red chalk
34.5 × 45.5
Laid down
NM 2977/1863
Numbered at lower right in pen and brown ink: 2870

This drawing was engraved by Aveline in *Nouveau livre d'enfants, dessinés par Edm. Bouchardon, sculpteur du roi*.[1] It forms part of the preparatory work for the Fontaine de la rue de Grenelle, on which Bouchardon worked 1739–45. The project includes four reliefs representing the seasons, with young children engaged in appropriate activities. A great many sheets are linked more or less closely with this monument.[2]

PROVENANCE
C. G. Tessin (List 1739–42, p. 73; Cat. 1749, livré 16, no. 107). Kongl. Biblioteket (Cat. 1790, no. 2870). Kongl. Museum (Lugt 1638).

BIBLIOGRAPHY
A. Roserot, *Edmé Bouchardon*, Paris 1910, pp. 56–68
Bjurström 1982, no. 807

[1] Bibliothèque Nationale, Paris, Fa 44 in fol. p. 54.
[2] J. Guiffrey and P. Marcel, *Inventaire général des dessins du Louvre et du musée de Versailles, Ecole française*, Paris, 1907–38, 2, nos 873–884.

PRE-ROMANTICISM

Mme de Pompadour was officially recognized as the mistress of Louis XV in 1746 and her brother was created Marquis de Marigny and appointed director of the King's buildings, a post that included responsibility for the arts. The new director, who was only twenty-eight, was sent on an introductory tour of Italy in a party that included the engraver Charles-Nicolas Cochin the younger – the driving force, together with the Comte de Caylus, behind the growing criticism of the rococo style. The party studied antique remains, including the recently discovered Herculaneum, and concluded that sculptors in particular had much to learn from these sources. Their conclusions for painting were less definite, but it was considered that the Antique did afford subjects and an ethical attitude towards art that could instil new life into it.

New tendencies generally show up particularly clearly in drawing, but at this point the most striking change is purely technical. In the first half of the century this field had been dominated by drawings in chalk, by figure studies and by the concept of form. Interest now shifted instead to landscape, atmosphere and light. Wash became the preferred medium, applied to a sketch done in ink or chalk. This technique also encouraged the study of chiaroscuro and a more emotional interpretation of subjects.

Mme de Pompadour maintained her position at court until her death in 1764 and her brother held his post until 1773. They exerted a strong influence on the arts on account both of their commissions, both for art in the 'official' style (which was expressed in national monuments, informed by noble themes and high ideals) and for art of an intimate, private nature.

After 1737 the Salon (an official exhibition of work by established artists working in France, first held in 1699 in the Maison Carré in the Louvre) became an annual rather than an irregular event, providing artists with an opportunity of meeting the public as well as potential patrons. The Salon was also important as a forum for public debate and criticism: a case in point is Diderot's invaluable contribution during the years 1759–81, when he published highly expert annual critiques of the exhibitions.

Jean-Baptiste Greuze (1725–1806) is a good representative of the new age. In some respects his art continues the tradition of Boucher, with its preference for studies of attractive women, Greuze differs from Boucher in his wish to portray women, particularly when they are newly wed, as wives and mothers. Studies of family life were also incorporated in his large compositions, based on dramatic events in rural and bourgeois life, which involve numerous figures. The whole family is engaged in these situations, which are presented theatrically on a shallow stage parallel to the picture surface, so that all expressive movements make their maximum effect.

The underlying theme is sentimentality and the passions, interpreted in numerous red-chalk studies, mostly of young girls experiencing emotional crises. There is a renewed interest in expressive physiognomy, following the systematic studies by Hogarth and Lavater. Women are usually chosen to represent the play of emotions because this fits their role in the pictures.

Madame de Pompadour, *Group of Putti, Poetry*
(Nationalmuseum, Stockholm)

149

Greuze assigns the drama – often a conflict between generations – to the men and relegates the women to an emotional choir in the background. This is evident in the composition drawings, often done very rapidly. A furious account of the drama is drawn with an assured and very free brush. In many of these drawings one is reminded of the great classicists, above all Poussin, whose initial studies have the same way of summarizing the figures and their psychological relationships. It is in the following stage, when Greuze fills out the composition with details and contrasts individual reactions to the incident in question, that narrative and moral elements take over.

It was in the 1760s that Greuze won popular acclaim at the Salon exhibitions, supported by extravagant praise from Diderot. However, in 1769 Greuze turned his back on the Academy and from then onwards held private exhibitions in his studio, maintaining his popularity for another decade.

Jean-Honoré Fragonard (1732–1806) was accepted as a pupil by Boucher in 1751 and was awarded the first prize by the Academy in the following year. In 1756 he went to the French Academy in Rome but failed to come up to expectations as a painter – the drawings he sent back as samples found more favour in Paris. It seems that the Italian landscape made such a powerful impression on him that he ignored other subjects. Instead of the horizontals of the Campagna, his pictures are dominated by the huge cyprus trees in the gardens of the Villa d'Este in Tivoli. Fragonard used red chalk as well as wash, and studied the play of light in the foliage and the humid shade around the tree-trunks. His enthusiasm caused Natoire, his teacher, to comment that 'he has too much fire, too little patience'.[1] This is unjust: Fragonard's drawings are grandly conceived and he undertook them with a great sense of purpose. There is something pantheistic about his approach to nature; the figures in his landscapes are tiny.

Fragonard evolved this manner of drawing in collaboration with Hubert Robert, who was one year younger but had arrived in Rome in 1754 as a protégé of the French ambassador. Although not officially admitted, he attended the French Academy. The two artists went sketching together, and the landscape drawings of Robert are sometimes so close to those by Fragonard that they cannot always be distinguished from them. This is particularly true of the studies in red chalk. When the Abbé de Saint-Non arrived in 1759, he engaged both artists to accompany him on journeys and compile a set of studies to document the variety of the Italian landscape.

Fragonard was possibly even more of an innovator in the use of wash. His approach is reminiscent of Rembrandt and Tiepolo, though it is not clear to what extent he was able to study their drawings. He had their ability to work on the paper, arriving at a finished result even in a hasty sketch. There was nothing of the systematic work one finds in Boucher, his master; everything was done on impulse, close to the subject, in the countryside.

There is a touch of Boucher in Fragonard's skill with erotic subjects, but even here the mood is quite different. Whereas Boucher's females tend to be somewhat affected china dolls, Fragonard's girls, rendered in compositions of whirling vitality, are light-hearted and playful.

Perhaps the freest work by Fragonard is the large set of illustrations for *Orlando Furioso* by Ariosto. This was one of his biggest projects: we know of about 160 sheets and they relate to only half of the book. There is no record of a patron and the drawings do not appear to have been done with engravings in mind. They seem to be spontaneous comments on the cantos. Fragonard drew a quick sketch with tremendous energy in black chalk and then added a more or less finished wash; in some cases there are a few slight accents, in others there is a chiaroscuro mood.

1 *Correspondance des directeurs de l'Académie de France à Rome avec les surintendants des bâtiments*, ed. A. de Montaiglon and J. Guiffrey, Paris 1901, vol, 2, letter 5299, 24 october 1759.

Fragonard had returned to Paris in 1761, but after 1767 he ceased to exhibit at the Salon and never applied for full membership of the Academy. His patrons were acquaintances and he undertook very few public commissions. For his less demanding customers he also produced finished drawings, often of literary subjects, which were intended to decorate a wall. He sometimes made replicas of these drawings.

As mentioned above, it is difficult to distinguish the work of Hubert Robert (1733–1808) from that of Fragonard during the period when they were studying together in Rome (1759–61). Robert was also influenced by Giovanni Battista Piranesi, whose engravings were familiar to every student at the French Academy in Rome. These two artists also worked together and Robert must have been impressed by the speed and energy with which Piranesi did his sketches; working rapidly with the pen, Piranesi would then apply a general wash and finish a drawing with the pen again. Robert gives similar studies a personal character with carefully constructed spatial effects. Whereas Piranesi creates complex spaces with dramatic shifts in the perspective, Robert provides a very different, serene perspective, and changes his space with light and atmosphere.

Robert returned to Paris in 1765 and used his sketches for *capricci*, freely combining classical monuments and ruins to form new, picturesque constellations. Boucher and the new interest in Anglo-Chinese gardens influenced his representations of a new type of landscape, where nature is arranged more ornamentally. In the chalk drawings his line is gentler and the foliage is broken up into open, rounded forms.

In *c.* 1780 Robert started to compose grand architectural fantasies, often with elements from his stock of Roman pictures. Besides the obvious connection with Piranesi, this work is related to contemporary utopian architectural projects by Ledoux, Boullée and Chalgrin.

For the rest of his life Robert largely adhered to the style he had established in the 1770s. He made replicas of attractive watercolours of ruins and spirited figures. During the Revolution he was confined to prison for some months in 1793–4, but his artistic vitality remained largely unbroken until his death in 1808.

Jean-Baptiste Le Prince (1733–81) was born the year after Fragonard and had the same teacher, Boucher. As a draughtsman he learnt to use the wash technique that Fragonard initiated and later he invented an engraving technique for the reproduction of washes. In *c.* 1758, furnished with a commission to decorate the Empress Elisabeth's palace in St Petersburg, he travelled to Russia by way of Holland (where he was greatly influenced by Dutch art). The decoration of the palace taxed his resources, but he took the opportunity of studying an exotic, unfamiliar world. He systematized his observations and produced sets of sheets illustrating Russian costumes and customs. He returned to France in 1763 with a great quantity of sketches. Using these, some Russian costumes and a collection of miniature mannequins, he composed paintings of Russian life edged with fantasy.

Le Prince was skilful and prolific, but his finished works bear no comparison with the sketches from life. Such a transformation is not in fact an insuperable problem, as we have seen in, for instance, the work of Watteau.

The *russerie* of Le Prince reflects his studies of Netherlandish genre paintings as well as the appeal of the exotic, similar to that of chinoiserie. But whereas the knowledge of China which lay behind chinoiserie was often very imperfect, Le Prince had a first-hand acquaintance with his subject. Still, he can give his observations an idyllic appearance, representing a world without either social or ethnic conflicts.

The composition drawings that Le Prince compiled from his detailed studies are themselves relatively independent of the finished works. Unlike Watteau, however, he had difficulty in subordinating his sketches to an overall conception. In his eagerness to represent a narrative he would ultimately produce a conglomerate of fragments.

Gabriel de Saint-Aubin (1724–80) was principally a draughtsman. More than one thousand drawings have been preserved, but only about fifty etchings and a dozen paintings. Though he came from a family of artists, he had little formal training and spent his time with writers and actors rather than with artists. He seems to have been present at innumerable events: balls, inaugurations, boulevard festivals, competitions, congresses, fires and so on. He attended the Salon exhibitions and art auctions, using the catalogues to make thumbnail sketches of the pictures. He was a pedantic reporter, noting the time of his observations in a micro-hand, often with an account of the circumstances.

Saint-Aubin combined virtuosity with a very personal artistry in his drawings, supplementing black chalk, if necessary, with impulsive accents of wash or watercolour. There is no mistaking his figures. A constant observer and recorder of what he saw, he had an unrivalled ability to catch a characteristic movement or attitude.

He was also a reporter in the sense that he concentrated on the essential features of a situation instead of submerging it in details. It is perhaps for this reason that his drawings, free from academic inventions, seem to give the most authentic picture of life in Paris in the 1760s and 1770s.

Besides registering outward appearances, Saint-Aubin was able to convey mood and atmosphere. His use of light is masterly, penetrating a dark room in narrow rays or almost extinguishing the details in a daylight scene. It is also light that dissolves the solid forms and creates the impressionistic effect in his pictures.

Saint-Aubin was an unusual person whom the art establishment never accepted. He failed to win the Academy prize and never became a member. His last drawing is of the cluttered room in which he lived and died.

Augustin de Saint-Aubin (1737–1807) was the younger brother of Gabriel and primarily an engraver. He chose the same themes as Gabriel and became an outstanding depicter of women. His drawings radiate the dawn of realism, allowing the personality of the subject to dominate, instead of modifying it to serve a piquant taste.

97 Jean-Baptiste Greuze
TOURNUS 1725–PARIS 1806
HEAD OF A YOUNG GIRL
Red chalk
43 × 30
NM 290/1980
Verso: Study of a sleeping baby. Red chalk

This is a characteristic example of this artist's large red-chalk studies of heads, most of which are studies in expression, with no direct link with a particular painting. This girl's head displays the same attitude as the girl with a raised profile in *La Malédiction – le fils ingrat*[1] and also bears some resemblance to *A Girl in a white dress* in the Wallace Collection;[2] the model moreover, could be the same as in a similar drawing in Leningrad.[3]

Of still greater interest is the hasty verso study of a sleeping infant, drawn with exceptional freedom and unique in Greuze's extant *œuvre*.

PROVENANCE
A. G. P. de Bizemont-Prunelé (Lugt 128). J. P. Heseltine.

BIBLIOGRAPHY
Catalogue, Heseltine, 1911, no. 16.
L. Guirand, *Dessins de l'école française du dixhuitième siècle provenant de la collection H . . .*, Paris 1913, no. 37, repr.
Bjurström 1982, no. 973

[1] E. Munhall, *Jean-Baptiste Greuze*, catalogue of exhibition, Palais des états de Bourgogne, Dijon 1977, no. 84.
[2] Wallace Collection catalogues, *Pictures and drawings illustration*, 3rd ed., London 1949, no. 427.
[3] L. Monod and L. Hautecœur, *Les dessins de Greuze conservés à l'Académie des Beaux-Arts de Saint-Pétersbourg*, Paris 1922, pl. IX, no. 157.

98 Jean-Baptiste Greuze
THE RETURN
Point of the brush and grey ink, grey wash
25.5 × 36.3
Laid down
NM 111/1975

Like many compositions by Greuze, this
scene involves a meeting. The closest
parallels in motif, style and technique are to
be found in a drawing of the same size in the
Wadsworth Athenaeum, Hartford, *Le retour
du proscrit*,[1] which Munhall links with *Return
of the Hunter* (British Museum), which has a
similar composition and technique.[2]
Munhall also points out the close connection
with the large compositions *Le Fils ingrat* and
Le Fils puni, on which Greuze resumed work
at the end of the 1770s, having conceived
them in the mid-1760s, worked up the first
versions in washes and sold these at the Salon
of 1765.[3]

The present drawing is closely related to
the composition, *Le Fils ingrat* (1777–8),
while the motif is clearly that of the final
scene, *Le Fils puni*. The son makes his
entrance from the right and is embraced by
two siblings, while others sit mourning in

the background; his mother is rushing to
meet him from the left, leaving a daughter
by the dead father's bed, which is suggested
on the left.

Assuming that the sheet refers to this
composition, it seems to belong to Greuze's
earliest work on this theme when he resumed
it at the end of the 1770s. It constitutes a
reversal and a perfect partner in composition
to *le Fils ingrat* of 1765; the gestures are the
same, but instead of standing for departure
and rejection, in the present sheet they
represent a meeting and a welcome. Munhall
confirms a date in the late 1770s for the
present drawing.

The Louvre has a similar study[4] showing a
lightly drawn figure with arms raised on the
left and a more distinct head on the right,
which is reminiscent of the returning figure
in the present sheet. It may have been done
for the same composition.

These drawings, like two similar sheets in
Tournus,[5] may be connected with Greuze's
plans for a long series of moralizing pictures,
which was never executed.[6]

PROVENANCE
Prouté, Paris.

BIBLIOGRAPHY
B. Magnusson, 'Greuze and the "peinture
morale"', *Nationalmuseum Bulletin*, 3, 1979: 3,
p. 165
Bjurström 1982, no. 972

[1] E. Munhall, *Jean Baptiste Greuze*, catalogue of
exhibition, Palais des états de Bourgogne, Dijon
1977, no. 80.
[2] Ibid., p. 175.
[3] Ibid., nos 48, 49 (Lille).
[4] RF 26.973. A similar composition, very loosely
drawn, in pen and brown ink and grey wash, is
also in the Louvre (RF 26.988).
[5] Munhall, op. cit., nos 38, 39.
[6] L. Hautecœur, *Greuze*, Paris 1913, pp. 100 ff.

99 Jean-Baptiste Greuze
WOMAN WITH A CHILD AND A
DOG ON A CHAISE-LONGUE

Pen and brown ink, grey wash
17.1 × 19.7
Laid down
NM 172/1920
Inscribed at lower right in pen and brown
ink: *J. B. Greuze.*

A reaction against the elegance of Boucher is
evident in the drawings of Greuze. Like
Chardin, he strives for realism and turns to
domestic life for the unpretentious subjects
which he wishes to depict. Moreover, his
drawings display the controlled
sentimentality that won Diderot's
admiration.

This drawing is in all probability a
document from Greuze's own family life,
depicting Mme Greuze and one of their
daughters, presumably Anne-Geneviève,
born in 1762, and the first of the couple's
children to survive infancy. The age of the
child shown here, then, points to a date
c. 1762–4 for the drawing.

Greuze met his future wife, Ann-Gabrielle
Babuti, the attractive daughter of a
bookseller in the Rue St Jacques, when he
returned from his journey to Italy in 1757,
and he married her in 1759. The drawing
embodies memories of the happy early years
of the marriage. Greuze later divorced his
wife when he discovered that she had been
repeatedly unfaithful to him.

PROVENANCE
French art market

BIBLIOGRAPHY
Bjurström 1982, no. 971

EXHIBITIONS
Stockholm 1958, no. 244
Washington, Fort Worth, San Francisco 1985–6,
no. 50

100 Jean-Baptiste-Marie Pierre

PARIS 1713–PARIS 1789
MARRIAGE
Red chalk
27.6 × 18.8
Laid down
NM 2966/1863
Signed by the artist on the old mount at lower centre in pen and grey ink: *Pierre fecit*. Numbered at lower right in pen and brown ink: *113*, changed to *112*, (struck out) and *2859* (Sparre)

A pupil of Natoire, Jean-Baptiste Pierre spent several years in Italy (1735–40). He reached the height of his reputation in the 1760s and in 1770 succeeded Boucher as Premier Peintre du Roi and Director of the Academy.

This drawing, belonging to a narrative genre that Pierre took up at the beginning of the 1740s, after his return from Italy, is a study for the painting *Le Ménage* (Hermitage).

PROVENANCE
C. G. Tessin (Cat. 1749, livré 14, no. 112). Kongl. Biblioteket (Cat. 1790, no. 2859). Kongl. Museum (Lugt 1638).

BIBLIOGRAPHY
Bjurström 1982, no. 1128

101 Jean-Honoré Fragonard

GRASSE 1732–PARIS 1806
LANDSCAPE WITH RUINS
Red chalk
21 × 29.3
No watermark
NM Z 1/1967
This drawing was identified as by Fragonard by Ernst Goldschmidt in 1944

Fragonard went to Rome in 1756 and spent four years in Italy, coming into contact with the Abbé de Saint-Non and travelling with him to Venice, Naples and other places. Fragonard produced numerous drawings during this period, including his famous series of ten red-chalk sheets from the Villa d'Este in Tivoli, done in the spring of 1760 while the artist was staying there with Saint-Non.[1]

Although there is no direct evidence to support the tradition that Hubert Robert was also staying at the Villa d'Este at that time, he and Fragonard influenced each other to such an extent that it is very difficult to distinguish their work from this period. The combined exhibition of their works in Washington in 1978 greatly benefited research at the Nationalmuseum and there is reason to compare the present drawing with one by Fragonard in Washington that can be dated to exactly the same years, 1760–61; it depicts the terrace and garden of an Italian villa. The latter's characteristics, as described by Eunice Williams, are equally applicable to the present sheet. She notes how the landscape, with its lush vegetation, appears deceptively natural in its overgrown disarray. But she continues, 'yet the arrangement of the box-like space, its carefully controlled patterns of light, and its closed diagonal vistas are typical of Fragonard's theatrical sense of composition. The sharply drawn accents – small sawtooth lines and staccato dots that suggest the variety of foliage, and disconnected dashes of chalk that form dramatic, bare branches – demonstrate his expressive use of graphic conventions.'[2]

PROVENANCE
Rosersberg. Acquired by the museum in 1874.

BIBLIOGRAPHY
A. Ananoff, *L'Œuvre dessiné de Fragonard*, 3, Paris 1968, no. 1607.
P. Bjurström, 'Drawings by Jean-Honoré Fragonard in Nationalmuseum', *Nationalmuseum Bulletin*, 2:1, 1978, pp. 39 f.
Bjurström 1982, no. 952

EXHIBITIONS
Stockholm 1922, no. 100
Bordeaux, Musée des Beaux-Arts, *La peinture française en Suède*, 1967, no. 126, pl. 61
Washington, Fort Worth, San Francisco 1985–6, no. 47.

[1] L. Cornillot, *Collection Pierre-Adrien Paris Besançon*, 1 ('Inventaire général des dessins des musées de province'), Paris 1957, nos 32–41.
[2] Eunice Williams, *Drawings by Fragonard in North American collections*. National Gallery of Art, Washington 1978, no. 8, p. 42.

The message conveyed by the drawing is more complex. A damaged statue, half overgrown, stands in the park. Nature is rampant and threatens to envelop the architectural elements. The ground is rocky and uneven, in contrast to the broad, trim walks in the paintings. The drawing hints at the passage of time, decay and mortality.

The differences in handling and attitude between the washed drawing and the paintings do not seem to be accidental. Although the instances of fragments of a particular motif being treated in different ways are rare, a general comparison of Fragonard's drawn landscapes with his paintings suggests that the drawing was conceived chiefly as an intimate work of art, addressed, even though it hangs on a wall, to the individual beholder – an object for close contemplation. The paintings played a prominent part as decorative elements in a room, while the drawings were assigned to small chambers and intellectual settings. In the drawings the artist portrayed the entire register of expressions; the wash is applied in an infinite range of values, from barely discernible surfaces to the bold outlines that are most apparent in the branches of the tree and the foreground vegetation. The forms vary from delicately indicated figures to boldly shaped plants.

PROVENANCE
Coll. Chabot and Duc de La Mure or Desmarets (sale, 17–22 December 1787, no. 173). Coll. Constantin. Coll. Marquiset (sale, 27 April 1890, no. 88). Coll. Henri Delacroix (sale, Paris, Palais Galliéra, 31 March 1962). Coll. Cailleux.

BIBLIOGRAPHY
A. Ananoff, L'Œuvre dessiné de Jean-Honoré Fragonard, 1, Paris 1961, no. 350; 2, Paris 1963, p. 308, no. 350, fig. 366
P. Bjurström, 'Drawings by Jean Honoré Fragonard in Nationalmuseum', Nationalmuseum Bulletin, 2:1, 1978, pp. 42–5
Bjurström 1982, no. 954

EXHIBITIONS
Paris, Hôtel de Sagan, Fragonard, 1931, no. 94
Paris, Musée Carnavalet, Chefs-d'oeuvre des collections parisiennes, 1950, no. 107
Washington, Fort Worth, San Francisco 1985–6, no. 48

[1] G. Wildenstein, The Paintings of Fragonard, London 1960, no. 349.

[2] Ibid., no. 350.

102 Jean-Honoré Fragonard
ITALIAN LANDSCAPE
Black chalk, point of the brush and brown ink, brown wash
23.2 × 17 cm
NM 6/1977

This highly finished landscape study is a portrayal or a reminiscence of a view from the park of an Italian villa. It no doubt dates from Fragonard's second Italian journey (1773–4), which he undertook together with Bergeret de Grandcour. The motif is closely connected with two paintings from that time, now in the Metropolitan Museum of Art, New York. In one of these, View of an Italian Villa,[1] we recognize the colonnade, and in the other, The Shady Avenue,[2] the

dominant tree on the right is in the same position. The paintings form a pair and measure 29 × 24 cm, which is only slightly larger than the present sheet.

Of course, there is no means of telling to what extent these pictures represent an observed reality. But the relative freedom with which Fragonard rearranges the various elements does suggest that they were compiled from the artist's repertoire of Italian landscape motifs.

The presentation, however, has clearly been adapted to the medium. The paintings radiate a light, optimistic atmosphere, with an almost intoxicating happiness, evoked by the greenery and trembling heat of summer. They are pictures of carefully tended parks, peopled by the leisured class and children at play.

103 Jean-Honoré Fragonard

RUGGIERO, TROUBLED IN MIND, PREPARES TO WRITE TO BRADAMANTE

Black chalk, point of the brush and brown ink, brown wash
39.8 × 24.4
No watermark
NM 236/1975

Nearly 160 illustrations by Fragonard for Ariosto's *Orlando Furioso* are known. They relate largely to twenty-five of the work's forty-six cantos. The distribution of illustrations among these cantos is uneven, and Fragonard presumably did not produce a complete series (this would imply the loss of a great number of drawings). The variety of watermarks among these illustrations indicates that he worked on them over a considerable period.

Besides the 137 illustrations published by Mongan, Hofer and Seznec in 1947, Mongan knew of several others from the series, among them those in the Louvre.[1] Since then Ananoff has catalogued another twenty-three sheets with motifs from Ariosto.[2]

There are no documentary pegs on which to hang a dating of these pictures. All of the Ariosto drawings are sketches rather than finished works suitable for an engraver to copy. But they differ quite considerably and are by no means a homogeneous set. Moreover, because Fragonard varied his means of expression, there are few stylistic criteria for a dating. However, the freedom of the compositions and the technical virtuosity make Mongan's dating in the 1780s, when Fragonard was at the height of his powers, the most probable.

The subject has been identified tentatively by Seznec as 'Ruggiero, troubled in mind, prepares to write to Bradamante.' The reference is to an episode in Canto XXV, where Ruggiero is so disappointed at not having encountered Bradamante during one of his heroic deeds that sleep evades him, and he decides to write to her about his exploits and tender feelings.

The bold warrior has set aside his sword but is not able to relinquish his magic shield. As his thoughts dwell on Bradamante, Inspiration appears before him in the guise of a winged genius assisted by a pair of putti. Ruggiero the fighter is portrayed here as a poet, too, and one recognizes Ariosto's features from Fragonard's own imaginative portrait of the writer, seated at his table, gazing mysteriously at a pair of small putti that symbolize love and folly.[3]

In the drawing Ruggiero has arisen and reels back from his vision, a manner of depicting the moment of inspiration that is commonly used by Fragonard.

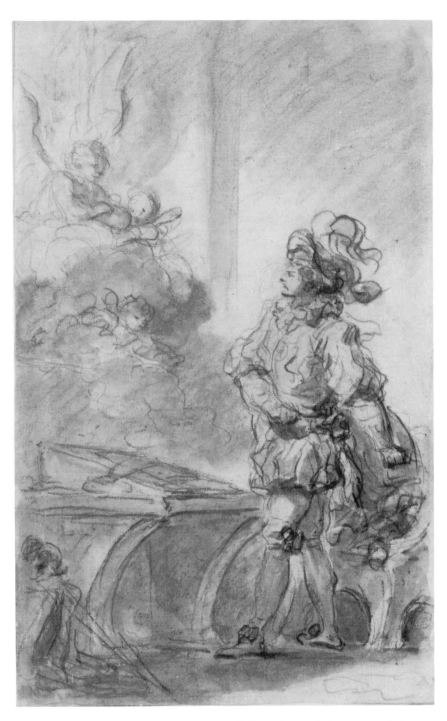

PROVENANCE
Fragonard family. Hippolyte Walferdin, Paris. Louis Roederer, Reims. A. S. W. Rosenbach, Philadelphia. Arthur A. Houghton Jr, New York. Agnew's, London. Artemis S. A. and R. M. Light Co., Boston.

BIBLIOGRAPHY
E. Mongan, Ph. Hofer and J. Seznec, *Fragonard Drawings for Ariosto*, New York 1945, p. 78, pl. 129
P. Bjurström, 'Fragonard och Ariosto', *Kontakt med Nationalmuseum*, Stockholm 1976, pp. 15–27
Bjurström, 'Drawings by Jean-Honoré Fragonard in Nationalmuseum', *Nationalmuseum Bulletin*, 2:1, 1978, pp. 46–8
Bjurström 1982, no. 956

EXHIBITION
Washington, Fort Worth, San Francisco 1985–6, no. 49

[1] E. Mongan et al., op. cit., p. 21.
[2] A. Ananoff, *L'Œuvre dessiné de Jean-Honoré Fragonard*, 1–4, Paris 1961–71, nos 482–485, 1133–1140, 1910–1912, 1918, 2662–2666.
[3] Ibid., opposite p. 9.

104 Jean-Honoré Fragonard

ORLANDO FELLS MANILARDO
Black chalk
45.4 × 29.7
Watermark: Letters R M
NM 651/1978

This illustration to Ariosto's *Orlando Furioso* is one of the most abstract drawings in the series and unique in that only black chalk has been used, without a wash. As a result, the free, cursive linework stands out very clearly and one can discern how an organic whole has been created by modulating the pressure and density in the chalk. The scene is a dramatic one, taken from Canto XII, 82–3, and the plastic form stands out from the maze of lines with monumental strength.

In the text, the episode is described as follows:

. . . la lancia
Arrestò contra il paladin di Francia
E la roppe alla penna dello scudo
Del fiero conte, che nulla si mosse.
Egli ch'avea a la posta il brando nudo,
Re Manilardo al trapassar percosse.
Fortuna l'aiutò che'l ferro crudo
In man d'Orlando al venir giù voltosse.
Tirare i colpi a filo ognor non lece,
Ma pur di sella stramazzar lo fece.

PROVENANCE
Fragonard family. Hippolyte Walferdin, Paris. Louis Roederer, Reims. A. S. W. Rosenbach, Philadelphia. Arthur A. Houghton, Jr, New York. Agnew's London.

BIBLIOGRAPHY
E. Mongan, Ph. Hofer and J. Seznec, *Fragonard Drawings for Ariosto*, New York 1945, p. 73, pl. 90
Bjurström 1982, no. 955

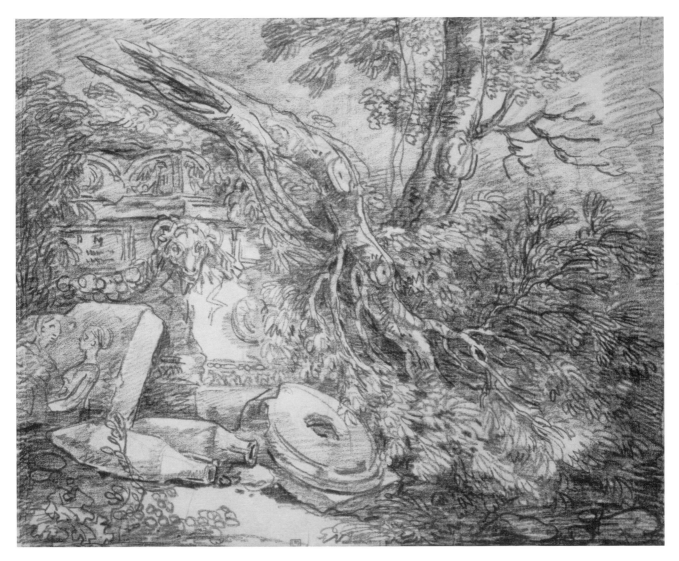

105 Hubert Robert

PARIS 1733–PARIS 1808
ANTIQUE FRAGMENT IN AN
ABANDONED GARDEN
Red chalk
35 × 45.5
Laid down
NM 86/1980

Although Hubert Robert arrived in Rome in 1754 to study at the French Academy, his first extant dated drawings are from 1757. Pannini was his teacher, and Fragonard and Saint-Non were his fellow-students and friends. They left Rome in 1761, but Robert stayed on until 1765.

Robert produced a series of sheets showing antique remains in Roman parks in 1763–4. In this version, the scene is dominated by a tomb with the initials D. M. (Diis Manibus), a fragment of a relief, several earthenware vessels and the base of a pillar.

The closest parallel is to be found in a Louvre drawing which is almost the same size: *Les dessinateurs dans le jardin Farnese.*[1] But the Louvre work, like three sheets in the Musée de Valence,[2] also incorporates human figures. In the present sheet it is just the absence of figures that conveys the impression of nature as sovereign and which ultimately conceals the remains of human cultivation. Human decay is also symbolized by the branch of a tree, still in leaf, which has fallen over the tomb.

PROVENANCE
L. Deglatigny (Lugt 1768a). Coll. Pobbé, Basle. Acquired from Cailleux.

BIBLIOGRAPHY
J. Cailleux, *Hubert Robert (1733–1808), Dessins et peintures*, Galérie Cailleux, Geneva 1979, no. 7 (145)
Bjurström 1982, no. 1143

EXHIBITION
Washington, Fort Worth, San Francisco 1985–6, no. 52

[1] 34 × 45 cm. Dated *c.* 1763.
[2] M. Beau, *La collection des dessins d'Hubert Robert au musée Valence*, Lyons 1968, nos 53, 54, 55. The Museum of Fine Arts, Boston, has another drawing that belongs to this group.

106 Hubert Robert
THE STEPS, SAN MARTINO AI
MONTI, ROME
Black chalk, grey wash
10.2 × 14.2
Watermark: J KOOL
NM 78/1980

This drawing repeats a composition that
Robert executed in red chalk *c.* 1758–9, now
in the Bibliothèque Municipale, Besançon.[1]

It can be observed that Robert used a ruler
and compass to construct the architecture
and then applied the wash all the more
freely. Cailleux dates the drawing to *c.* 1765.

Robert used the composition as the
starting-point for a painting that is a free
representation of a great hall. The foreground
arcade, the stairs and the deep hall are
recognizable from the drawing, but the
heavy pillars in the foreground are replaced
in the painting by a group of four Ionic
columns. Cailleux dates the painting, now in
the Hermitage, to 1765–70.

PROVENANCE
Ernest May. Cailleux.

BIBLIOGRAPHY
J. Cailleux, *Un album de croquis d'Hubert Robert*,
Geneva 1979, no. 53
Bjurström 1982, no. 1144

EXHIBITION
Washington, Fort Worth, San Francisco, 1985–6,
no. 53

[1] Coll. P.-A. Paris, album 451, no. 49. This
drawing is considered by Victor Carlson, *Hubert
Robert, Drawings and Watercolors*, catalogue of
exhibition, National Gallery of Art, Washington
1978, p. 151, fig. 5. He includes a copy after
Robert's drawing done by Jean François Thérèse
Chalgrin (p. 151, fig. 4).

107 Hubert Robert

GOTHIC GALLERY
Point of the brush and grey wash over black chalk
20.6 × 22.9
Watermark: Fleur de lis
NM 81/1980
Verso: Figures in front of a curved gallery. Black chalk

The gothic gallery is shown with dramatic lighting. In the foreground some figures are gathered round a large cauldron on a fire, others peer down into a grave and one is departing to the right with a ladder.

A watercolour from 1759, in the Staatliche Kunsthalle, Karlsruhe, seems to be the first instance of this motif in Robert's work. He returned to a similar theme as late as 1793 in *La Violation des restes des rois de France à Saint-Denis*, in the Musée Carnavalet, Paris.

The verso drawing has another motif that occurred many times in this artist's work: the curved galleries under the Colosseum.[1] Here they provide the background to a group of figures seated among the ruins in front of the remains of the edifice.

PROVENANCE
Ernest May. Cailleux.

BIBLIOGRAPHY
J. Cailleux, *Un album de croquis d'Hubert Robert*, Geneva 1979, nos 65, 77
Bjurström 1982, no. 1154

EXHIBITION
Paris, Galérie Cailleux, *Hommage à Hubert Robert*, 1967, no. 31, viii

[1] Painting in the Louvre, RF 2959, dated 1760. Drawing in the museum in Valence.

108 Hubert Robert

LOADING A WAGGON
Black chalk
17.6 × 22.4
Watermark: VAN DER LEY
NM 82/1980
Verso: Woman drawing a ruined triumphal
arch; to the right of this a landscape. Black
chalk

This is possibly a preparatory study for the
portrayals of workers in *Démolitions du Pont au
Change*[1] and *Démolitions du Pont Notre-Dame*,[2]
which date from *c.* 1786.
 The verso drawing reproduces two
decorative compositions with a lined frame,
which indicates that they were intended for
panelling. The style of the drawing suggests
a date in the latter half of the 1780s.

PROVENANCE
Ernest May. Cailleux.

BIBLIOGRAPHY
J. Cailleux, *Un album de croquis d'Hubert Robert,*

Geneva 1979, nos 109, 108
Bjurström 1982, no. 1155

[1] Three different versions are known: two in Paris
(one in the Musée Carnavalet, the other in the
Louvre) and one in the Alte Pinakothek, Munich.

[2] Three different versions are known: two in Paris
(one in the Musée Carnavalet, the other in the
Louvre) and one in the Cailleux coll.

109 Hubert Robert
THE RUINS OF L'ABBAYE DE LONGCHAMPS
Watercolour
26.2 × 37.8
NM 129/1950
Signed at lower left: *Robert 1797*. Inscribed at lower left in pen and ink: *Ruines de L'abbaye de Longchamps*

This is one of the few watercolours by Robert that can be dated for certain to the end of the 1790s. In it his experience from painting ruins in Rome is applied to a French motif, but the fact that these ruins are gothic does not prevent him from presenting the figures in classical dress. Robert was influenced here by Piranesi, who tended to fill his pictures of ruins with figures pointing out various elements in the composition or otherwise dramatizing its content.

The Abbey of Longchamps was situated on land which today is part of the Bois de Boulogne, but in the eighteenth century was outside the limits of Paris. As Robert had a house at Auteil, not far from Longchamps, he could easily have visited the site. The gothic abbey is depicted here with a view of Mount Valérien in the distance.

PROVENANCE
G. A. Lillja (1798–1884). A. Jäderholm. E. Fredhammar.

BIBLIOGRAPHY
G. Jungmarker, 'Krönika, handtecknings- och gravyrsamlingen', *Nationalmusei Årsbok*, n.s. 19/20, 1949–50, p. 100
Bjurström 1982, no. 1158

EXHIBITIONS
Stockholm 1958, no. 251
Washington, National Gallery, *Hubert Robert, drawings and watercolors*, 1978, no. 60

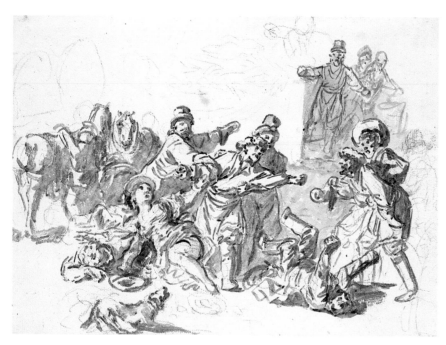

110 Jean-Baptiste Le Prince

METZ 1734– SAINT-DENIS-DU-PORT 1781
A FIGHT. STUDY FOR THE
PAINTING 'A KABAK OUTSIDE
MOSCOW'
Point of the brush and brown ink over red
chalk
19.9 × 28
Laid down
NM 163/1983

For the painting and this drawing Le Prince
could make use of his travels in Russia 1758–
63, which enabled him to draw ethnic types
and peasant costumes from Siberia in the east
to Livonia in the west. Signed and dated
1767, the painting[1] was shown in the Salon
of 1769.

The drawing conforms in its central part
with the painting but differs as regards the
horses on the left and the figures in the right
background. This unusually lively sheet is
striking for the free technique and
spontaneity displayed by Le Prince.

PROVENANCE
Cailleux

BIBLIOGRAPHY
Bjurström 1986, no. 1825
P. Grate, 'Le Cabale' de Jean-Baptiste Le Prince,
Revue de l'art, 1986, p. 22

[1] Nationalmuseum, no. 6727.

111 Gabriel de Saint-Aubin

PARIS 1724–PARIS 1780
THE KING WELCOMED IN THE
INTERIOR OF A PALACE
Pen and black and brown ink
17.3 × 12
No watermark
NM 89/1977
Old inscription on the verso in pencil: *Te
Deum chanté à Notre Dame en actions de Grâce de
la convalescence de Louis XV à son retour de Metz,
ce qui lui Valut depuis le titre de Bien-aimé*

This is one of several drawings which Dacier
considers were assembled in the early
nineteenth century by a professor of drawing,
who bequeathed the entire collection to the
uncle of A. Moreau-Néret.[1]

The verso inscription does not tally either
with the scene or with its setting.

In an unidentified, crowded hall, guarded
by halberdiers and with a high, vaulted
ceiling, the king is shown entering from the
left and receiving flowers from a girl. The
background is difficult to decipher but seems
to consist of a large tapestry covering most of
the wall.[2] On high, under the arch, are three
female allegories: Generosity with a pelican
on the left, Force lancing a lion on the right
and, below these, Delight with a sheep.

The style points to a date in the latter half
of the 1770s, which implies that the
monarch is more probably the young Louis
XVI, at a time when the allegorical
attributes possibly had some credibility.

PROVENANCE
A. Moreau-Néret. Anne M. Ford. Acquired at
London, Sotheby's, sale, 4 July 1977, lot 194.

BIBLIOGRAPHY
E. Dacier, *Gabriel de Saint-Aubin*, 2, Paris 1931,
p. 112, no. 638, pl. 23
Bjurström 1982, no. 1178

EXHIBITION
London, Royal Academy, *France in the 18th century*,
1968, no. 640

[1] Dacier, op. cit., 2, p. 112.

[2] Dacier, loc. cit., sees this part as a gateway, with
a suggestion of a processional crucifix. An opening
is ruled out, however, by the shadow cast on the
area from the window on the right.

112 Gabriel de Saint-Aubin

THE GRENELLE FOUNTAIN, PARIS
Black chalk, pen and black ink, touches of
body-colour
18.4 × 12.2
Laid down
NM 390/1891

Edmé Bouchardon's fountain, symbolizing
the four seasons, was inaugurated in 1749.

PROVENANCE
W. Wohlfart. F. W. Wohlfart.

BIBLIOGRAPHY
A. Gauffin, 'Gabriel de Saint-Aubin i
Nationalmuseum', *Konsthistoriska sällskapets
publikation*, Stockholm 1915, p. 27
A. Gauffin, *Konstverk och människor*, Stockholm
1915, pp. 148 ff.
A. Gauffin, 'Gabriel de Saint-Aubin au Musée
National de Stockholm', *Gazette des Beaux-Arts*,
6:3, 1930, 1, pp. 47 ff.
E. Dacier, *Gabriel de Saint-Aubin*, 1, Paris 1929,
pl. 26; 2, Paris 1931, p. 100, no. 576
Bjurström 1982, no. 1182

EXHIBITIONS
Stockholm 1922, no. 92
Stockholm 1933, no. 80
Paris 1947, no. 570
London, Arts Council, *French drawings from Fouquet
to Gauguin*, 1952, no. 145
Stockholm 1958, no. 232
Stockholm 1979, no. 507

113 Augustin de Saint-Aubin
PARIS 1736–PARIS 1807
FOUR STUDIES OF WOMEN
Pencil
12.6 × 19.8
Laid down
NM 276/1968
Inscribed on the old mount at lower left in
pen and brown ink: *Aug. St aubin delineavit*;
at lower centre in red ink: *J:P:H* (Lugt 1508)

This sheet was one of seven items in a lot that
was sold at London, Sotheby's in 1967. It
seems either to have formed part of a
collection or to have been a fragment from a
sketchbook of female nudes from *c*. 1780–85,
with names, addresses and comments on the
models.

Other studies of the same or similar
models exist in the Chicago Art Institute[1]
and the Fitzwilliam Museum, Cambridge.[2]
The Nationalmuseum also has another study
of the same kind.[3]

PROVENANCE
Baron Jérôme Pichon. J. P. Heseltine (Lugt
1508). R. A. Wilson. Sir Bruce Ingram. London,
Sotheby's sale, 20 August 1967, nos 162–168.
Faerber and Maison

BIBLIOGRAPHY
Bjurström 1982, no. 1175

[1] See *Drawings from the French school from the collection
of J. P. Heseltine*, London 1911, no. 39; H. Tietze,
European master drawings in the United States, New
York 1947, no. 107; F. Boucher and P. Jaccottet,
Le dessin français au XVIIIe siècle, Lausanne 1952,
p. 178, pl. 114; C. O. Schniewind, Three French
drawings, *Bulletin of the Art Institute of Chicago*, 36,
1942: 5, pp. 68–70. According to Dr Joachim,
the study of the girl leaning over the window-sill
and holding a watering can was used in a coloured
stipple engraving by Phillippeaux and Moret,
entitled *La Jardinière*, dated *c*. 1793 by E. Bocher,
*Les graveurs françaises du xviii*e* siècle*, 5, *Augustin de
Saint-Aubin*, Paris 1879, no. 416.

[2] See catalogue of exhibition, *100 dessins français du
Fitzwilliam Museum de Cambridge*, Paris, Galérie
Heim, 1976, no. 90. This drawing also belonged
to Ingram's collection (Inv. no. 102–1961).
Another of these sheets featured in Houthakker B.,
Master Drawings, Amsterdam 1968.

[3] Bjurström 1982, no. 1147.

114 Esprit-Antoine Gibelin

AIX-EN-PROVENCE 1739–AIX-EN-
PROVENCE 1814
ACHILLES FIGHTING THE RIVER
GOD SCAMANDER
Pen and black ink, grey wash, partly over
black chalk
41.2 × 62
The central part of the composition on an
added piece of paper
No watermark
NM 1717/1875

According to Josephson, Gibelin won a prize
in Parma for the painting for which this
drawing is a study.[1]

PROVENANCE
J. T. Sergel (Lugt 2339 b).

BIBLIOGRAPHY
R. Josephson, *Sergels fantasi*, Stockholm 1956, 1,
p. 118, fig. 138
Bjurström 1982, no. 960

[1] Reproduced in the catalogue of the exhibition,
Parma, Accademia di Parma, *Saggi dei concorsi di
pittura i architettura e scultura, 1752–96*, 1979,
pl. 1.

NEOCLASSICISM

Joseph-Marie Vien (1716–1809) represents the transition to neoclassicism. Taught by Natoire and steeped in the erotic mythology of Boucher, he modified their tradition by clothing his protagonists *à l'antique*. The pleasing, decorative element is still there, but the movement and vitality of earlier interpretations are replaced by settings with posed figures, arranged as a bas-relief. This is an insipid classicism, lifeless and sentimental.

Vien was receptive to ideas from Winckelmann, Raphael Mengs and the Comte de Caylus. He also adapted readily to changes in taste, performing equally competently as the last Principal Painter to the monarch as the first to Napoleon.

As the chief teacher of the period, Vien influenced the coming generation of artists in general and David in particular. The latter accompanied him when he moved to Rome in 1774 to become director of the French Academy there, a post he held for seven years.

As students in Rome the young artists were bound to be influenced both by their surroundings and by the discussions about art among men of letters in the city. Arguments in favour of classicism were also to be found in the academic principles. When Vien arrived in Rome he found a mixed group of artists who had followed different paths under his predecessor, Natoire, in their pursuit of classicist ideals.

The oldest member of this group was Esprit-Antoine Gibelin (1739–1814), a native of Aix-en-Provence who had worked for many years in Rome in the prevailing relief-like style. He adapted his technique to the subject. Battle scenes were conjured up with a broad brush and by dramatic accents in ink, while a fine pen and a delicate wash were used to draw a mythological sacrifice.

François-André Vincent (1746–1816), only two years older than David, was much more successful than him initially. He won the Rome Prize in 1768 and stayed in Italy until 1776. His work there is known to us chiefly from drawings of historical or mythological scenes in a vigorous, classicist style, together with free, spontaneous caricatures that belong to an Italian tradition. Vincent's drawings make a dynamic impression that comes from his choice of subject as well as from his apparently rapid and confident technique.

Jacques Gamelin (1748–1803), born in the same year as David, also made the conventional trip to Rome but then settled in the south of France. Subjects from antiquity also predominate in his work, but his lively, spontaneous style sets him apart from the placidity of contemporary classicism.

Louis-Jean Desprez (1743–1804) belonged to the same generation but was over thirty when he went to Rome in 1777 and from there he moved to Sweden in 1784. Desprez had many talents, as painter, architect and stage designer. By settling in Stockholm he avoided the revolution in France. A variety of traditions and influences meet in his drawings. For the Abbé de Saint-Non he produced sheets in the manner of Fragonard and Hubert Robert. He was the first to include Egyptian motifs in architecture of the revolutionary era and his theatre sets predict romantic scenography.

Anton von Maron, *Johann Joachim Winckelmann* (Staatliche Kunstsammlungen, Weimar)

115 François-André Vincent

PARIS 1746–PARIS 1816
SACRIFICE TO AN EGYPTIAN GOD
Pen and grey wash over black chalk,
heightened with white, on greyish paper
34 × 48.5
NM 154/1983
Signed at lower left in pen and black ink:
Vincent f. R 1772

This drawing once had a companion with a
similar Egyptian subject, although we do not
know the historical or theatrical background
to which either alludes.

These two drawings were executed in the
first year of Vincent's stay at Rome, where he
arrived in 1777, having won the Premier
Prix de Peinture in 1768. They can thus be
considered his first finished works of this
period. Vincent was originally strongly
influenced by Vien, but gradually developed
a style of his own.

BIBLIOGRAPHY
Bjurström 1986, no. 1853

116 Louis-Jean Desprez

AUXERRE 1743–STOCKHOLM 1804
THE EXPATRIATED BEING
THROWN INTO THE SEA FROM
THE VILLA OF TIBERIUS AT CAPRI
Pen and brown ink, brown wash
34.4 × 22.9
NM 51/1874:48

This is a preparatory study for a painting
ordered by the Count d'Angivillier, *directeur
général des bâtiments et jardins* of Louis XVI
from Desprez during the artist's last years in
Rome. In a letter of 26 November 1784
d'Angivillier argues, however, that he finds
the subject too ferocious and asks Desprez to
contemplate an alternative theme.

BIBLIOGRAPHY
N. G. Wollin, *Desprez en Italie*, Malmö 1935,
pp. 181 f.

EXHIBITION
L. J. Desprez, Centre Culturel Suédois, Paris,
1974, no. 26

REVOLUTION AND EMPIRE

Classicism came into fashion in the closing years of the *ancien régime*, but the Revolution gave it entirely new implications. Instead of being just a pastime for the privileged, art was to address the nation and serve an educational, moralistic function, providing examples and encouraging noble deeds. Art should play an active part in the transformation of society.

Jacques-Louis David (1748–1825) was a central figure in this new development. He took part in politics and became a deputy. The new standards were formulated by him and his art enshrined the prevailing ideals, alluding to the virtues of the Roman Republic during the Consulate and after that to the grandeur of the Roman Empire. Classicism was already in the air at the time of the Revolution, but its content and implications were now to be altered.

The Revolution and the Empire were significant for the arts in a different way by activating a new, larger public. The Revolution was in fact initiated by wealthy groups among the bourgeoisie, while the proletariat and the *petit bourgeoisie* were inspired to make the necessary sacrifices. The power of the Academy was broken – in principle, any artist now had the right to exhibit at the Salon. The cultivated bourgeoisie was indifferent to rules and principles, preferring liberal ideas that would stimulate the new arts. Paris superseded Rome as the capital of art. Variety flourished and, with it, individualism.

Even as a child David was an ardent draughtsman. On the advice of Boucher, Vien enrolled him as a pupil and considered that his primary task was to control David's 'trop grande sensibilité'. It took David several attempts to win the prize, in 1774, that would bring him to Rome, where he drew both the city and its monuments. He produced a series of *vedute* dominated by horizontals and with the silhouette of the city, recognizable from some familiar monuments in the distance. His drawings after antique statues and reliefs, as well as after monumental Renaissance paintings have a somewhat hesitant line, in some instances with a light wash added. David himself wrote, 'Antiquity has not ceased to be the great school for modern painters, the spring from which they fetch the beauty in their art. We attempt to imitate antiquity in the essence of its drawing, the expression in its figures and the grace of its forms.' The study of antiquity was an ingredient in his own creative activities. His main purpose was to establish the ideal forms by isolating the contours, both those surrounding each figure and those indicating each individual element. Thus, instead of building up the composition by contrasting brighter and duller segments, he used surfaces with the same tonal value.

David applied what he had studied to the material for his compositions. The manner of drawing is much the same, dominated by contours and by a vigorous and expressive linear style. Here, too, the chalk was his principal medium. In drawings of figure subjects he almost invariably reproduced the models nude, until he had reached a definite conception of the picture.

Classicism had grandeur, clarity and dignity as central attributes. In the

Jacques-Louis David, *Marie-Antoinette on her way to the guillotine*
(Cabinet des Dessins, Musée du Louvre, Paris)

Age of Enlightenment, however, there was also a demand for realism. With themes from antiquity, such as *The Oath of the Horatii* (1784), the problem could be avoided, but when David started on *The Oath of the Tennis Court* (1791, unfinished) realism became essential – the setting and the figures were known to the public. The picture also had great political significance, as a manifestation of the opinion that beauty resides in truth and clarity.

It is just in drawings, which had moral implications for David, that he worked towards a *verismo* which seeks and finds an innermost truth. This is first discernible in the expressive contour that stands for *Marie Antoinette on her way to the guillotine* (1793), continues with all the individual studies for *The Oath of the Tennis Court* and culminates in the fury in the finished drawing of the dead Marat.

Black chalk continued to be David's principal means of expression and he went on using it in the meticulous preparation of his compositions. His late work tends towards greater abstraction and a somewhat standardized idealization.

Pierre-Paul Prud'hon (1758–1823) was a contemporary of the neo-classicists, but his work is nostalgically romantic. His subjects, though mythological and allegorical, were chosen for the strong passions they represented. Prud'hon preferred dimly lit woods and nocturnal scenes – chiaroscuro was an important part of his pictorial language. Nearly all his pictures have a meditative mood, but the message is indefinable. A lyrical atmosphere houses a variety of impressions: sensualism offsets moralism, eroticism is balanced by chaste solitude.

Prud'hon arrived at an original drawing technique that suited the ideals he wished to express. He used black chalk and white heightening on white or blue paper. But rather than draw lines, he indicated contours with a stump. The picture was then modelled with dots of varying strength and vertical shading. Figures emerge from the shadows, immaterial as in a dream, liable to disappear at any moment. This manner of drawing is highly personal, inspired to some extent by Leonardo, Correggio and the masters of French rococo. As a draughtsman Prud'hon had no immediate predecessor and no proper follower.

Anne-Louis Girodet Trioson (1767–1824) was a pupil of David and was in Rome 1790–95. His paintings exemplify the drift away from David and stand somewhere between the celebratory eloquence of his master and the sensuous lyricism of Prud'hon. His ambition, however, resulted in a surfeit of theatrical effects, so that major works, such as *Endymion* (1792) and *The Entombment of Atala* (1808), are hollow because of their sentimental rhetoric. These huge pictures were very popular at the time.

Girodet wrote poetry and much of his art has literary themes. As one might expect, he also illustrated books, among them some of the classics. His drawings were engraved by his pupils. His style originated in the calligraphic contour that was practised by certain followers of David – for instance, Pierre-Narcisse Guérin. The technique is highly developed in a late work, the illustrations for the *Aeneid* (from 1811). The composition consists of two or three narrow reliefs in which the figures are spread out in a perspective that is almost Egyptian, with somewhat heavier contours to indicate the foreground. Every movement and pose is carried to extremes, every expression of emotion is underscored and there is a general feeling of *horror vacui*. Girodet's starting-point was obviously the illustrations for the *Odyssey* and the *Iliad* by Flaxman, published in Rome in 1793. He developed this language in a manner that presages romanticism. His drawings also have dream-like qualities that seem to point forwards to surrealism.

Jean-Auguste-Dominique Ingres (1780–1867) also used the pure outline as

J. A. D. Ingres, *The Architect Jean-Louis Provost*
(Mrs Rudolf J. Heinemann, New York)

his principal means of expression. His drawings fall into two categories: sketches, many of them hasty, for paintings, and precise, finished sheets of nudes, portraits and landscapes. As a student in Rome (1806–20) he earned a living by drawing portraits and subsequently developed this work into an independent art form.

It was mainly Renaissance artists, Raphael in particular, that interested Ingres in Rome. This was in keeping with the Neoclassical view that drawing – that is, design – is the principal means of artistic expression. But Ingres was content with the surface of objects. Forms appear to be reliefs and his line is a contour that separates surfaces. Shading, in thin parallel strokes, is used sparsely.

Ingres' strictest compositions are perhaps his Roman *vedute*, which are mainly architectural. The viewpoint is shallow; objects are drawn parallel to the surface, indicating the contours but supressing structure. The subject is made to seem abstract, without volume, a geometric pattern made to resemble façades, pillars and so on. The sky is cloudless and no figures intrude upon the scene.

Form for Ingres was not an end in itself. His line also served realism, reproducing true reality. This search for veracity is most evident in the portrait drawings. Here Ingres uses the same simple pencil line to catch the sitter's features. In doing so, he also conveys a psychological truth in these pictures, which are full of serenity and concentrated expressiveness. The heads are modelled with gentle delicacy, the hair may be given a decorative touch and the rest of the figure is suggested with a few thin, precise lines, possibly against a background view which gives an almost symbolic indication of the sitter's nationality. In this way Ingres focuses attention on the portrait itself, using the method practised centuries earlier by Clouet as well as by Holbein.

The studies of models are the purest examples of the Ingres' linear style. Each contour, curve and break is recorded with certainty and sensibility. Details of folds in fabrics are noted and it is this precision that creates individuality even in the nude studies, usually the most anonymous subject of all.

117 Jacques-Louis David

PARIS 1748–BRUSSELS 1825
PORTA SAN PAOLO AND THE
PYRAMID OF CESTIUS
Point of the brush, grey ink
12.4 × 21
No watermark
NM 87/1969
Inscribed: *J.D.* (Jules David) and *E.D.*
(Eugène David), and at lower left in grey ink:
porte St paul

During the five years that David spent in
Italy as a student at the French Academy, he
did many drawings after classical subjects,
from nature, and as preparatory work for his
paintings. He assembled a large part of this
material in a dozen big albums, of which two
are now in the Louvre, one in the Fogg Art
Museum, Cambridge, Massachusetts, and
one in Stockholm. All the David drawings
reproduced in this book come from the last-
mentioned album.

David has attracted very little attention for
drawings of landscapes, yet these studies are
a fresh and stimulating feature of his art.
Their clear disposition of light and shade,
together with their harmonious composition,
earn David a place in the series of eminent

French landscapists in Rome. Like Claude
and Poussin, as well as Ingres, David stresses
the horizontals in the landscape, thereby
differentiating his work from that of the
preceding generation, whose choice of
landscape reveals a penchant for the
picturesque.

PROVENANCE
David sale (17 April 1826, lot 66; 11 March 1835,
lot 16). Marquise de Ludre (sale, Paris, *Galérie
Charpentier*, 15 March 1956, lot 11). Germain
Seligmann, New York.

BIBLIOGRAPHY
Bjurström 1986, no. 1454

EXHIBITION
Washington, Fort Worth, San Francisco, 1985–6,
no. 62

porte st paul

118 Jacques-Louis David
PORTA SAN PAOLO AND THE
PYRAMID OF CESTIUS
Pen and grey ink, grey wash
13.3 × 19.4
No watermark
NM 88/1969
Inscribed: *J.D.* (Jules David) and *E.D.*
(Eugène David)

PROVENANCE
David sale (17 April 1826, lot 66; 11 March 1835,
lot 16). Marquise de Ludre (Sale, Paris, *Galérie
Charpentier*, 15 March 1956, lot 11). Germain
Seligmann, New York.

BIBLIOGRAPHY
Bjurström 1986, no. 1455

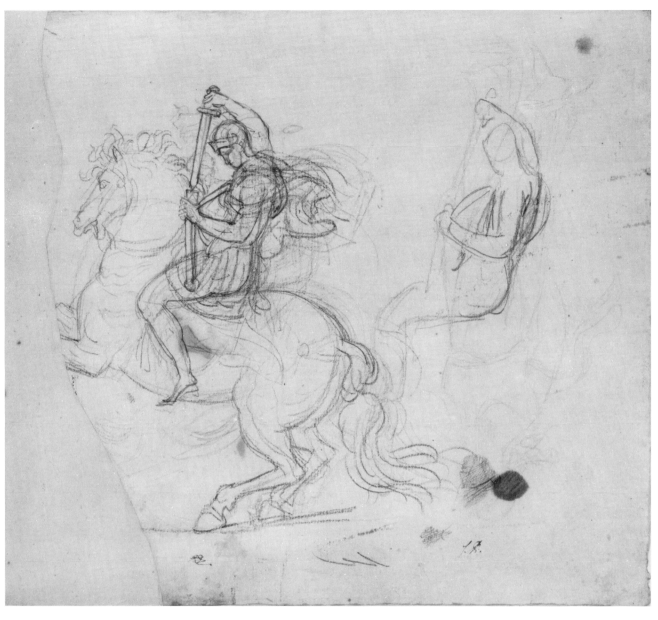

119 Jacques-Louis David
ROMAN WARRIOR ON
HORSEBACK
Black chalk
25 × 28.8
Watermark: Fleur de lis and letters J KOOL
NM 111/1969
Inscribed: *E.D.* (Eugène David) and *J.D.*
(Jules David)

In profile facing left, the mounted man in
Roman armour is returning his sword to its
sheath. The figure is repeated on the right.
These are studies for the rider on the far right
in *The Sabine Women* (1799), a painting
which marks David's return from
commemorating the Revolution to the
Antique. Instead of the traditional abduction
scene, he chose the episode three years later,
when the Sabines returned and the women
placed themselves between the armies to stop
the fighting.

PROVENANCE
David sale (17 April 1826, lot 66; 11 March 1835,
lot 16). Marquise de Ludre (sale, Paris, *Galérie
Charpentier*, 15 March 1956, lot 11). Germain
Seligmann, New York.

BIBLIOGRAPHY
P. Bjurström, 'En skissbok av David', *Kontakt med
Nationalmuseum*, Stockholm 1969, pp. 15–16
Bjurström 1986, no. 1478

120 Jacques-Louis David
THE DEATH OF DAMPIERRE
Black chalk
20 × 17.7
Watermark: D & G BLAUW (fragment)
NM 104/1969
Inscribed: *E.D.* (Eugène David) and *J.D.*
(Jules David)

In 1792 David was elected to represent Paris
in the National Convention, which brought
him into politics. His painting also became
more specifically political, a tendency that is
first evinced in this sheet, which portrays the
Marquis de Dampierre as one of the great
heroes of his day. The Marquis had supported
the Revolution at an early stage and in 1793
was put in command of the French army; he
fought the joint British and Austrian forces
outside Valenciennes and died two days after
his leg was severed by a cannonball at
Quiévrain on 6 May.

In keeping with his earlier representation
of Socrates, David has chosen to portray
Dampierre as a Stoic, enduring his fate with
fortitude; he has also used the profile of the
fallen horse as a background for a plastic
composition of the same type as *Belisarius*
and *Socrates*. For some reason this draft was
never turned into a painting. Perhaps the
death of Marat some months later afforded a
contemporary subject that was still more
symbolic and dramatic.

PROVENANCE
David sale (17 April 1826, lot 66; 11 March 1835,
lot 16). Marquise de Ludre (sale, Paris, *Galérie
Charpentier*, 15 March 1956, lot 11). Germain
Seligmann, New York.

BIBLIOGRAPHY
P. Bjurström, 'En skissbok av David', *Kontakt med
Nationalmuseum*, Stockholm 1969, pp. 13–14
A. Schnapper, *David. Témoin de son temps*, Fribourg
1980, p. 153
Bjurström 1986, no. 1471

121 Pierre-Paul Prud'hon

CLUNY 1758–CLUNY 1823
REPENTANCE
Black chalk, heightened with white
32 × 16 cm
No watermark
NM 274/1972

This representation of *Repentance (Le Repentir)* is part of a larger composition, *L'Amour séduit l'Innocence, le Plaisir l'entraîne, le Repentir suit,* that Prud'hon executed in 1810.[1] He had handled the subject twenty years earlier, although all the figures were shown half-length.[2]

The drawing is done after the finished painting, in connection with an engraving of the composition by B. Roger. The latter worked from two drawings, in pen and ink and in black and white chalk respectively. Prud'hon then provided him with two more drawings, one of *Amour and Innocence* and this one of *Repentance.*[3]

A drawing of the whole composition is now in the Fogg Art Museum, Cambridge, Massachusetts, and the drawing of *Amour and Innocence* is in the Louvre.

The present drawing was reproduced, slightly enlarged, in a lithograph by Jules Boilly.

PROVENANCE
Jules Renouard (sale, 19 May 1855, no. 25). Martial François Marcille. Camille Marcille (Lugt 605a; sale, 6 March 1876, no. 112). Bournet-Veron. Labouchère (Paris, Hôtel Drouot, sale, 13 February 1939, no. 63). Lionel Cabany (Paris, Hôtel Drouot, sale, 23 February 1959, no. 140 D). Slatkin (London, Sotheby's, sale, 26 June 1969, no. 50).

BIBLIOGRAPHY
E. de Goncourt, *Catalogue raisonné de l'œuvre . . . de P. P. Prud'hon,* Paris 1876, no. 60, pp. 141, 144
Ch. Clément, *Prud'hon,* Paris 1880, p. 410, note
J. Guiffrey, 'L'œuvre de Pierre-Paul Prud'hon', *Archives de l'art français,* 13 (Collection de la société de l'art français'), Paris 1924, no. 16
Bjurström 1985, no. 1664

EXHIBITIONS
Chartres, *Exposition archéologique,* March 1858, no. 99
Chartres, *Exposition départementale,* 1869, no. 41
Paris, École des Beaux-Arts, *Exposition des œuvres de Prud'hon,* May 1874, no. 224
Santa Barbara, Museum of Art, *European Drawings,* 1964, no. 95
Washington, Fort Worth, San Francisco 1985–6, no. 64

[1] Guiffrey, op. cit., p. 3, no. 5.

[2] Ibid., p. 2.

[3] Ibid., pp. 4–5.

122 Anne-Louis Girodet Trioson

MONTARGIS 1767–PARIS 1824
THE TROJANS TAKING LEAVE OF
THEIR COUNTRY
Black chalk
26.5 × 38.2
No watermark
NM 560/1971

Besides paintings, Girodet produced some
notable series of illustrations, published
posthumously. He was considering the
illustration of Virgil's *Aeneid*, or perhaps an
accompanying volume of separate plates, as
early as 1811. Of the 161 illustrations that
he did for the *Aeneid*, less than half (78) were
published on that occasion.

This drawing is a finished, full-scale work.
An important part is played, particularly in
this sheet, by stylized details such as the
background vegetation and the foaming
waves in the foreground. The drawing was
used for a lithograph by Aubry-Lecomte,
published in *Enéide. Suite de compositions de
Girodet. . . . Publiée par M. Pannetier à Paris*
(*c.* 1827).

Girodet was influenced by Flaxman's
volumes of outline engravings illustrating
The Iliad of Homer and *The Odyssey of Homer*,
published in Rome in 1793. In the sale of
Girodet's effects in 1825, nos 719–724
comprised some ten volumes of engravings
after Flaxman.[1]

The style of Girodet's final compositions is
connected with Flaxman's method of
representing the scene as a bas-relief, but his
temperament is far more imaginative: while
inheriting David's classicism, Girodet also
represented the drift towards romanticism.[2]

PROVENANCE
Coll. A.-C. Pannetier. De la Bordes (sale, Paris,
15 April 1867). Ambroise Firmin Didot. François
Firmin Didot. Acquired at Paris, Hôtel Drouot,
sale, 17 November 1971, lot no. 21.

BIBLIOGRAPHY
Bjurström 1986, no. 1574

[1] *Catalogue des tableaux, esquisses, dessins, et croquis,
de M. Girodet, peintre d'histoire*, Paris, 11–25 April
1825.
[2] Cf. H. Boucher, 'Girodet illustrateur. A propos
des dessins inédits sur l'Enéide', *Gazette des Beaux-
Arts*, 6:4, 1930, pp. 304–19 and A. Sérullaz,
Dessins français de 1750 à 1825 dans les collections du

Musée du Louvre – le Néo-classicisme, 'Les expositions
du Cabinet de Dessins', 1972, no. 84.

123 Jean-Auguste-Dominique Ingres

MONTAUBAN 1780–PARIS 1867

ANGEL OF DEATH

Pencil

30.4 × 15.1

Irregular sheet, with one strip 15.5 × *c*. 2
added at lower right corner and another,
8 × approx. 4, midway along the right-hand
side. The sheet has been torn in two almost
13 cm from the upper edge.

Laid down

NM 131/1959

Inscription along upper edge in pencil
(fragmentary): *ara rue de la verrerie 4. u8*; and
along lower edge: *la mort regrette le Coup quelle
vient de porter . . . le Duc d'Orléans*

This is a study for an allegory, planned but
never carried out, of Louis Philippe's eldest
son, Ferdinand-Philippe, Duc d'Orléans
(1810–42). The drawing no doubt dates
from the year of the Duke's death, 1842.

The Musée Ingres, Montauban, has three
studies for the same composition.[1]

PROVENANCE

Ingres (Lugt 1477), probably sale of 6–7 May
1867. Wildenstein.

BIBLIOGRAPHY

Bjurström 1986, no. 1616

EXHIBITIONS

Caracas, *Exposición de dibujos del renacimiento al siglio
XX*, 24 May–9 June 1957, no. 40
Washington, Forth Worth, San Francisco 1985–6,
no. 65

[1] J. Momméja, Collection Ingres au musée de
Montauban, *Inventaire général des richesses d'art de la
France*, 7, Paris 1905.

ROMANTICISM

In the new century neither the court nor the church was the principal patron any more. Museums were the new monuments to be erected, the new public was the people, the new subjects for painting were contemporary events. The compositions, on the other hand, were still modelled according to the same rules that had been developed for subjects derived from classical antiquity.

The artists chose to depict subjects that had interested or even upset, the public, and that had a great emotional impact; they turned to precursors like Rubens to find the rich colour scheme which was a prerequisite for their rich new emotional repertoire.

Théodore Géricault (1791–1824) was for a time a pupil of Guérin, who introduced him to the Neoclassical tradition which derived from David. Besides acquiring a complete classicist vocabulary (sculptural definition of form, finished composition and epic treatment), Géricault was strongly influenced by later artists – by the chiaroscuro of Caravaggio and the diagonal compositions of Rubens.

Géricault had less than a decade as a practising artist. He produced a limited number of major works, all with contemporary subjects. The romantic side to his art lay chiefly in his preference for dramatic themes, represented with a passion for veracity.

Horses featured time and again in his art, from pictures of the race of the riderless horses in Rome (1817) to English scenes with dray horses (1821). The anatomy of a horse – muscles, body and legs – displays the energy that fascinated Géricault.

Most of Géricault's drawings are connected with his lithographs and the limited number of his large paintings. He was not particularly systematic but had a great sense of purpose. His best documented painting is the gigantic *The Raft of the 'Medusa'* (1819), which portrays a raft full of dead and dying people from the wreck of a slave ship after weeks of waiting to be rescued. The composition drawings show Géricault working towards the moment in this incident that has the greatest dramatic potential. He built up the composition in the baroque manner and studied the individual figures from live models. He drew the corpses and heads of executed criminals. The preparatory work is starkly realistic, but in the final version Géricault has softened this effect by enveloping the scene in chiaroscuro from the cloudy sky. Géricault studied his models in the nude and the attitudes he chose have associations with antique reliefs and monumental sculpture. He combined the figures so that they tower upwards in a wild interplay of gestures and attitudes. It is just this interaction of the forms that prevents the effect from being theatrical.

Géricault chose the medium that would suit what he wanted to express. Studies after models were usually done in pen and ink or in chalk. In composition drawings he liked to add a flowing wash to create a dramatic, painterly effect. He preferred black chalk in preparatory work for lithographs and used a light wash to strengthen the plastic effect in horse studies.

Eugène Delacroix (1798–1863) was orphaned at an early age and decided to

become a painter when he was very young. At the age of seventeen he joined the studio of Guérin and there met Géricault, whom he admired and who greatly influenced his artistic development, not least as a draughtsman. Delacroix practised drawing daily, choosing his subjects among old masters, nature, models and wild animals. These exercises gave him a strong sense of form that was to stand him in good stead in his numerous preparatory sketches for compositions.

Delacroix was the major painter of the romantic movement, excelling at scenes involving many figures and giving his glowing palette an almost supernatural brightness. He copied Veronese, Rubens and other old masters and learned how they had constructed their compositions. His drawings are also similar in kind to those of the great masters of the seventeenth century. The line is supreme, but painterly qualities are present too. The drawings are truly monochrome and the subject is not so much reproduced as expressed by the violently passionate curves.

Delacroix was attracted by unusual subjects and dramatic events. His pictures usually depict the climax of an incident and the preparatory drawings develop the suggestion of violent movement and strong passions. In the illustrations for Goethe's *Faust* (1826), for instance, it is chiefly in the attitudes of the figures that Delacroix sketches the psychological drama. The nightmarish mood is conveyed by their cramped postures, their distorted faces and the lugubrious surroundings.

On a trip to Morocco in 1832 Delacroix documented his impressions in innumerable sketches, drawings and watercolours. Together with his annotated sketch-books, these provided him with a never-ending source of material from which to work. The drawings are done with a free, energetic line that quickly establishes the main features of the picture. As each element is judiciously located in the whole, the structure of the composition is built up at the same time.

Like Géricault, Delacroix was equally at home with a number of media: pencil and chalk, pen and ink as well as watercolour. The products of a fertile imagination, of an ability to make quick summaries of what the artist sees, and of a combination of dynamism and a sense of order, the drawings of Delacroix are a rich treasure-house. The watercolours, particularly the hasty entries in his sketch-books, have a bold patchwork effect that looks forward to the art of modern times.

For Victor Hugo (1802–85) drawing was a means of expressing poetic fantasies. This makes him an apt representative of the romantic movement in art. As an amateur, uninhibited by the need to achieve a professional finish, Hugo was able to express his visions spontaneously, studying and reproducing details of reality on the one hand and indulging in exaggeration on the other.

His early work alternates between caricatures and straight landscapes. Starting in 1837, the city views and landscapes became increasingly fantastic, but still retained some foundation in reality. Nature predominated as Hugo became increasingly skilful at juxtaposing the sombre outlines of a landscape and infinite space.

In this realistic phase of his art, a fundamental naiveté is balanced by growing technical competence. In time, however, the literary urge to express the inexpressible, to draw that which cannot be represented, gained precedence. In the second half of the 1840s, when Hugo had difficulty in expressing himself as a writer, he turned again for a time to drawing as an outlet for his energy. Landscapes with ruins, moorland and deserts symbolized his verbal silence.

The pendulum swung back when Hugo went into exile in December 1850.

The drawings, now more sporadic, witness to his metaphysical thinking about spiritualism, table-turning and so on. By the middle of the decade he was close to the border between the representative and the abstract: blobs, silhouettes and impressions of textile or vegetable matter were wittily worked up to suggest a representational content.

Mediaeval fantasies made their appearance at about this time. In his art Hugo followed the contemporary trend: Gustav Doré's illustrations for Rabelais had been published in 1854, followed by those for Balzac's *Contes Drolatiques* in 1855, and Hugo continued in the same spirit, influenced in addition by his experiences during a journey in Belgium and Holland.

During the next decade Hugo greatly simplified his style of artistic expression. He produced narrative drawings in series and established a direct link with his writing by assembling a set of drawings in the manuscript of *Travailleurs de la mer*. But he drew less and less, practically ceasing *c.* 1870.

The technique of drawing fascinated Hugo. He used a pencil, pen and ink, wash, ink blots, silhouettes, impressions and spilt coffee. He worked with all these media in a sensual manner that gave his drawings a haunting, mystical dimension.

124 Théodore Géricault

ROUEN 1791–PARIS 1824
SKETCHES FOR A
GIGANTOMACHY
Pen and brown ink
19.2 × 26.6
NM 1446/1973

Clément records a painted sketch for a *Battle of gods and giants*.[1] Drawings with the same subject exist in the former Pierre Dubaut collection,[2] in the Rouen Museum (inv. no. 1375), the former C. Powney collection, the Cleveland Museum (Inv. no. 64.28), the Smith College Museum, a private collection in Paris, and elsewhere.[3]

These are the scattered remains of what may have been the project for a painting, datable close to 1814–16, along with other classical projects, several of which have left traces in the Chicago sketchbook.

PROVENANCE
A. de Hévesy. P. O. Dubaut (Lugt 2103 b).

BIBLIOGRAPHY
Bjurström 1986, no. 1557

EXHIBITION
Winterthur, Kunstmuseum, *Théodore Géricault*, 1953, no. 117

[1] Ch. Clément, *Géricault. Étude biographique et critique*, Paris 1879, p. 299, no. 94; J. Thuillier and Ph. Grunchec, *L'opera completa di Géricault*, Milan 1978, no. A 86.

[2] Exhibition, Winterthur, Kunstmuseum, *Théodore Géricault*, 1953, no. 165.

[3] J. Thuillier and Ph. Grunchec, loc. cit.

125 Théodore Géricault
STANDING MALE FIGURE

Pen and brown ink

23.7 × 15

No watermark

NM 175/1978

Géricault decided some time in the spring of
1818 to treat the shipwreck of the *Medusa* in
a painting of monumental scale. The *Medusa*,
a French government frigate, had foundered
off the Senegal coast in July 1816. Since her
lifeboats were insufficient, 150 passengers
and crew members were put on a makeshift
raft to be towed to the nearby shore. But the
captain and officers, in their haste to reach
land, abandoned the raft and let it drift. For
thirteen days it floated helplessly while the
men on it fought for food and space. Mutinies
and fighting steadily reduced the number of
the shipwrecked. After a few days without
food, cannibalism was practised by all the
survivors. When a rescue ship finally sighted
the raft on the thirteenth day, only fifteen
men were found to be still alive.

Géricault did countless studies for the
composition and tried out various episodes to
represent the incident: the mutiny,
cannibalism, the sighting of the rescue
vessel, the rescue. He finally opted for the
conception involving the discovery of the
rescue ship. The evolution of Géricault's
work on the painting has been reconstructed
by Lorenz Eitner, to whom this drawing was
not known at the time.[1] The final
composition towers to the right in the
representation of a negro, who, aided by two
more men, has climbed onto a barrel to get as
high as possible as he signals to the
oncoming ship.

The present drawing shows the figure of
this negro, but in an earlier version, before
he was grouped with the man supporting
him.[2]

PROVENANCE

P. O. Dubaut (Lugt 2103 b).

BIBLIOGRAPHY

Bjurström 1986, no. 1563

[1] L. Eitner, *Géricault's Raft of the Medusa*, London
1972.

[2] Ibid., pls 66, 67, nos 67 (Louvre), 68 (present
location unknown).

126 Théodore Géricault
STABLE BOY GROOMING A
HORSE
Pencil, brown wash
18.9 × 18.5
NM 216/1982

Géricault joins the company of Delacroix as
the outstanding Romantic draughtsman. It
is worth noting that Géricault's magnificent
effects are achieved with the aid of studies
of classical forms. Even with a theme so
charged with action as the scene depicted in

this drawing, his representation has the
monumentality of a classical statue.

This subject of stable boys at work occurs
in Géricault's early production, *c.* 1814, as
well as during his stay in England, when he
did a number of lithographs of men shoeing
horses. The style of the present sheet, which
dates from *c.* 1818–20, presages the latter.

An initial sketch for the drawing is now in
a French private collection. A version that is
practically identical, though preceding the
present sheet in date, is in the sketchbook in
Chicago.[1]

PROVENANCE
Binder. P. O. Dubaut (Lugt 2103b).

BIBLIOGRAPHY
Bjurström 1986, no. 1565.

EXHIBITIONS
Paris, Hotel Charpentier, *Exposition Géricault*,
April–May 1924, no. 220 (the exhibition was also
shown at the Musée des Beaux-Arts, Rouen)
Washington, Fort Worth, 1985–6, no. 67

[1] L. Eitner, *Géricault. An Album of Drawings in the
Art Institute of Chicago*, Chicago 1960, folio 27.

127 Eugène Delacroix

CHARENTON-SAINT-MAURICE 1798–PARIS 1863

A SEATED MOOR
Black and red chalk with touches of watercolour
36.5 × 30
Laid down
NM 71/1915
Notations at lower right in the artist's hand: *16 février.*

This drawing was executed on 16 February 1832, during Delacroix's first visit to Tangiers 25 January–6 March. Two preliminary studies for the drawing are in the Louvre.[1] The same figure is depicted on a sheet in the collection of Edward M. M. Warburg in New York, where the Moor is standing.[2]

PROVENANCE
Delacroix sale (Lugt S. 838 a–b), 22–27 February 1864, no. 529. M. Planté. A. Robaut. Winkler and Magnusson.

BIBLIOGRAPHY
A. Robaut (and E. Chesneau), *L'Œuvre complet de Eugène Delacroix*, Paris 1885, no. 1589
M. Sérullaz, 'Unpublished drawings by Eugène Delacroix at the Nationalmuseum, Stockholm', *Master Drawings*, 5 (1967): 4, p. 405, no. 3, pl. 41

EXHIBITIONS
Paris, École des Beaux-Arts, *Eugène Delacroix*, 1885, no. 390 (?)
Stockholm, Nationalmuseum, *Delacroix' lejonjakter*, 1981, no. 4
Washington, Fort Worth, San Francisco 1985–6, no. 70

[1] A. and M. Sérullaz, *Dessins d'Eugène Delacroix 1798–1863* (Inventaire géneral des dessins école français), 2, Paris 1984, nos 1734, 1735.

[2] M. Sérullaz, *Mémorial de l'exposition Eugène Delacroix, organisée au Musée du Louvre à l'occasion du centenaire de la mort de l'artiste*, Paris 1963, no. 171.

128 Eugène Delacroix

SKETCHES OF ARABS
Pencil with touches of watercolour
15.5 × 21.3
Laid down
NM 65/1949
Notes in the artist's hand at upper left: *le frère
du pacha de Larach(e)*; at lower left: *jeudi 8
mars*; at the right: *Abou*. Colour-notations:
violet (several times), *burnous blanc, rouge et
vert*

This study was executed on Thursday, 8
March 1832 at Alcassar El-Kébir. On the
same day Delacroix noted in his sketchbook,
now at the Louvre (RF 1712 *bis*, folio 9
verso), 'Avant d'arriver à Alcassar.
Population, musique, jeux de poudre sans
fin. Le frère du pacha donnant des coups de
bâton et de sabre. Un homme perce la foule
des soldats et vient tirer à notre nez. Il est
saisi par Abou. Sa fureur. Par la turban défait
on l'entraîne, on le couche plus loin. Mon
effroi. Nous courons, le sabre était déjà
tiré . . .'[1]

PROVENANCE
Delacroix sale (Lugt S. 838 a–b), 22–27 February
1864, perhaps part of no. 571 or 572. Robaut.
Marcel Guyot.

BIBLIOGRAPHY
M. Sérullaz, 'Unpublished drawings by Eugène
Delacroix at the Nationalmuseum, Stockholm',
Master Drawings, 5 (1967): 4, p. 405, no. 4,
pl. 42 a
Bjurström 1986, no. 1502

EXHIBITION
Stockholm, Nationalmuseum, *Delacroix'
lejonjakter*, 1981, no. 3

[1] *Journal*, 1, p. 133. The Cabinet des dessins at the
Louvre has three more drawings executed on the
same day: Album RF 9154, folios 18 recto,
inscribed: *Alcassar jeudi 8 mars*, and 19 recto: *le jour
que nous avons traversé Alcassar. Pluie*, and RF 9261:
Encampment of Alcassar El Kébir.

129 Eugène Delacroix

FIVE SKETCHES OF NUDE
FIGURES FOR THE SALON DE LA
PAIX
Pen and ink
22.4 × 39
Watermark: Paraphe
NM 167/1920

The drawing consists of, at upper left, a first sketch for Bacchus; at right, a first sketch for Mars; below, a study with variants for the latter. At lower left, there is a study for Minerva; the small figure behind the goddess does not appear in the final composition.[1]

In October 1851, having just finished the ceiling of the Galérie d'Apollon at the Louvre, Delacroix was already thinking of a new decoration, that of the Salon de la Paix in the Hôtel de Ville. We do not know the exact date that he was awarded the commission for the sum of 30,000 francs, the archives having disappeared in the fire which destroyed the work itself on 24 May 1871. The circular ceiling represented 'Peace consoling men' and 'Bringing abundance'; the eight rectangular coffers that flanked it were consecrated to Ceres, the Muse Clio, Bacchus, Venus, Mercury, Neptune, Minerva and Mars respectively. Episodes from the life of Hercules were depicted on the eleven curved spandrels that formed a frieze between the two doors, the windows and the tall chimney.

Delacroix was working on the Salon de la Paix as early as February 1852, with the help of his collaborator Pierre Andrieu. At the beginning of March 1854 the artist was to show the completed work to his critics and to the public (Sérullaz).

PROVENANCE
Delacroix sale (Lugt S. 838 a–b), 22–27 February 1864.

BIBLIOGRAPHY
M. Sérullaz, 'Unpublished drawings by Eugène Delacroix at the Nationalmuseum, Stockholm', *Master Drawings*, 5 (1967): 4, p. 406, no. 7, pl. 44
Bjurström 1986, no. 1505

[1] A group of pencil drawings for the decoration of the Hôtel de Ville is at the Petit Palais (Inv. nos 189–196). The sheet of studies for Bacchus and the Muses (Inv. no. 196) and a sheet of studies in the Louvre (RF 9543) representing Venus, Minerva and Mercury, together with a study of Cupid, in the same technique as the present drawing, are specially worth mentioning.

130 Victor Hugo

BESANÇON 1802–PARIS 1885
MEDIEVAL FORTRESS PERCHED
ON ROCKS
Pen and brown ink, point of the brush and wash in brown and blue
19.9 × 15.6
No watermark
NM 5/1982
Signed at lower right in pen and brown ink:
VICTOR HUGO

The medieval fortresses that Hugo had studied as a traveller along the Rhine acquired great symbolic importance during his exile in Jersey. Here, the dominant effect of the romantic edifice on its rock is combined, moreover, with an intricate tracery in the foreground, giving the impression of cliffs and trees bowed by the wind. The early 1850s is a probable date.

PROVENANCE
Lucien Goldschmidt

BIBLIOGRAPHY
Bjurström 1986, no. 1608

131 Victor Hugo
A PUFF OF WIND ('SOUFFLE DE
VENT')
Point of the brush and brown ink
12.2 × 19.2
No watermark
NM 36/1981

The drawing dates from *c.* 1869.

PROVENANCE
Jean Hugo. Acquired at Monaco, Sotheby Parke
Bernet, sale, 15 June 1981, lot 50.

BIBLIOGRAPHY
J. Massin, *Victor Hugo, 2, Architecture, paysages,
marines, décors, pochoirs, pliages, etc.*, Paris 1967, no.
976
Bjurström 1986, no. 1615

EXHIBITION
Paris, Galérie Lucien Weil, *Dessins et Ebauches
provenant de la succession Victor Hugo*, 1972, no. 74

REALISM

Honoré Daumier (1808–79) was first and foremost a draughtsman. Even the lithographs, numbering almost four thousand, that he produced for *Charivari* and *La Caricature* from his early youth until old age were drawn straight on the stone.

Daumier, together with Courbet and Millet, helped to create the movement known as realism that sprang up after the revolution of 1848. Although his earlier work contained traces of classical grandeur as well as of romantic feeling, it was nonetheless realistic, being largely devoted at first to political caricature. This form of art requires acute observation and a visual memory, talents Daumier also used in his lithographs of Parisian life, portraying businessmen and lawyers, workers and blue-stockings, tramps and rascals.

Although the satire is never overdone, Daumier did not restrain the element of caricature in facial expression and physical deformities. The figures have a monumental appearance, often brought out by making the clothes cling to the body and reveal its details. There is a grandeur in the composition that is reminiscent of the Renaissance and baroque masters. The satire made the everyday scenes seem acceptable. Daumier's ability to combine grandeur of form and content with satiric wit is matched only by Goya.

All this is most evident in the free drawings, where satire is not the primary requirement. Refined by the moral force, the tone can be elevated from satire via indignation to a fateful drama. There is a quiet forgiveness in the satirical works – except when they are aimed at 'les gens de justice', the judges and lawyers of Paris whom Daumier hated so implacably, seeing in them the servants of the establishment, using their knowledge to hound the poor. As a young man Daumier had been sentenced to six months in prison for some caricatures of King Louis-Philippe. Later in life his political experiences made him an ardent pacifist.

The drawings do include studies from life, but it is striking how soon the impressions are modified and clarified by creative fantasy. Compositions are worked up with a dynamic line, chiaroscuro and feeling for the monumental qualities of form, transforming trivial scenes into dramatic events, charged with atmosphere.

The importance of line for expression is particularly clear in the work of Daumier. Although often accompanied by ink and wash, black chalk was his principal medium. An undulating line indicates strong feelings of joy or sorrow. A zig-zag pattern, interrupted by acute angles, shows the artist's anger and scorn. Similarly, long, gentle curves convey a peaceful mood and give even everyday scenes a monumental grandeur.

François Millet (1814–75) also used drawing as his principal means of artistic expression. He is known as a painter, but all his canvases have a drawn structure. A driving force in his art is the desire to depict the gruelling conditions under which peasants lived. His outlook on life was basically pessimistic. Labour, heavy and joyless, was essential for all human existence; glimpses of contentment were to be found only in brief breaks for rest, when

an atmosphere of peace and quiet spread across the fields.

Millet was not a naturalist. He interpreted individuals as idealized symbols of the hard-working peasantry. He selected simple subjects: the work of sowing and harvesting, men in a field, women in the home. Even the landscape is reduced to its elements, with a horizon that separates heaven from earth. 'Making the trivial serve to express the sublime – that is the real thing.'

Millet drew figures and landscapes mostly in black chalk. He used a low horizon and summarized the figures in simple, monumental forms that tower up like silhouettes, defined by a calm, whole contour. They are tied to the soil under a cloudless sky, so that details are engulfed by shadows. The unpopulated landscape is considerably more expressive, with an undulating horizon and billowing contours in ditches and ploughed fields. Telling accents with the black chalk are permitted here.

In 1849 Millet moved from Paris to Barbizon, joining the group of landscape painters who were working there, in order to obtain inspiration on the spot. Théodore Rousseau (1812–67) was one of the principal figures in this group. He had a pantheistic conception of nature, depicting woods and fields as serene, solitary subjects, with no trace of human existence. His drawings are contemplative preparations for the paintings and include studies of details as well as sketchy compositions.

132 Honoré Daumier

MARSEILLE 1808–VALMONDOIS 1879
LA FINE BOUTEILLE
Crayon, pen and ink and watercolour
22.1 × 29.3
Watermark: Letters HL (?)
NM 229/1979 (earlier Department of
Paintings, B 1609, acquired in 1950)
Signed at lower right: *h. Daumier*

The sheet can be dated to *c.* 1856–60.
Adhémar interprets the scene as a gathering
of the first Barbizon painters on a summer
evening at a café near the forest. At that time
(1857) the painters Charles Daubigny
(1817–78), Jules Breton (1827–1905),
Daubigny's pupil Adolphe Appian (1818–
98), and the writer Théodore de Banville
(1823–91), used to meet at Père Anthony's
in Marlotte.

The shutters have been drawn, the
landlord enters with two bottles from the
cellar and the candlelight produces deep
shadows. At this time the artist was
concentrating on the effect of light on forms.
His drawing also catches the proud
countenance of the landlord and the intense
interest displayed by the three seated artists.[1]

PROVENANCE
Somers. Coleman. Bernheim Jeune. Svensk-
Franska Konstgalleriet. Thorsten Laurin.

BIBLIOGRAPHY
A. Alexandre, *Honoré Daumier – L'homme et l'œuvre*,
Paris 1888, p. 377
Catalogue de la vente Mme Coleman, Paris 1917, no. 55
O. Benesch, 'Die Sammlung Thorsten Laurin', *Die
Bildenden Künste*, 1920, p. 168
E. Klossowski, *Honoré Daumier*, Munich 1923, no.
265C
Les dessins de Daumier ('Ars Graphica') intr. by Ch.
Baudelaire, Paris 1924, pl. 4
Konstrevy 1927, 6, p. 20 (repr.)
R. Hoppe, *Daumier-Courbet*, Stockholm 1929,
p. 30
R. Escholier, *Daumier*, Paris 1930, pl. 65, and
Paris 1938, p. 45
R. Hoppe, *Katalog över Th. Laurins samling*,
Stockholm 1936, no. 429
J. Lassaigne, *Daumier*, Paris 1938, pl. 44
B. Fleischmann, *Honoré Daumier: Gemälde und
Graphik*, Vienna 1937, pl. 86
M. Sachs, *Honoré Daumier*, Paris 1939, pl. 86
J. Adhémar, *Honoré Daumier*, Paris 1954, pl. 104
J. Adhémar, *Honoré Daumier – drawings and
watercolours*, New York/Basel 1954, pl. 23
C. Schweicher, *Daumier drawings*, New York/
London 1961, ill. 37
K. E. Maison, *Honoré Daumier, Catalogue raisonné of
the paintings, watercolours and drawings*, London
1967, no. 328
C. Roy, *Daumier dessins*, Genevae 1971, p. 46
Bjurström 1986, no. 1383

EXHIBITIONS
Paris, Durand-Ruel, 1878, no. 156
Copenhagen, Föreningen Fransk Konst, *Courbet-
Daumier-Guys*, 1923, no. 25
Vienna, Albertina, 1936, no. 57
Copenhagen, Statens Museum for Kunst, *Franske
handtegninger*, 1939, no. 17

[1] J. Adhémar, *Honoré Daumier Zeichnungen und
Aquarelle*, Basel 1954, p. 22 and pl. 23.

133 Jean-François Millet

GRUCHY 1814–BARBIZON 1875
THE GLEANERS
Black chalk
16.1 × 20
No watermark
NM 233/1982
Verso: A mill. Black chalk. Inscribed in pen
and brown ink: *Ier pensée des glaneuses – au
revers leçon de perspective*

This is a preparatory drawing for *The
Gleaners*, from 1852–3, now in a private
collection in the United States. The figures
are reversed in relation to the painting, as
they are in a drawing in the Louvre[1] and in a
sheet in the collection of Mrs Herbert N.
Strauss.

PROVENANCE
de Bayser

BIBLIOGRAPHY
Bjurström 1986, no. 1630

[1] G. Rouchès and René Huyghe, *Cabinet des dessins
du Musée du Louvre, Catalogue Raisonné. École
française* 11, no. 10602.

134 Jean-François Millet
WOMAN SWEEPING
Pen and brown ink
16.8 × 13
No watermark
NM 332/1970
Verso: Woman carding wool. Black chalk.
On the left a fragment of a composition with
a mother and child.

The recto drawing is a study for the pastel *La
Balayeuse* (1867). The Louvre has other
studies.[1]

A woman carding wool was a subject that
Millet returned to several times. It appears in
a drawing from 1851–1[2] and again in an
etching from 1855–7[3], in a pencil sketch
now in the Louvre[4] and in an unfinished
painting in the Stedelijk Museum,
Amsterdam.[5] Finally, Millet did a painting
with this theme that he exhibited at the

Salon of 1863.[6] The present drawing
probably dates from a relatively late stage in
the artist's handling of the subject.

PROVENANCE
J. F. Millet (Lugt 1460). Hector Brame, Paris.

BIBLIOGRAPHY
Bjurström 1986, no. 1635

[1] J. Guiffrey and P. Marcel, *Inventaire général des
dessins du Louvre et du musée de Versailles, École
française*, Paris 1907–38, nos 10425–10429.
[2] L. Bénédite, *The Drawings of J. F. Millet*, London
1906, repr. Present location unknown.
[3] L. Delteil, *Le peintre graveur illustré*, 1, Paris
1906, no. 15. 25.6 × 17.7 cm.
[4] Guiffrey and Marcel, op. cit., no. 10390,
24 × 27.4 cm. Detail study no. 10389.
[5] 89 × 56 cm.
[6] Coll. Mr George L. Weil, Washington.
89.5 × 73.5 cm.

MASTERS OF LINE

Camille Corot (1796–1875) inherited the ideals of harmony and balance from classicism, as one can see in the studies from nature that he painted in Italy 1825–6. Instead of working to rule, however, Corot established an immediate rapport with his subjects by building up the picture on the canvas in paint, instead of first drawing it in.

Corot used drawing as a separate element in his art. In Rome he followed Poussin, sketching and recording. He started, however, from his own perception of the subject, beginning by noting the contours in the landscape with a thin pencil or pen and filling in the shaded parts with light hatching. Each drawing required an individual character, each subject a focus. Corot then proceeded to penetrate the details, analysing a tree down to the smallest twig, patiently following the flow of water in a forest stream, meticulously studying the structures of hills and rocks. The drawings express an affinity with nature at the same time as the subtle line work gives them an almost abstract quality. The landscape breathes tranquillity, but there is surface tension in the pattern formed by the plane of the land, rock formations and tree-trunks. The composition has little depth because its lines are roughly equal in value.

The figure and portrait drawings rely in the same way on lines and contours. Here Corot continued the tradition of Ingres, adding a hesitant nervous element that brings the model closer.

Corot's drawing style changed by degrees in the second quarter of the century. He became more interested in atmosphere, and the construction of his austere landscape became more schematic as he pared it down to essentials. In *c.* 1850 he went a step further and sacrificed exactness for the play between light and shade. He now developed a preference for charcoal, stump and white heightening on tinted paper. He made great use of black to achieve a synthesis, accentuating a few large forms (a tree, a plot of land) so that they stand out in a steamy, diffuse atmosphere that has a lyrical mood. Corot argued that an artist should start with form, the serious drawing, before proceeding to values; a hasty sketch is not enough.

Constantin Guys (1802–92) was exclusively a draughtsman. He took part in the Greek War of Independence (1823–4) and started to draw *c.* 1830. He travelled a great deal, reporting the Crimean War (1853–6) as correspondent of the *Illustrated London News*.

Settling in Paris at the age sixty, Guys was for almost three decades the foremost portrayer of fashionable life in Paris. Baudelaire, who was a close friend, described him as 'a genius for whom no aspect of life lacks interest',[1] His washes, often watercoloured, describe the frivolity and shamelessness of society life with a mixture of delight, curiosity and incisiveness. He was an acute observer, drew with a quick, light and elegant hand and was entirely concerned with the surface of life, sharing in this respect the attitude of the Impressionists. The people he portrays are faceless, anonymous gentlemen with glistening top-hats and ladies with swishing skirts. The couples on

1 Charles Baudelaire, *Constantin Guys, Le peintre de la vie moderne*, Geneva 1943, p. 11.

200

horseback or in carriages are caught in a continual round of engagements.

Pierre Puvis de Chavannes (1824–98) revived the classical style and was influenced by Ingres. Figures in his drawings have a noble stature and harmony. Starting from nature, he aimed to parallel reality. Studies from models were followed by sketches that simplify and concentrate, eliminating inessential details. The synthesis is a picture with harmonious forms, drawn with generous, pure lines. There is the same calm dignity about the gestures and attitudes, which convey the contemplative, usually poetic mood expressed by these works. The drawings of Puvis de Chavannes possess a force and purposefulness that are lacking in his paintings, which tend to be anaemic.

Edgar Degas (1834–1917) also started in the manner of Ingres. As a very young man he had been advised by the aged master, 'Draw lines, many lines, from memory, after reality'. His early output consisted mainly of historical paintings, for which he made many preparatory nude studies in pencil or chalk. The human – primarily female – body came to be the principal theme of his art. He drew figures with accented contours that flow harmoniously. His subtle treatment of forms creates the suggestion of flesh and blood, body and skin, giving the nude study a new sensuous dimension. Thus the body that he reproduced was not a construction along classical lines but a real body, observed with an unswerving passion for truth.

Abandoning historical subjects, Degas turned to contemporary life and concentrated on two aspects of it: horse racing and dance. They are characterized by movements, poses and attitudes that had not been portrayed before in art. In a completely non-classical way, Degas continued the tradition of Ingres in his study of the female body in striking but often ungainly positions. The pictures of women leaving a bath or combing their hair provided further opportunities for this type of intensive study of life.

In the course of the nineteenth century drawing lost its classical function as an essential preparation for great works of art. After this break with the academic tradition, the study of models was still included in the curriculum, but not as an integral part of a complete artist's training. There were unlimited possibilities for individual variation and a multitude of prototypes. One tendency starts from the exact linear style of Ingres, another from the more expressive line of Géricault and Delacroix, a third from the representation of reality by Millet and a fourth from Hugo's world of fantasy.

The Impressionists considered that drawing was of secondary importance, and for many others it was of only occasional interest. In the latter part of the nineteenth century drawing had real significance for just a few major artists: Paul Gauguin, Georges Seurat, Henri de Toulouse-Lautrec, Odilon Redon, Auguste Rodin and Paul Cézanne.

Toulouse-Lautrec (1864–1901) had two accidents at the age of thirteen that stunted the growth of his legs. Deprived of a normal adolesence, he started to draw and continued to do so for the rest of his life. He began with caricatures and even in his teens was extremely skilled at drawing horses in movement. He developed a quickness of perception and a visual memory that enabled him to capture the fleeting moment with a few strokes. His early practice at caricature likewise led to an ability to pinpoint a figure or face with the same economy of means.

For some years Toulouse-Lautrec submitted to the teaching of Bonnat and Cormon, successively Directors of the Academy of Art, but he found it uncongenial. He settled in Montmartre in 1884 and stayed there until shortly before his death. Life in this bohemian district absorbed him completely and provided him with subjects in its dancing halls, bars, variety theatres and brothels. The unconventional characters that caught his attention there are

portrayed in a style whose exaggeration matches that of the entertainments in Montmartre. The pictures throb with a rhythm that seems to come from the dancing at the Moulin Rouge.

Lautrec's interest in the essence of reality led him to use his talent for savage caricature even in portraits of serious actors. The linear form of composition that had been developed from the exactness of Ingres to the expressiveness of Degas was also his principal means of expression. Sweeping and sinuous, there is something plant-like about his line. In his approach to composition Lautrec was deeply influenced by Japanese prints. In the foreground an enlarged detail is cut by the picture edge as though by accident; the scene behind this rapidly recedes into the distance, often with lines to indicate the vanishing-points. In this way Lautrec created an exceptional closeness to his subjects and this contributes to the throbbing intensity of his pictures.

The sculptor Auguste Rodin (1840–1917) used drawing to arrive at the plasticity of forms in studies of models and movement. A trip to Italy in 1875 included a decisive encounter with the art of Michelangelo, whose sculptures

Auguste Rodin, *Study for the Gates of Hell,*
1881
(Musée Rodin, Paris)

Rodin drew to perfection, often from a very difficult angle. To record his own sculptures, he developed a manner of drawing that is reminiscent of the eighteenth century. When he started to work on *The Gates of Hell* in the 1880s, the preparatory drawings, done in gouache with powerful streaks of sepia, have heavy forms and dramatic lighting.

This plastic style of drawing is very different from the later work of Rodin *c.* 1900 – nude studies which the sculptor drew with a single sweeping contour, without taking his eye off the model. The proportions suffer, of course, but the line has an intensity of feeling, darting over the paper without hesitation. Sometimes a sketch was corrected with a second contour. Many of the figures were filled in with a flat watercolour to indicate the hue of the skin.

Pictures may be redrawn to correct a mistake, add a drape to the original study and so on, but the almost autonomous line and the two-dimensional effect of the watercolour are preserved. In 1906 a troupe of Cambodian dancers visited France; their gracious appearance and pleasing attitudes fascinated Rodin, evoking a distinct category of drawings. He was chiefly concerned to catch the rhythm in their movements and gestures, without concerning himself unduly about anatomical accuracy.

Trained in the academic tradition, Rodin was convinced that the study of models provided a foundation for the artistic expression of almost any human thought or emotion. After a long detour he returned in old age to a genuine study of models, expressing the human form in its most natural and instinctive positions, using a style reduced to its most essential element – a single continuous contour.

Paul Cézanne (1839–1906) drew exclusively as a preparation for painting. His hand is highly characteristic – a soft, undulating line, frequently interrupted – but he adapted his manner to his subject. There are model studies in the style of Michelangelo, powerful and energetic; some portrait drawings express contemplation and psychological insight; in some composition drawings it is the architectural element that dominates, each figure contributing to the rhythm of the whole.

A very special part was played by drawing in the watercolours that Cézanne started to produce in the late 1880s. In these he developed a remarkable relationship between colour and design, making them complementary. The drawing served to indicate the structure of the subject. The lines represent boundaries between forms rather than between surfaces. Working from memory, Cézanne reconstructed the familiar profile of Mont St Victoire, a park or a forest glade. The watercolour may be restricted to a few strokes that distinguish the picture planes, indicate the space between elements or, in a range of hatching, build up a mountain-side or foliage. Cézanne conjured up not reality so much as the idea of reality, condensed into elementary surfaces and planes. In this he was a forerunner of Cubism.

The art of Cézanne provides a suitable conclusion for this review of French drawing. He can be said to have incorporated the whole of the French classical tradition: balance and harmony, logical analysis and emotional restraint.

135 Jean-Baptiste-Camille Corot

PARIS 1796–PARIS 1875
VIEW FROM NEPI
Pencil
17.4 × 23
No watermark
NM 84/1984
Inscribed at lower right in pencil: *Nepi Juin
1826*

This drawing was done during a trip that
Corot undertook in June 1826 to the Viterbo
district. There are other sheets from the same
journey, dated and inscribed with place
names such as Civita Castellana and
Ronciglione. The present drawing represents
the Suppantonia valley east of Nepi, in the
direction of Castel Sant'Elia and its church.[1]
The Art Institute of Chicago has a drawing
that was probably executed on the same
occasion but is drawn from the opposite
direction.[2]

PROVENANCE
A. Stein

BIBLIOGRAPHY
Bjurström 1986, no. 1369

[1] J. S. Held, 'Corot in Castel Sant'Elia', *Gazette des
Beaux-Arts*, 6:23, 1943, pp. 183–6.

[2] 22.2 × 35.1 cm. This is possibly a double page
from the same sketchbook as the present drawing,
which is done on a single leaf. It is signed *Nepi –
Juin 1826*. See A. Robaut, *L'Œuvre de Corot*, 4,
Paris 1905, no. 2504. See also catalogues of
exhibitions, Art Institute of Chicago, Chicago,
Corot, 1960, no. 143; Paris, Louvre, *Dessins
français de l'Art Institut de Chicago de Watteau à
Picasso*, 1977, no. 38.

136 Jean-Baptiste-Camille Corot

ITALIAN LANDSCAPE
Charcoal
24 × 30.6
No watermark
NM 207/1972
Inscribed on a separate piece of paper: *à mon ami Audry C Corot le 18 fevrier 1869*

The drawing seems to have been done
c. 1869, just before Corot presented it to
Audry, one of the art dealers with whom he
worked.

This use of broad strokes of charcoal is
characteristic of Corot's late style of drawing.
The subject, probably Italian, seems to have
been taken from memory.

PROVENANCE
Audry. Huguette Berès.

BIBLIOGRAPHY
Bjurström 1986, no. 1370

137 Constantin Guys

FLUSHING 1805–PARIS 1892
'COCOTTE PARISIENNE'
Black chalk, point of the brush and grey ink
26.5 × 18.5
No watermark
NM 32/1916

PROVENANCE
Acquired at Bukowski's.

BIBLIOGRAPHY
Stockholm 1986, no. 1585

138 Pierre-Cécile Puvis de Chavannes

LYON 1824–PARIS 1898
THE POETRY OF THE FIELDS, OR
VIRGIL
Black chalk
39.7 × 29.3
No watermark
NM 16/1969
Inscribed at lower right in black chalk: . . .
Hymnis (?) P. Puvis de Chavannes

In 1891 Puvis de Chavannes was asked to decorate the Boston Public Library. His initial response was 'The offer is princely but the undertaking staggering. Boston is far, and I am old. I guess I'm afraid.'[1] He nevertheless accepted the commission, but shortly afterwards received another one, for the decoration of the Staircase of Honour of the Paris City Hall. This caused him to hesitate, but on 7 July 1893 the contract was signed. It recorded the dimensions of each of the surfaces to be painted and offered the artist 250,000 francs.

He seems to have been given *carte blanche*, and the general programme for the work was certainly drawn up by him: 'If you consider the staircase of the Boston Public Library from the point of view of the decorative work that can be done there, a first principle imposes itself immediately: When I was given the honour of decorating the staircase for the Boston Public Library, I sought to represent in an emblematic way the ensemble of the intellectual riches gathered together in this handsome building. This ensemble seems to me summarized in the composition called *The Inspiring Muses Acclaim Genius, Messenger of Light* (upper landing).[2]

The other eight compositions were: on the left-hand wall the poetry of the fields (Virgil), dramatic poetry (Aeschylus and the Oceanides) and epic poetry (Homer); on the right-hand wall History, Astronomy, and Philosophy; on the back wall Chemistry and Physics.

The scene with Virgil was exhibited at the Salon of 1896. The Stockholm sheet is a composition drawing for this picture and shows its arched top. In the final version Virgil has been displaced to the left and into the background.

PROVENANCE
Germain Seligmann (Collector's stamp GS).
Jacques Seligmann & Co.

BIBLIOGRAPHY
Bjurström 1986, no. 1668

[1] L. d'Argencourt and J. Foucart, *Puvis de Chavannes*, Paris, Grand Palais, and Ottawa, National Gallery of Canada, 1976–7, under nos 208, p. 212.

[2] loc. cit.

139 Edgar Degas

PARIS 1834–PARIS 1917
WOMAN COMBING HER HAIR
Charcoal, chine appliqué
54.1 × 49
Laid down
NM 56/1920
Inscribed verso in blue chalk: *1368, Pb 464*

This is a preliminary study for a pastel in the M. Exteens collection, Paris.[1] It is one of a series of drawings and pastels after models in which Degas strove to render the naturalness of his ballet girls and jockeys. Instead of using classical poses, he asked his models to go through the movements of having their baths, even setting up zinc tubs for the purpose in his studio. He persuaded them to continue through their morning ritual – drying themselves after the bath, combing their hair, and so on. This was a theme that engaged him in the late 1870s and throughout the 1880s; Lemoisne dates the pastel to 1887–90.

The present drawing is characterized by the synthetic forms, with trunk and limbs as assembled components. This also points to a date in the late 1880s. There is another, more realistic version, likewise done in charcoal.[2]

PROVENANCE
Degas (Lugt 658, red, recto). Atelier/Ed. Degas (Lugt 657 red, verso). Degas, Paris, fourth sale, 2–4 July 1919, no. 187.

BIBLIOGRAPHY
Bjurström 1986, no. 1494

[1] P.-A. Lemoisne, *Degas et son œuvre*, 4 vols, Paris 1947–9, no. 935
[2] Degas, Paris, third sale, 7–9 April 1919, no. 314 (acquired by Durand-Ruel).

140 Henri de Toulouse-Lautrec

ALBA 1864–MALROMÉ (GIRONDE) 1901
THE ACTOR MOUNET-SULLY IN
ANTIGONE
Pencil
17.5 × 11
No watermark
NM 300/1956
Inscribed on the paper on which the drawing
is glued: *Mounet dans Agamemnon*

This is a study for the lithograph *Bartet et
Mounet-Sully, dans Antigone* (1894).[1] There is
often something almost calligraphic about
the line in Lautrec's drawing, but in his
portraits it is used for penetrating studies of
the physiognomy. In this sheet the
representation verges on the sharpness of a
caricature. This is still more so in the
lithograph, where the face is reversed in
relation to the drawing.

PROVENANCE
Bunau-Varilla (sale, 9–10 July 1947, cahier no.
9). Raykis. Svensk-Franska konstgalleriet.

BIBLIOGRAPHY
M. G. Dortu, *Toulouse-Lautrec et son œuvre*, New
York 1971, 6, no. 3724
Bjurström 1986, no. 1736

EXHIBITION
Stockholm 1958, no. 286

[1] L. Delteil, *H. de Toulouse-Lautrec*, Paris 1920, no.
53.

141 Henri de Toulouse-Lautrec

RIDER ON A GALLOPING HORSE
Pencil
17 × 26.9
To the right a female profile (erased)
No watermark
NM 128/1968
Red cachet TL in circle at lower left, verso
Verso: Portrait sketches of a man, three in
profile facing left, on the far right a full-
length figure, on the far left a head full face

This sheet seems to date from the artist's
youth (c. 1881).

PROVENANCE
Tapié de Céleyran. D. Viau. P.-A. Weill. M. G.
Dortu.

BIBLIOGRAPHY
J. P. Crespelle, 'Toulouse Lautrec, feuilles
d'études', *Au pont des arts*, 1962, repr. pp. 9
(detail), 65
R. Boulier, *Aux Ecoutes*, 5 October 1962, repr.
M. G. Dortu, *Toulouse-Lautrec et son œuvre*, New
York 1971, 5, nos 2119 (recto), 2118 (verso)
Bjurström 1986, no. 1733

EXHIBITION
Stockholm 1968, no. 43

142 Auguste Rodin

PARIS 1840–MEUDON 1917
BALLET GIRL FROM CAMBODIA
Pencil and watercolour
30.7 × 19.5
No watermark
NM 186/1918

When King Sisowath of Cambodia paid a
state visit to France in 1906 in connection
with a colonial exhibition in Marseilles, he
was accompanied by a troupe of twenty
ballerinas in the custody of his daughter,
Princess Soumphady.

Rodin, already interested in the subject of
dancing and notably curious about the Far
East, executed numerous studies of the
young dancers and even followed the
company to Marseilles in order to continue
this work.

PROVENANCE
Gösta Olsson.

BIBLIOGRAPHY
Bjurström 1986, no. 1685

143 Auguste Rodin

TWO FEMALE NUDES

Pencil and watercolour

33 × 25

No watermark

Zornmuseet, Mora

Inscribed at lower right in pencil: *Aug Rodin*, and inscribed: *au maitre peintre Zorn Rodin bassin et jets d'eau*

The figures are coloured with a brown wash and set off by a blue field that suggests water.

PROVENANCE

Gift from the artist to Anders Zorn in 1906 in recognition of the latter's portrait of Rodin, done in the same year.

BIBLIOGRAPHY

Bjurström 1986, no. 1693

144 Paul Cézanne

AIX-EN-PROVENCE 1839–AIX-EN-PROVENCE 1906

GROUP BATHING

Pencil

12.2 × 15.8

No watermark

NM 304/1919

The drawing shows six men at the river's edge, some nude, others clothed; the composition conceived according to classical taste. Certain authors, including Venturi, are of the opinion that this sketch was drawn from life and depicts soldiers stationed in Aix bathing in the river. Chappuis, however, finds the sheet lacking the spontaneity of a study from life. The drawing is dated by Venturi to 1878–87; by Chappuis to 1872–5.

PROVENANCE

Ambroise Vollard.

BIBLIOGRAPHY

A. Vollard, '*Paul Cézanne*, Paris 1914–15', repr. p. 160

L. Venturi, *Cézanne son art – son œuvre*, Paris 1936,

1, p. 303, no. 1265

A. Chappuis, *The Drawings of Paul Cézanne*, London 1973, 1, p. 122, no. 352

Bjurström 1986, no. 1352

145 Paul Cézanne
LES ARBRES EN V
Watercolour and pencil
42.3 × 30
Laid down
NM 1304/1985

Commenting on this drawing, one of the subtlest and most stringent from the hand of Cézanne, Venturi writes, 'Here, lines not only outline the trees or encompass the structure of the composition, they are poetic expression.

They spring upward and, vanishing toward the upper edge of the picture, or cut short by it, suggest infinite ascension. Furthermore, these lines vary in thickness and are interrupted here and there by reflections of light – that is, they lose their identity as lines in order to become thoroughly incorporated in the pictorial effect. Unity of the effect is thus accomplished and the work of art is fully realized.'

Cézanne uses the watercolour, here and elsewhere, to represent light and the space between forms, while the slim trunks are indicated by pairs or questing contours, between which the paper has been left white.

PROVENANCE
Paul Cézanne (the artist's son), Paris. Bernheim-Jeune, Paris. Miss Chapin, Paris. Princess M. Caetano di Bassiano, Paris. The Leicester Galleries, London. Sir Hugh Walpole, London (sale, Walpole coll., London, Christies, 11 January 1947, lot 47). London, Sotheby's sale, 5 December 1984, lot 31.

BIBLIOGRAPHY
L. Venturi, *Paul Cézanne, son art – son œuvre*, Paris 1936, no. 961 (ill.)
F. Novotny, *Paul Cézanne*, Vienna 1937, pl. 103
L. Venturi, *Paul Cézanne Watercolours*, London 1943, p. 12, fig. 6
G. Nicodemi, *Cézanne Disegni*, Milan 1944, no. 58, ill.
F. Novotny, *Paul Cézanne*, New York 1948, pl. 95
F. Elgar, *Cézanne*, Paris 1968, p. 258, ill.
J. Rewald, *Paul Cézanne The Watercolours*, London 1983, p. 164, no. 322, ill.
Bjurström 1986, no. 1353

EXHIBITIONS
London, Leicester Galleries, *The Art collection of the late Sir Hugh Walpole, part 1*, 1945, no. 137
London, Tate Gallery, Leicester Museum and Art Gallery, Sheffield, Graves Art Gallery, *Paul Cézanne*, exhibition of watercolours, 1946, no. 15

[1] L. Venturi, *Paul Cézanne Watercolours*, London 1943, pp. 12–15.

BIBLIOGRAPHY

Books

J. Adhémar, *Le dessin français au XVIe siècle*, Lausanne 1954

R. Bacou, *Il settecento francese* ('I disegni dei maestri', 13), Milan 1970

S. Béguin, *Il cinquecento francese* ('I disegni dei maestri', 5), Milan 1970

P. Bjurström, *French Drawings, Sixteenth and Seventeenth Centuries*, 'Drawings in Swedish Public Collections', 2, Stockholm 1976

P. Bjurström, *Italian Drawings, Venice, Brescia, Parma, Milan, Genoa*, 'Drawings in Swedish Public Collections', 3, Stockholm 1979

P. Bjurström, *French Drawings, Eighteenth Century*, Drawings in Swedish Public Collections 4, Stockholm 1982

P. Bjurström, *French Drawings, Nineteenth Century*, Drawings in Swedish Public Collections 5, Stockholm 1986

F. Boucher and Ph. Jaccottet, *Le dessin français au XVIIIe siècle*, Lausanne 1952

R. Huyghe and Ph. Jaccottet, *Le dessin français au XIXe siècle*, Lausanne 1948

P. Lavallée, *Le dessin français*, Paris 1948

P. Rosenberg, *Il seicento francese* ('I disegni dei maestri', 11), Milan 1970

P. Rosenberg, *French Master drawings of the 17th and 18th centuries in North American collections*, Art Gallery of Ontario, Toronto etc, 1972–3

J. Schönbrunner and J. Meder, *Handzeichnungen alter Meister aus der Albertina und anderen Sammlungen*, 12 vols, Vienna 1896–1908

M. and A. Sérullaz, *L'ottocento francese* ('I disegni dei maestri', 6), Milan 1970

M. Sérullaz, L. Duclaux and G. Monnier, *Dessins du Louvre école française*, Paris 1968

O. Sirén, *Italienska handteckningar från 1400– och 1500– talen i Nationalmuseum*, Stockholm 1917

J. Vallery-Radot and Ph. Jaccottet, *Le dessin français au XVIIe siècle*, Paris 1953

Catalogues cited in abbreviated form

Cat. 1712
Catalogue des livres, estampes et desseins du Cabinet des beaux arts et des sciences, appartenant au Baron Tessin, Stockholm 1712

Cat. 1730
Manuscript catalogue drawn up by Carl Gustaf Tessin at some date between 1728 and 1739 (Nationalmuseum)

Cat. 1749
Manuscript catalogue drawn up by Carl Gustaf Tessin at some date between 1749 and 1755 (Nationalmuseum)

Cat. 1785
Catalogue d'une collection [Tessin's] . . . *dont la Vente au plus offrant se fera le* [8] du mois de [Mai] 1786, Stockholm 1785

Cat. 1790
Manuscript catalogue drawn up by Fredrik Sparre while the collection belonged to the Kongliga Biblioteket (Royal Library). The original manuscript is in the National Archives; there is a copy in the Nationalmuseum

List 1739–42
Manuscript list of the items that Tessin brought back from his stay in Paris, 1739–42 (Kungliga Biblioteket, Ms. S.12)

Mariette
Pierre-Jean Mariette, *Description sommaire des desseins des grands maistres . . . du cabinet de feu M. Crozat*, Paris 1741

New York, Boston, Chicago 1969
J. Pierpoint Morgan Library, New York; Museum of Fine Arts, Boston, Art Institute of Chicago, *Drawings from Stockholm. A Loan Exhibition from the Nationalmuseum*, 1969

Paris 1935
'Les Dessins français dans les collections du XVIIIe siècle', *Gazette des Beaux-Arts*, Paris 1935

Paris 1947
La Suède et Paris, Paris, Musée Carnavalet, 1947

Paris 1950
Dessins du Nationalmuseum de Stockholm. Collections Tessin et Cronstedt, Paris, Bibliothèque Nationale, 1950

Paris 1956
Paris, Musée Carnavalet, *Théâtre et fêtes à Paris. XVIe et XVIIe siècles. Dessins du Musée National de Stockholm*, 1956

Paris, Brussels, Amsterdam 1970–71	Paris, Musée du Louvre, Brussels, Bibliothèque Royale Albert 1er, Amsterdam, Rijksmuseum, *Dessins du Nationalmuseum de Stockholm. Collection du Comte Tessin 1695–1770*, 1970–71
Stockholm 1922	Stockholm, Nationalmuseum, *Carl Gustaf Tessins franska handteckningar från 18:e århundradet*, 1922, cat. no. 15
Stockholm 1933	Stockholm, Nationalmuseum, *Exposition d'un choix de dessins du Quinzième au dixhuitième siècle*, 1933, cat. no. 43
Stockholm 1958	Stockholm, Nationalmuseum, *Fem sekler fransk konst 1400–1900*, 1958, cat. no. 247
Washington, Fort Worth, San Francisco 1985–6	Washington, National Gallery, Fort Worth, Kimbell Art Museum, Fine Arts Museums of San Francisco, *Dürer to Delacroix. Great Master Drawings from Stockholm*, 1985–6

ACKNOWLEDGEMENTS

The author and publishers would like to thank the following museums and galleries for permission to reproduce works from their collections. Thanks are also due to Colin Eisler for his helpful suggestions during the preparation of this book.

Page
16 Herzog Anton Ulrich Museum, Brunswick
17 (Staatliche Museen Preussischer Kulturbesitz, Kupferstich-Kabinett, West Berlin
18 Musée Condé, Chantilly
21 Courtesy of the Trustees of the British Museum
22 Cabinet des Dessins, Musée du Louvre, Paris
24 Cabinet des Dessins, Musée du Louvre, Paris
36 (above) Cabinet des Dessins, Musée du Louvre, Paris; (below) Nasjonalgalleriet, Oslo
57 The Uffizi Palace, Florence
58 Trustees of the Pierpont Morgan Library, New York
60 Kupferstich-Kabinett, Staatliche Museen Preussischer Kulturbesitz, West Berlin
91 Musée des Gobelins, Paris
171 Staatliche Kunstsammlungen, Weimar
174 Cabinet des Dessins, Musée du Louvre, Paris
175 Mrs Rudolf J. Heinemann, New York
202 Musée Rodin, Paris

INDEX